NIGHT·LOW-LIGHT·FLASH
PHOTOGRAPHY

NIGHT·LOW-LIGHT·FLASH PHOTOGRAPHY

DAVID STRICKLAND

Salem House

Salem, New Hampshire

© David Strickland 1985

First published in the United States by Salem House, 1986
a member of the Merrimack Publishers' Circle,
Salem, New Hampshire 03079.

ISBN: 0 88162 134 X (Hardback)

ISBN: 0 88162 135 8 (Paperback)

LIBRARY OF CONGRESS CATALOG CARD NUMBER: 85-61672

Designer: Sarah Jackson

Assistant Designer: Colin Lewis

Editor: Matthew Sturgis

Picture Researcher: Caroline Mitchell

Filmset by Flair plan Photo-typesetting Ltd

Printed in Italy by Tipolitografia
G. Canale & C. S.p.A. - Turin

First published in Great Britain in 1985
by Macdonald & Co (Publishers) Ltd
London & Sydney

CONTENTS

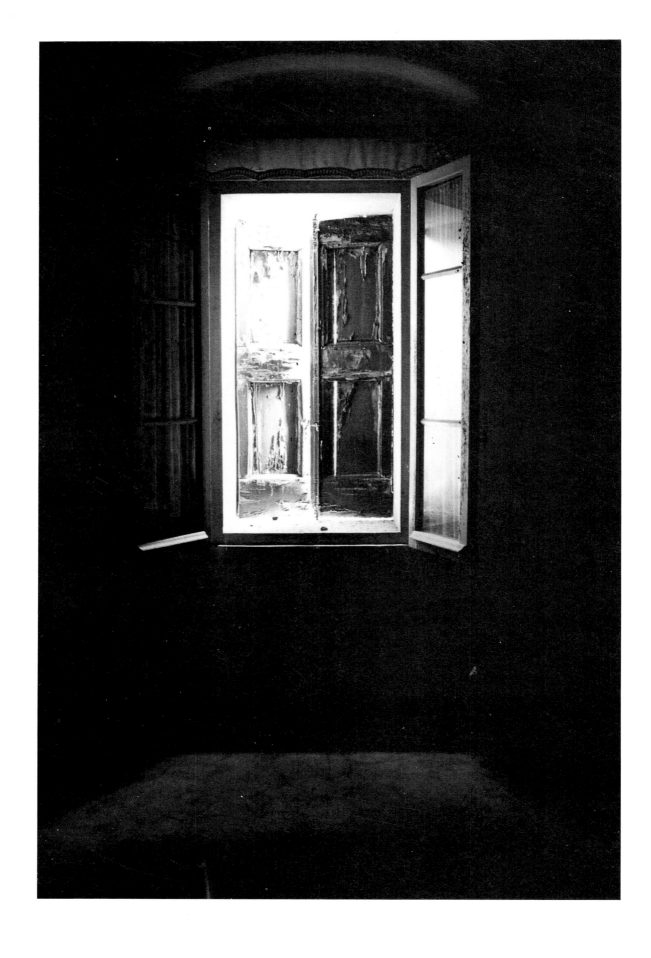

INTRODUCTION

Night photography has long been a distinctive and distinguished subject – during the winter of 1895–6 the English photographer Paul Martin took a series of pictures of 'London by Gaslight', using mainly available light; no mean feat for the time. The night reduces a scene to its basic elements; the clutter seen in daylight disappears. At night the light is one of extremes, with pools or points of light standing out against featureless shadow areas. Even a full moon gives a low-level, contrasty light. Because of these extremes of light, photography at night has great creative potential; subjects can be isolated, and artificial lighting used to give the photographer near total control over the picture.

Potential night or low-light subjects are as numerous as daylight ones. There are, however, some subjects that are seen mainly or only at night, and which are particularly suited to photography – firework displays for instance. Many indoor leisure activities take place during the evening or at night, and most of these can offer the photographer interesting material. So too can subjects that we normally see during the day. Shooting at night can give us a fresh view of them, while the problems of lighting, exposure, processing and printing, can give us greater insight into the techniques of photography.

Photography in low light demands a heightened understanding of the principles and techniques of photography. All the elements of the art – exposure control, lighting, composition, tone and colour – become much more critical. The essence of photography is light; indeed the word is derived from the Greek for 'drawing with light', and understanding and using light are as much parts of the photographer's equipment as is his camera. Paradoxically, taking pictures in the dark is one of the best ways to learn about light. By taking photographs in such conditions you can begin to learn what sort of light is required to replace or supplement the limited existing light.

Flash can be used not only in darkness, but also to balance existing light or to highlight a part of the picture. With flash it is possible either to emphasize the available light, or to create an artificial lighting scheme for the scene. The latter is particularly useful if you wish to freeze movement. One of the great practitioners of this art is O. Winston Link, who took many pictures of the Norfolk and Western Railway in America, using a powerful battery-operated flashbulb system.

The advantages of flash, particularly electronic flash, over other forms of artificial light are that it is portable and gives a consistent light at a colour temperature balanced to daylight. This means that when shooting in colour, you can use flash in the daylight without any problems of colour balance. Unfortunately, with most cameras the flashgun hot-shoe is located immediately above the lens. This is very restricting for the serious photographer, as it gives that predictable, hard, flat-looking front light. By moving the flash to one side, or up or down, or better still by bouncing it off a reflector of some sort, more varied and interesting results can be achieved.

Using flash or some other form of artificial light may sometimes be impractical or detrimental to the picture, destroying the effect you are aiming at. Available light, however, is often limited, necessitating long exposures. This is when the camera stand and cable release come into their own. Photographing landscapes and buildings at dusk, when there is some daylight to give extra shadow detail and a light sky to lift the background, can give very successful, available-light pictures. Moreover, at this time of day, by varying the exposures, you can get pictures ranging from what appears to be full daylight to darkest night, with the colour varying from rich golds to deep blues.

Many successful low-light photographers use flash only as a last resort. To them the challenge of low-light photography is to try to show the subject 'as it is'. To preserve the integrity of the scene is their main aim.

OPPOSITE *This picture deals with extremes of light, a recurring problem with available-light and night photography. The light filters into the room, accentuating the peeling paint of the shutters and reflecting off the window glass. The picture comprises a series of rectangles from the 35mm format down to the panels of the shutters. (Tri-X rated at 800 ASA, Nikon 35mm: 1/15 sec. – f5.6)*

7

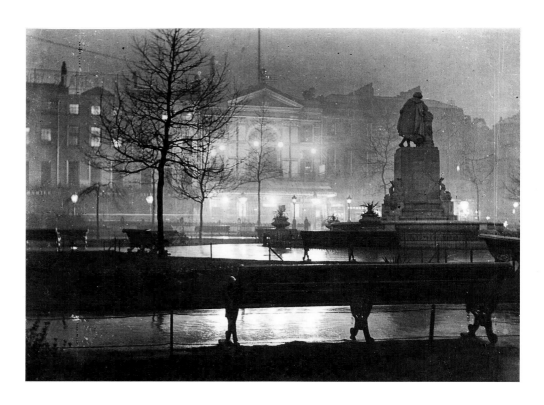

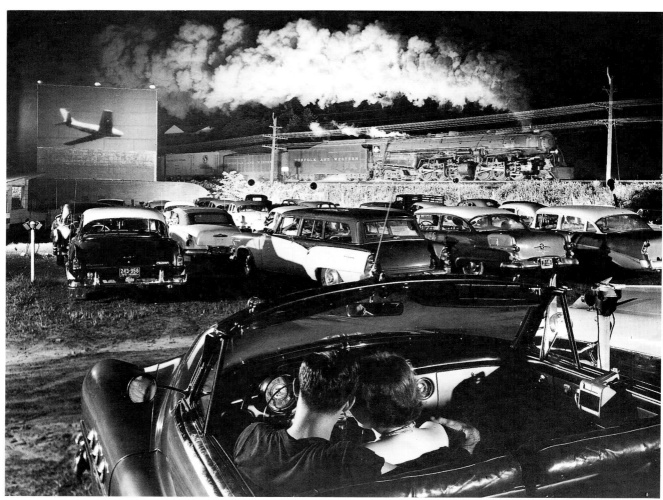

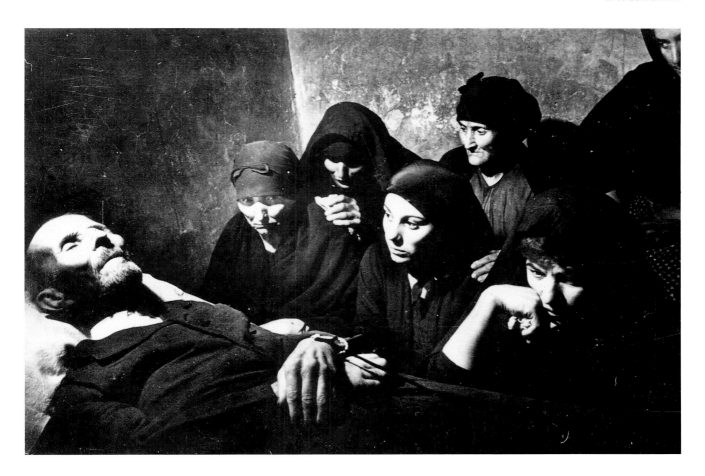

ABOVE *The composition and lighting of this picture by Eugene Smith heighten the relationship between the mourners and the dead man. Compositionally the picture is made up of a number of diagonals: the corpse, the line of mourners and the face of the priest in the top righthand corner. The faces of the two men also create their own diagonal. This combination of diagonals with the stark lighting gives the picture a sense of tension.*

OPPOSITE ABOVE *Although nearly 100 years old this picture by Paul Martin would look very much the same if taken today. It has all the classic elements of night photography: light sources appearing in the picture, reflective surfaces, and silhouettes that take the eye into the scene.*

OPPOSITE BELOW *O. Winston Link's picture of the Hot Shot passing the Drive-In Theatre at lager, West Viginia, shows what an expert can do with flash equipment. Taken in 1956, he used a 4×5 Graphic View Camera with a 3⅝-inch wide-angle Dagor lens and a set up of forty-two #2 flash bulbs and one #0 flash bulb. Luck as well as skill was necessary; at the point of taking the picture Link could only see the headlight of the locomotive in the total darkness. (ECKo Royal Pan, Graphic View Camera 4×5 inches: 1/200 sec – f11 – f16)*

The great advantages of available light are that you can work with more freedom, and are less obtrusive – often an important consideration for the nature or documentary photographer. The American photographer Eugene Smith was able to handle the most delicate and sensitive situations, as this available-light picture of mourners in a Spanish village shows.

For some photographers the subtleties of light and colour that low-light gives cannot be surpassed by artificial, studio lighting. Like painters, for them the ideal studio light is a natural north light. The right lighting for a picture cannot be forced, but must be watched and waited for.

Although low-light and night photography are complex and problematic, the sooner you can free yourself from the constraints of technique, and concentrate on what is happening in the viewfinder, the better. This book will help you to master the techniques. It will also show you how to produce interesting and satisfying pictures, making the most of your equipment, while never forgetting that it is the person behind the equipment who counts for most.

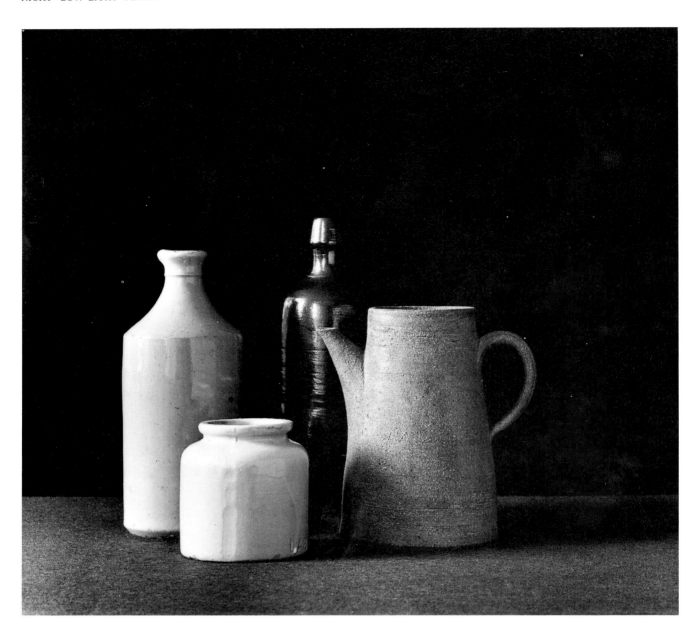

ABOVE *A still life constructed from simple everyday objects; shape, tone and texture are the main elements of this picture. The group is placed off centre frame, side lit from a window with the blind letting in only a small amount of light. This soft directional light brings out the texture of the pots and the cloth on which they are placed. (FP4 rated at 125 ASA, Nikon 50mm: 5 secs – f11)*

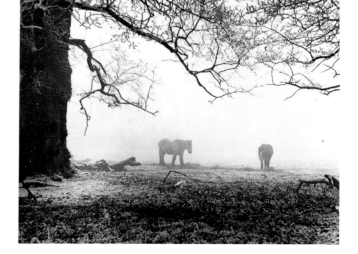

RIGHT *Mist and fog flatten a picture, giving the scene a two-dimensional quality. The frost-laden trees and grass in the foreground create a frame for the horses, which just appear from the mist. (FP4 rated at 125 ASA, Nikon 50mm: 1/15 sec – f4)*

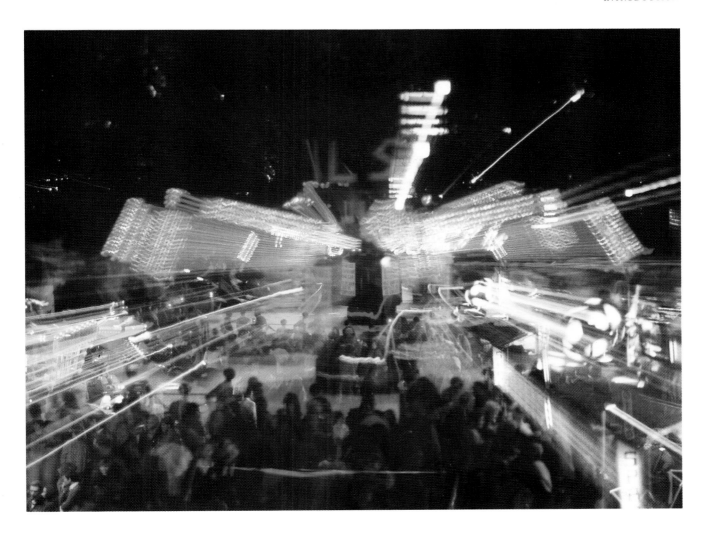

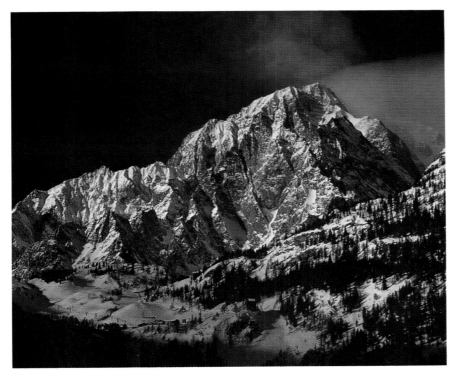

ABOVE *Interesting effects can be achieved by altering the focal length setting of a zoom lens during a long exposure. The camera must be placed on a tripod and the lens focused at its longest setting. Then, while the shutter is open, zoom the lens out to its widest setting. In this way static subjects can be given the appearance of movement, or patterns can be created from displays of light, as in this picture of a funfair ride. (Ektachrome 160 tungsten rated at 160 ASA, Nikon 80 – 200mm: 1 sec – f5.6)*

LEFT *Day for Night. As well as suppressing reflection, a polarizing filter can be used to darken skies and give extra colour saturation. On a subject that has high contrast, by deliberately underexposing, as well as using a polarizing filter, the picture looks as if it had been taken at night. A number of exposures were made and the one selected was one stop underexposed. (Kodachrome 64, Nikon 35mm: 1/60 sec – f8)*

11

I EQUIPMENT

THE CAMERA

There is no doubt that the 35mm single lens reflex (SLR) is the most popular camera system in the world today, used by serious amateurs and professional photographers alike, and therefore it is the basic camera referred to in this book. Most of the systems manufactured offer an extensive range of fast lenses (lenses with a wide maximum aperture), which are essential for night photography, plus a full range of camera accessories. Nearly all the systems have through-the-lens metering coupled directly to the aperture and shutter controls. Some, however, have totally automatic exposure control, which for low-light and night photography may be limiting, as on many occasions the exposure control will need to be in the hands of the photographer. You should ensure that your camera has a manual mode on the metering.

LENSES

As with any type of photography, try to have as many lenses as possible. As you are likely to be using the lenses at maximum aperture quite often, it will pay to buy the best lenses you can afford. Cheap lenses are often of little use at maximum aperture, because of poor resolution.

Wide-angle lenses 24mm–35mm
The wide-angle lens is used frequently in reportage and architectural photography. The wide-angle gives a good depth of field at wide apertures, and some reportage photographers use the 35mm as a standard lens.

Standard lenses 50mm–55mm
These are usually the fastest lens in any system.

Telephoto lenses 80mm–85mm
In the telephoto range the 80mm and 85mm are particularly good for portraiture, allowing a large head-shot without the need to be sitting in the subject's lap. These lenses also give you the working room to place lights between the camera and the subject if required.

Telephoto lenses 85mm–300mm
The telephoto lens is needed to get pictures where direct access to the subject is restricted, as at sports fixtures or pop concerts. The lens should have good resolving power at maximum or near maximum aperture, and you need to be able to operate it when the camera is hand-held. At pop concerts and floodlit sports you will need to use a fast shutter-speed to stop movement. It is possible to use up to 300mm lens hand-held; after that a tripod becomes necessary.

In addition to these there are other specialist lenses suited to more particular kinds of photography.

Zoom lenses
The zoom lens is very good for action photography where the subject is constantly moving backwards and forwards in the picture area, or in situations where you need to change from a wide to a close shot without losing the picture in the viewfinder. Most of the medium-range zooms, 70 to 210mm, are light enough to use hand-held with some practice.

The zoom lens is often relied upon by many amateur photographers as an alternative to using a number of fixed lenses, but remember that it is designed to fulfil a particular need, and may not give such good results as the equivalent fixed lenses. Many of the new zoom lenses have a macro facility for close focusing.

Macro and micro lenses
These lenses are specially designed for use in close-up photography. They can also be used for normal photography, but with some loss of picture quality.

Lens hoods
A lens hood is useful on any lens, but is essential for low-light and night photography, where you are often shooting directly, or nearly directly, into the light, and where lights often appear in the picture. The lens hood will cut down the risk of flare in the lens, which can result in an overall flattening of the image.

FILTERS

Filters are used to modify the light passing through the camera lens. They can be used for many reasons – to correct colour, to alter tonal values in black-and-white photography, for pictorial effects, and to deal with atmospheric effects and polarized light.

Colour-correction filters
A colour correction filter is used to convert transparency daylight film to tungsten light, or tungsten film to daylight. For the former task use a No. 80A filter, and for the latter a No. 85B.

Colour-compensating filters
Colour compensating filters are used to correct any colour bias in the film, or in a particular light source, such as a fluorescent light. In black-and-white photography, colour filters can be used to lighten and darken tones. A yellow or yellow-green filter will darken the sky to an approximately correct tonal value in terms of human vision, whereas an orange or red filter will darken the sky, making it look almost night-like, with any clouds appearing to be much lighter.

Graduated filters
Graduated filters are now available in a wide range of colours, for use with both black-and-white and colour film. They alter only part of the picture.

Polarizing filters
A polarizing filter can be used to reduce or eliminate reflections on glass and water. It can also be used to darken the sky, creating a day-for-night effect.

Diffraction filters
Diffraction filters, such as colourburst, starburst and prism filters, are particularly effective when a light source or a reflection appears in a picture. The filters create patterns of colour and light in the picture.

Ultraviolet filters
Atmospheric haze often occurs in distant landscape views, and is caused by light being scattered by the water and dust particles in the atmosphere. The eye is less sensitive to this than photographic materials, as the haze is composed primarily of ultraviolet light, which is outside the visible spectrum. This haze can, however, be used to give pictures a greater feeling of depth – an effect often referred to as 'aerial perspective'. Other filters, such as the pale-pink skylight and the various pale-yellow filters, can also be used to reduce ultra-violet light.

Neutral density filters
A neutral density filter reduces the intensity of visible light, and can be used with both black-and-white and colour film. If you have an ultra-fast film in your camera, and wish to use flash, a neutral density filter will effectively reduce the working speed of the film.

CLOSE-UP ATTACHMENTS

There are a number of ways of producing close-up pictures without using a macro lens.

Supplementary lenses
Supplementary lenses are placed in front of the camera lens.

Reversal rings
Reversal rings couple the inverted standard lens to the camera body, increasing its magnificaton by about one and a half times.

Extension tubes
Extension tubes usually come in sets of three, and can be used individually or together. They fit between the lens and the camera body.

Bellows
Bellows also fit between the lens and camera body, but give a greater magnification than the extension tubes.

With any of the attachments, other than supplementary lenses, an exposure increase may be necessary if you do not have through-the-lens metering.

MOTOR-DRIVE

For the action and sports photographer a motor-drive unit, or a camera that has power wind, is a useful piece of equipment. It enables you to shoot continuously, either in single frames or in a sequence of frames, without taking your eye from the viewfinder. With a motor-drive, however, it is all too easy to use up film at a very fast rate.

EXPOSURE METERS

Through-the-lens meters
Most modern 35mm SLR cameras have through-the-lens metering coupled to both the aperture and shutter controls; some are completely automatic. The obvious advantages of through-the-lens metering are that it is quick to use, and will automatically take into consideration any lens changes and added accessories, such as extension tubes or filters, that affect exposure.

Most systems are fairly sensitive and are powered by

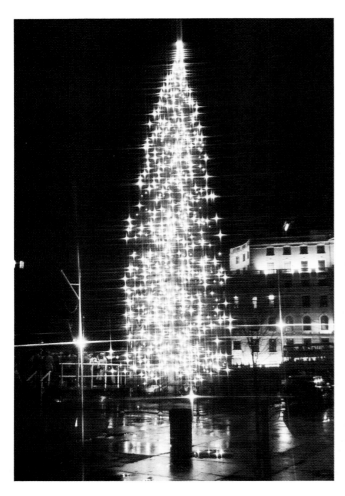

ABOVE *By using a starburst filter on this picture the Christmas tree was given a more festive feeling. The reflections on the wet pavement also add interest. (Fuji 400 rated at 800 ASA, Nikon 24mm: 1/30 sec – f4)*

RIGHT *The combination of early morning light and mist rising from the lake give this picture an ethereal quality. The picture is made more atmospheric by the monochromatic colour. (Kodachrome 64, Nikon 150mm: ½ sec – f3.5)*

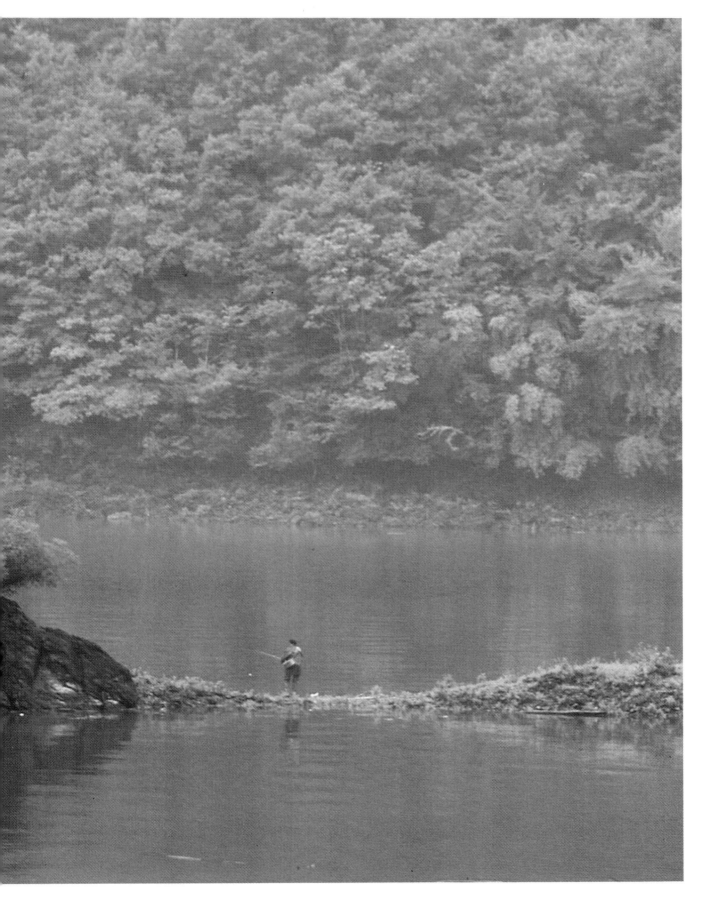

CdS or silicon cells. The way the light is measured varies from camera to camera, but the most common method is the centre-weighted system. This reads from most of the viewfinder area while giving preference to the centre and foreground. On some of the new cameras that have multi-program meters, an integrated reading is taken over the entire focusing area and there is a special facility for backlit subjects.

When working at night or in low light, or in situations where a light source may appear in the picture, care needs to be taken in making a reading. As with any exposure you will need to decide which areas of the picture you wish to register on the film, and a certain amount of trial and error is then required to get the correct exposure for your picture. If in doubt make more than one exposure, altering the exposure below and above the one given as correct in the camera; this is known as 'bracketing'. Whenever you find yourself in a situation that poses an exposure problem, make notes of the exposures to compare against the results; this will give a basis to work from in any later and similar situation.

Hand-held meters

There are three basic types of hand-held meter: the selenium cell, which has its own built-in photo-electric cell; the CdS meter, which is battery operated and is far more sensitive than the selenium meter; and the spot meter, which operates in much the same way as the through-the-lens meter on a camera, but takes its reading from only a small area of the picture.

The CdS meter is by far the best meter for low-light conditions, although the spot meter, a specialist piece of equipment, can give more accurate readings. The CdS meter does have a tendency to remember its last reading, particularly if moved from a bright to a low-light scene. It is best, therefore, to wait for a few minutes to allow the meter to clear if you are using it under such conditions.

With pictures where you have extremes of light you will need to decide which areas you wish to have exposure preference, related to the exposure tolerance of the film you are using. It is possible, if you have time and a telephoto lens, to use the camera as a spot meter by taking readings of a much smaller area to help decide exposure preference.

Flash meters

If you intend to make extensive use of your flash equipment it may be worth investing in a flash meter. They operate in much the same way as a normal meter except that they need to be synchronized to the flash unit. The meter is placed in front of the subject, directed towards the camera, a button triggers the flash and a reading is given.

CAMERA STANDS

For the low-light and night photographer a camera stand is an essential piece of equipment. It must give firm support to the camera and allow maximum adjustment for height and angle. Although height is important, so is the ability to get close to the ground, and so a stand with a reversible centre column is useful.

A monopod is lighter and more transportable than a tripod, but it is really little more than a camera prop, and gives only slightly longer exposure opportunities than a hand-held camera. If you need to be mobile there are small table-top tripods available, or G clamps with ball-and-socket heads that can be clamped to the back of a chair or some similar support.

If you are using a camera stand you will also need a cable-release to avoid unnecessary camera-shake. Get one with a plunger lock to use on extra-long exposure when the shutter is set on 'Bulb'.

LIGHTS

On some occasions supplementary or alternative lighting may be required, either to enhance the existing lighting or to create a deliberately artificial effect, or even to reproduce as near as possible the existing lighting at a workable level. There are two types of artificial light, tungsten and flash. Flash is the more popular form with most photographers.

Flash

Electronic flash provides a cheap and efficient light source that is compatible with daylight. The main factors to be considered when choosing a flash unit are: light output – how powerful is it? Flash duration – how fast is it? Recycling time – how long between each flash? Power supply – what type of power does it use? If battery-operated, how many flashes are available?

The light output depends on the size of the capacitor and the voltage supply. The flash duration varies according to the type and size of unit, as does the recycling time. With a battery-operated unit the number of flashes will depend upon both the size of the power-pack and on how you are using the unit.

As the flash duration is fixed according to the unit involved, usually between 1/300 and 1/1000 of a second on the portable units, the exposure is calculated by dividing the manufacturer's guide number for a particular film by the distance from the flash to subject; this gives the required aperture setting. For instance with a guide number of 80 at a distance of ten feet (3m) the aperture will be f.8.

Many new flash units have a built-in calculator and sensor to control flash duration. The film speed is set on the calculator, which gives a colour band according to the aperture setting. There is a similar colour-coding on

the flash sensor. Once the two are set at the same colour code the unit is ready to use. The sensor measures the amount of light reflected back from the subject, and quenches the flash as soon as it receives the right amount of light. It also takes into consideration the tonal quality of the subject; a light tone reflecting more light will be given less exposure than a dark tone.

The camera must be set to the appropriate shutter-speed, or mode, to achieve synchronization of flash and shutter. If this is not done, the film is likely to be only partially exposed or totally unexposed. The SLR has a focal-plane shutter that has two blinds, one following the other as the shutter travels across the film plane. At higher speeds the film is exposed in successive strips. So to avoid partial exposure use the slower shutter-speeds, where the blinds totally uncover the film area.

If you are serious about using flash, avoid the electronic flash unit that operates only on the camera hot-shoe. This type of unit has a limited use and can give unattractive lighting results unless it is bounced off a reflector, or has a softlight adaptor. For less than double the price of an on-camera unit, you can buy a rechargeable shoulder pack unit that can also be operated directly from the mains. Some of these units can take up to three separate flash heads, giving a more varied and controllable light source.

Tungsten lights

With the advent of home video there are many more tungsten light units on the market. In the main they are quartz-iodine or tungsten halogen floods. They are designed to cover a large area, and they give a fairly hard light. The normal photoflood is more controllable, although it will give less light. To avoid using stands it is possible to get clip-on lights, with or without reflectors. With the non-reflector lights a bulb that has a built-in silvered reflector is required. Photoflood bulbs can also be used on a temporary basis to replace household bulbs in home lighting to give extra light. Care must be taken not to burn-out fittings, as the photoflood is an overrun bulb and will generate a lot of heat.

With any type of light, natural or artificial, a reflector is a useful and cheap lighting aid, whether it is purpose-made or just a piece of white card.

Accessories

When working at night you will find a pocket torch (flashlight) invaluable. It enables you to set the aperture and shutter, to check the effect a flash is giving, and to light a point to focus on. Also useful are a notepad and pencil, and a packet of self-adhesive labels to mark film cassettes.

CARRYING YOUR EQUIPMENT

There are many types of camera case and bag; some are designed to carry and protect equipment, others just to look good. If you have a lot of expensive equipment, the carrying case should, in my opinion, look as unobtrusive as possible; firstly to prevent you from being noticed as a photographer, and, secondly, to avoid theft. It should be heavy enough to provide protection for the equipment but not be uncomfortable to carry for any length of time.

If you are photographing a specific subject, work out in advance what you will need in the way of equipment, so that you do not have to carry unnecessary weight. If you do need to carry a lot of equipment, it is best to spread the weight over two cases rather than take a single unwieldy one.

RIGHT *The dome of Saint Paul's Catherdral in London is bathed in a warm glow as the early morning sun finds its way through the surrounding office blocks. Because of the redness of the light the contrast between the lit dome and the unlit portion of the building below is evened out in terms of exposure. Taken later in the day these extremes of exposure would have resulted in loss of detail in the lower half of the picture. (Ektachrome 200, Nikon 35mm: 1/30 sec – f5.6)*

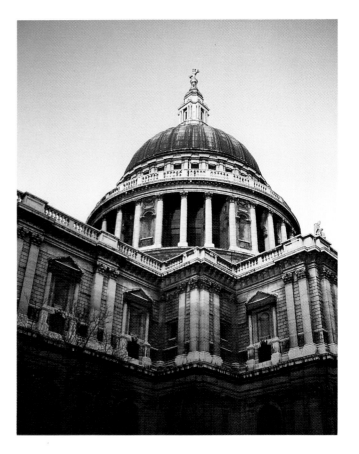

BELOW *The late afternoon sun cutting across Sydney Harbour picks out the boats and the city skyline from the deep blue of the sea and sky, which merge as a continuous tone of blue from foreground to background. This single-coloured ground makes the complexity of the rest of the picture more readable.*

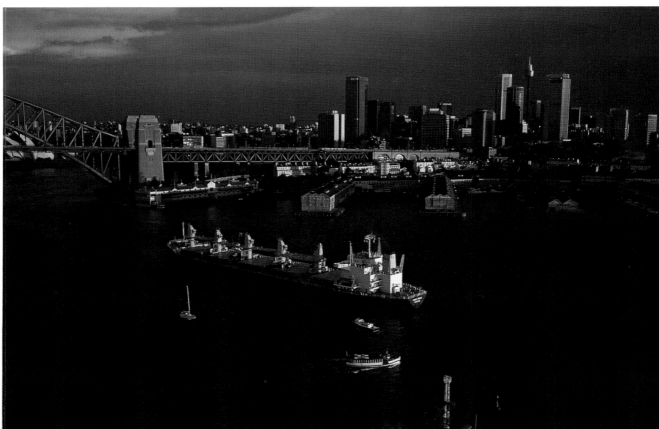

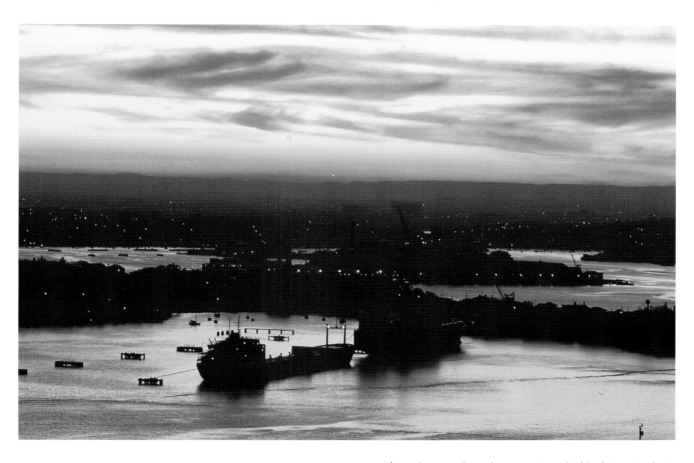

ABOVE *A continuous colour plays a great part in this picture too, but this time the rest of the scene is a silhouetted pattern of boats and harbour, broken by the points of street lights. The cloud formations echo the pattern of the shapes below.*

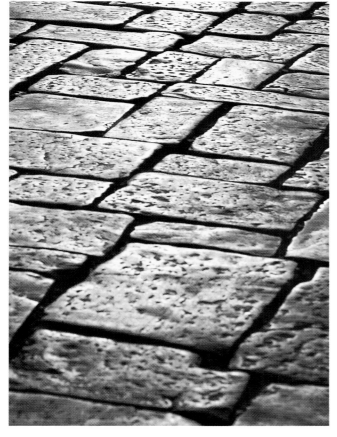

LEFT *Because this Roman road has been worn smooth over the centuries, the sun reflects off it at sunset, completely changing the colour of the stone. The pattern and texture are also strengthened in contrast to the reflecting light. Camera position and angle are important here, and a number of shots were taken to get the right balance of contrast. (Kodachrome 64, Nikon 50mm: 1/30 sec – f8)*

2 USING LIGHT

We use light not just to see by, but also to qualify what we see. Light defines time for us in terms of day and night, summer and winter. We also have an emotional and psychological response to light that defines mood and feeling. The colour, as well as the angle, of light adds to its changing effects. Indeed it is the light reflected back from an object that enables us to define its colour and texture. We are using light constantly to define both visually and emotionally the world we live in. With photography we must learn to consciously exploit these visual and emotional aspects of light to create interesting and meaningful pictures.

The low-light hours around dawn and dusk are some of the best for photography, as they produce a wide and interesting range of colour and light. In the early morning just before sunrise the light has an eerie and luminious quality; as the night recedes it is just possible to define shape and colour. The light at this time creates a cool, low-key effect, with muted colours and tones often rendering a scene in near monochrome. Early morning mist and fog can make it appear even more muted, giving the picture a two-dimensional surface quality. By under- or over-exposure you can reverse this. The overexposed picture will have a high-key ethereal quality – with objects seeming to float – while the underexposed picture will appear more sombre.

At dawn the sun rises rapidly, casting an orange light with long, deep shadows that have a blue tinge, and making anything in full sunlight stand out in stark contrast to the shadow areas. At this time, as in the late afternoon, any warm colours lit by the sun – reds, yellows and oranges – will appear even warmer. This is because the sun is low in the sky and its light has to pass through more of the earth's atmosphere, which filters out the short wavelengths of light – blue and green – but lets through the longer red wavelength; hence the golden sunsets and red dawns.

The early morning light rapidly gives way to the more general light of morning and to normal daylight, and it is not until the late afternoon. as the sun starts to drop to the horizon, that the light becomes interesting again. The low sun of the late afternoon will last longer than the early morning sun, giving more time for photography. For many photographers this is the best time of day for landscape and architectural photography, as the low light gives more contrast than broad daylight. The colours are very intense at this time, as the lit areas stand out against shadow areas. The sun is lower in the winter months giving a harder, clearer light than in summer.

To get a really good sunset the sky needs to be broken by cloud, which picks up the colours of the sun as it drops below the horizon. As the sun drops below the horizon there is a brief period when its light is still reflected from the clouds, creating a soft overall glow, where colours soften and start to merge, before giving way to total darkness. In this period the light can go through the spectrum from the red afterglow of sunset, to pinks and violets.

At this time, with a clear sky or sky broken with cloud, the horizon glows with light against the dark, almost featureless landscape, as the sky goes from a pink-gold to a deep blue. Silhouettes can be exploited; a figure or a building will, with the right camera angle and position, stand out in stark relief against the horizon.

A reflective surface gives added interest to any low-light or night picture, as it creates another point of brightness or, if it is large, a mirror image. At dawn and sunset any reflective surface in the dark areas of the picture can by careful choice of camera position and angle be made to pick up and reflect the light.

Man-made and natural surfaces like metal and stone can be made to appear to have numerous different qualities if photographed in the appropriate light. This means not only the right time of day but also the right weather; a car or plane can be made to look hard and menacing if photographed in a cold blue light, or in the rain with droplets of water on it. The same object photographed in the warm glow of the late afternoon sun will appear welcoming and benign.

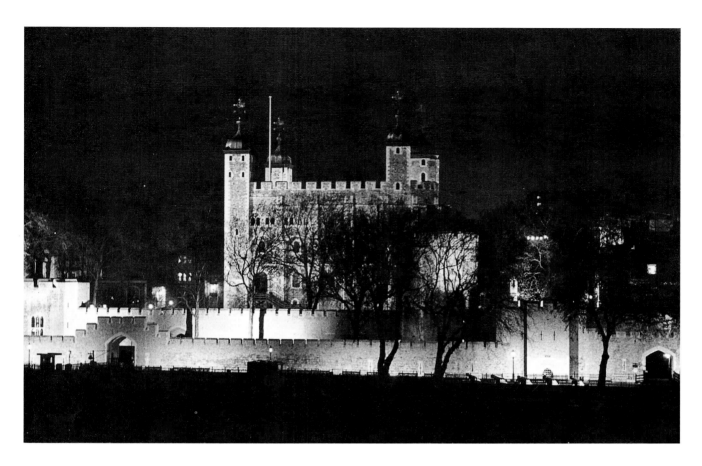

LIGHTING

There are two main approaches to lighting. One is to light for effect, dramatizing the subject as with stage lighting or floodlighting on a building. The effect is deliberately artificial. The other approach is to make the lighting look as natural as possible. This kind of lighting is very much more difficult to achieve.

With low-light and night photography the light source often appears as an important element in the picture. Back light often features too, separating an object or person from the background by a rim of light. Reflections and reflective surfaces also play an important part in low-light and night photography, as they can create alternative light sources or elements of light.

The cheapest and most versatile piece of lighting equipment is a reflector. Reflectors can be made from almost any type of material – card, fabric, foil or mirrored glass – or be bought purpose-made. Most reflectors are white or silver but they can be made in any colour or texture depending on the effect required; there is even a black reflector on the market that works subtractively. The main uses of a reflector, however, are either to bounce back available light or to bounce artificial light to create a softer light. The main problem with using a reflector to bounce back light is keeping it at the right position and angle. To do this effectively you really need another person to hold the reflector while

Floodlit buildings can look flat in photographs. The stark lighting against the night sky can kill any of that feeling of depth that is important in architectural photography. The Tower of London, however, proved an excellent subject, as the many outer walls and the distinct shape of the central keep gave the picture depth. (XP1 rated at 400 ASA, Nikon 80mm: 1 sec – f8)

Ektachrome 400 rated as normal.

Transparency film can be up-rated in the same way as black-and-white film, and will result in a similar loss in tonal colour range with increased grain structure.

A section of the picture left enlarged four times to show grain detail.

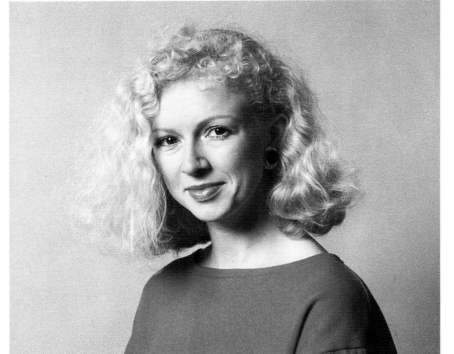

There is no real loss of quality in this picture. (Ektachrome 400 rated at 800 ASA)

An enlarged section of the picture left.

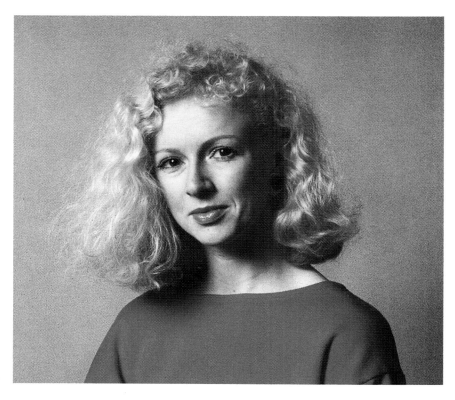

Here the shadow areas start to fill-in with the increased contrast and more pronounced grain. (Ektachrome 400 rated at 1600 ASA)

An enlarged section of the picture left.

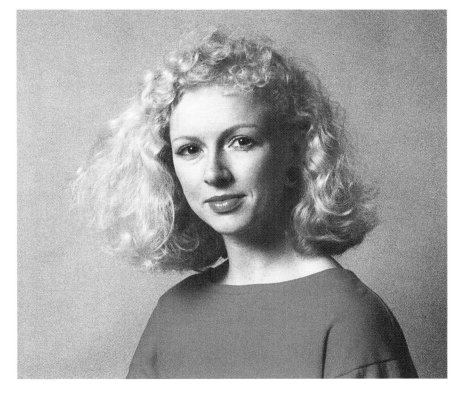

In this picture the colour starts to weaken and the blue background starts to look quite grey. The grain becomes even more pronounced. (Ektachrome 400 rated at 3200)

An enlarged section of the picture left.

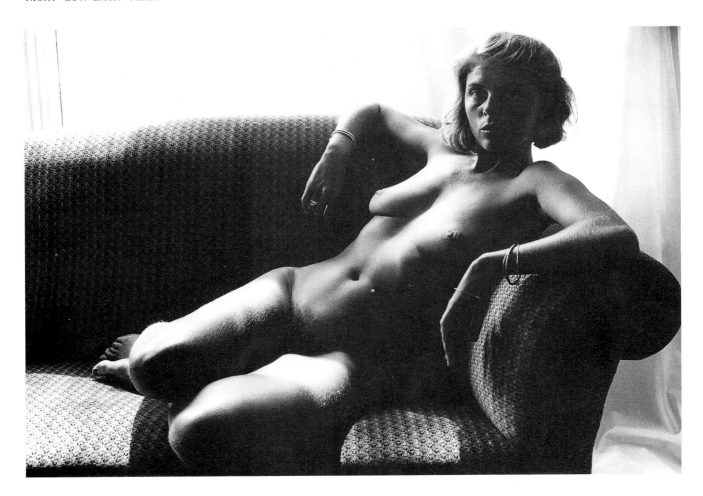

you take the picture. If you are working indoors a makeshift stand, made from a chair or something similar, can be used. Outside it is a little more difficult, but a tripod can be a useful way of propping up a reflector, even if it is also being used to the support the camera.

As a way of bouncing light, a flat reflector, a wall or some other light surface can be used. There are manufactured reflectors of the umbrella type that are relatively cheap to buy. They come in many colours and forms but all comprise a fabric stretched over a wire frame, with the stem used to mount it on a light-stand. The light is either bounced off the umbrella or, if it is translucent, shone through it and thus diffused. The resulting light will be softer but more concentrated than that from a flat reflector.

FLASH

Electronic flash is the most versatile of artificial light sources, it is cheap to run, easy to carry, and gives a light with a colour temperature balanced to daylight. This means it can be mixed with daylight when using colour film. Flash can be used to fill in shadows with available light, to give detail to shadow areas, and as a

ABOVE *The aim of this shot was to achieve as wide a tonal range as possible and accentuate body shape and texture. This has been done by placing the model in a bay window and covering the window behind and to the right with a white sheet. This simplifies the background and reduces the amount of light. The remaining window on the left now gives a strong directional light, which at one point throws a rectangle of light across the model's legs, accentuating their shape. The picture was printed from the dark end of the tonal range. (FP4 rated at 125 ASA, Nikon 50mm: 1/15 sec – f3.5)*

OPPOSITE *A dark or black background will give a portrait a theatrical effect. This picture is lit with one flash head bounced off a reflector to the left of the subject. It was placed slightly behind the subject to ensure only one side of the face lit. The flash also had a deflector placed behind it to keep the light off the background. (Plus-X rated at 125 ASA, Nikon 50mm: f11)*

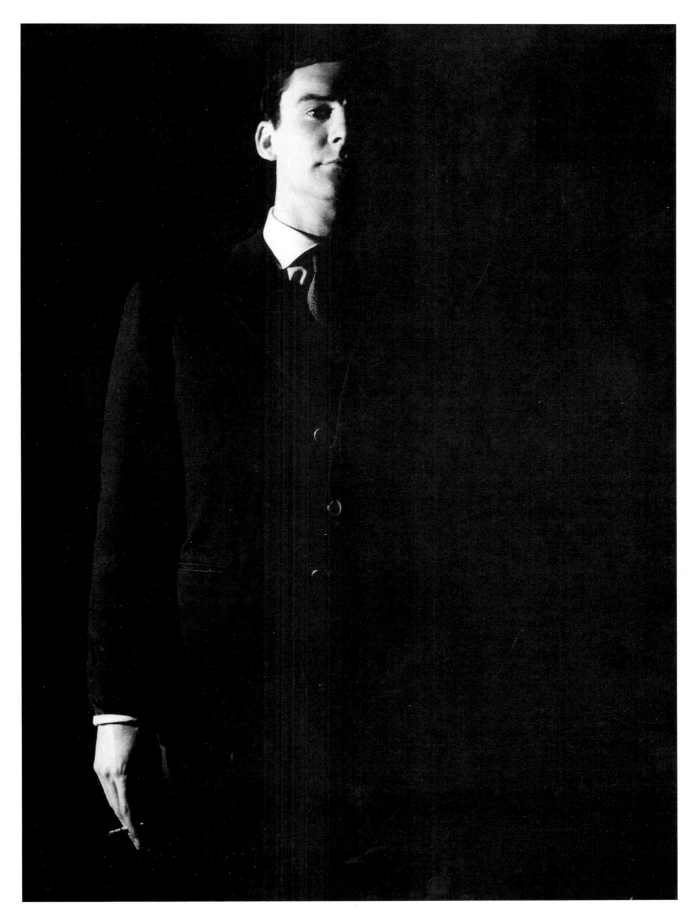

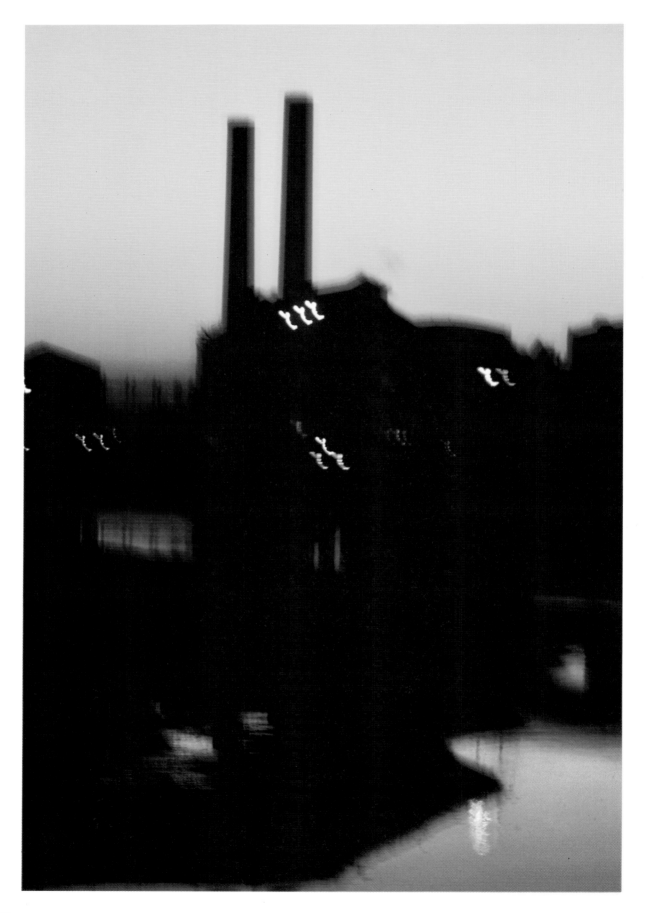

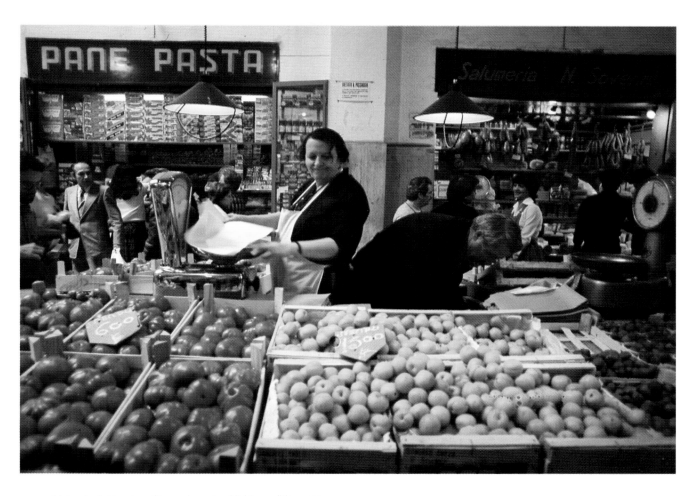

ABOVE *Using daylight colour film under mixed light conditions can enhance a subject, as in this picture taken in a food market in Italy, where the dominant tungsten lights give a warm colour cast. The red-orange cast strengthens the colour of the fruit and vegetables and is not detrimental to the skin tones of the people. (Ektachrome 200, Nikon 24mm: 1/60 sec – f2.8)*

OPPOSITE *Although this picture is out of focus and shows camera movement, these defects combine with the strong sky colour to produce an exciting image. (Kodachrome 64, Nikon 80mm: 1 sec – f8)*

means of independent lighting. The main problem with using flash is that it is difficult to predict its effect, but with experience this becomes easier to judge.

As mentioned in the equipment section, a unit that can only be used on the hot-shoe of the camera is of little use to the serious photographer. A shoulder pack unit that can be run from the mains as well as from batteries, and with the facility for more than one flash head, is ideal. On nearly all occasions it is best not to have the flash mounted on the camera hot-shoe. A flash bracket that can position the head to one side is far better if you have to use the flash on-camera; it will avoid such things as red-eye, when shooting in colour, and gives slightly more modelling to a subject. The other thing that needs to be watched for is unsightly shadow, either on the subject or the background.

The following pictures show some examples of flash-lit portraiture; the same basic principles can be applied to still-life and figure work. Remember that distance from flash to subject is a governing factor in flash exposure. Leave the background dark, by keeping the subject away from it, work hard against it, or light it separately. Also watch out for flare from any shiny surfaces in the picture. It sometimes occurs in portraits as ugly highlights on the subject's forehead or nose.

With the flash on camera directed straight at the subject, ugly shadows will be created. Here the light is hard, there is no modelling on the face and the skin tone is flat.

By moving the flash off the camera, raising it about one-and-a-half feet (45 cm) and placing it to one side, the shadows created on the face help to give it shape and modelling. A diffuser can be placed in front of the flash head to soften the light to improve skin tone.

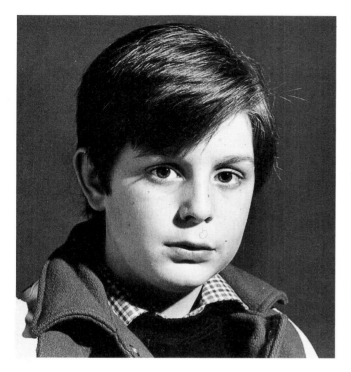

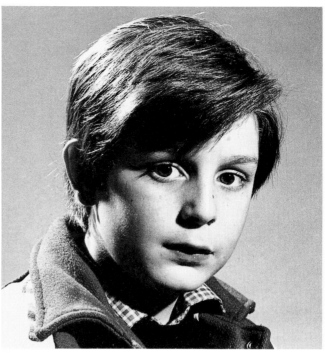

Using the same lighting as the previous picture, a reflector was placed opposite the light on the other side of the subject to lighten the dark side of the face.

By turning the flash away from the subject and bouncing it into a reflector the whole effect is much softer, giving a wider gradation of tones.

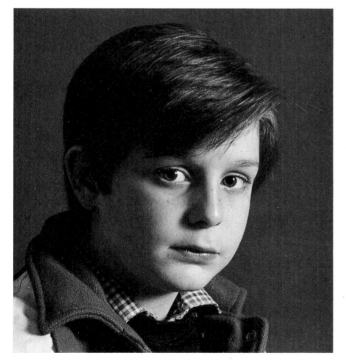

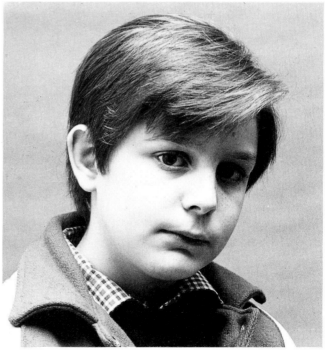

With the flash in the same position off camera, a second light was placed behind and to one side of the subject, about three feet (90 cm) above head height, to create highlights in the hair and give extra modelling to the left side of the face. Care must be taken to ensure the light is shaded from the lens. A third light was placed directly behind the subject to light the background.

By bouncing the flash up into the ceiling between the subject and camera the resulting light looks very close to daylight.

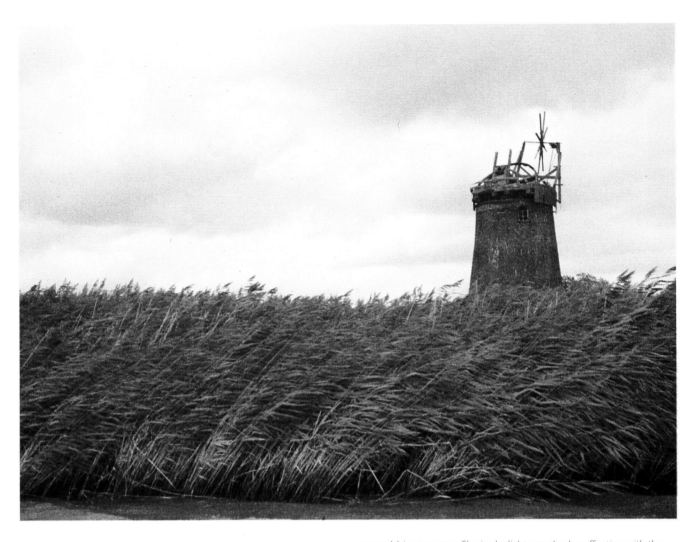

ABOVE *Using tungsten film in daylight can also be effective with the right subject. The wind-blown reeds and derelict windmill shot in the rain look much bleaker because tungsten film was used. The film was rated at its recommended ASA number, which meant the picture was slightly overexposed. In daylight, without a conversion filter, the film is best rated at the equivalent daylight film rating. (Ektachrome 160 Tungsten, Nikon 35mm: 1/60 sec – f5.6)*

OPPOSITE *The violet cast in this picture is typical of reciprocity failure, which at this time of day exaggerates the already violet light. (Kodachrome 64, Nikon 35mm: 30 secs – f3.5)*

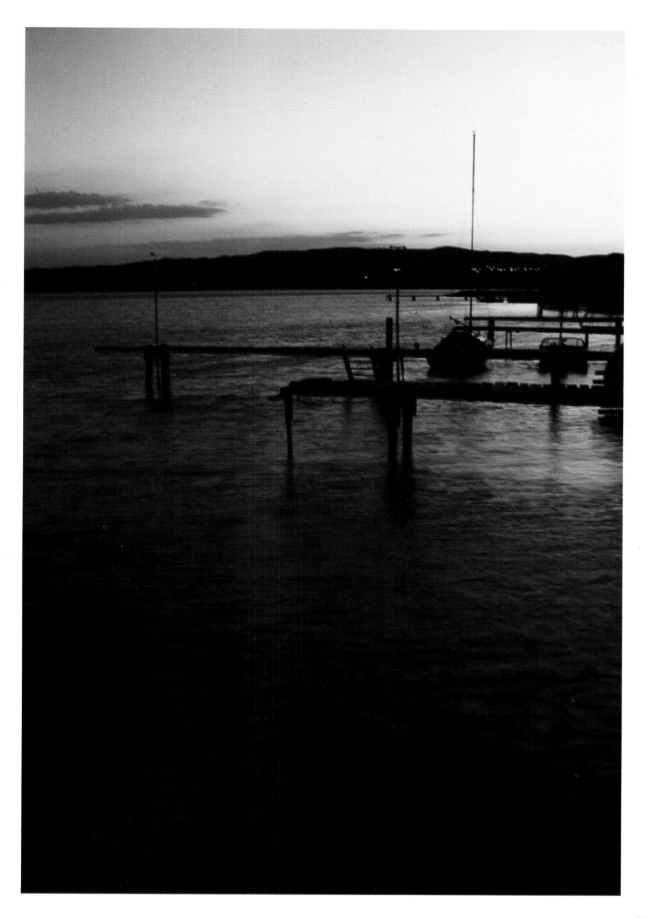

3 FILM AND PROCESSING

For most low-light and night photography a fast or ultra-fast film will be required; 400-1000 ASA. The ASA, DIN or ISO number of a film relates to its sensitivity to light; the higher the ASA number the more sensitive the film. A fast film will have a more apparent grain structure than a slow film, which causes a lowering in resolution, and hence a less defined negative image. To gain better image-quality a slower film should be used. This is possible for subjects, such as still-life, landscape and archietecture, where a slow shutter-speed and a tripod can be employed.

When using flash, you should use a film that gives the widest range of working apertures and flash-to-subject distances. If, however, you have a fast film in the camera and need to use flash, but cannot get a working aperture or reasonable flash-to-subject distance, a neutral density filter can be placed over the lens to effectively reduce the film-speed. These filters come in a wide range of densities, from one third of a stop to thirteen and a third stops reductions of exposure. A polarizing filter can also act as a neutral density filter. Both types of filter are a neutral grey and can be used safely with both black-and-white and colour film.

Your choice of film type and speed will depend on the subject and the lighting conditions you are shooting under. Ideally you should be able to use the extremes of both aperture and shutter speed, in order to have as much control over the picture as possible, but under some of the conditions you will meet when taking night photographs this will not always be possible. Often a specific film will have to be used for a specific purpose, and processed to suit the particular conditions it was used under.

BLACK-AND-WHITE FILM

Almost all black-and-white negative material and colour transparency film can be up-rated, and given increased development to compensate for the deliberate underexposure. Manufacturers do not, however, recommend the up-rating or increased processing of colour negative film. To up-rate a film, double the working speed on the film-setting dial on the camera for each stop-increase in exposure; a film normally rated at 400 ASA therefore increases one stop to 800, two stops to 1600 and three stops to 3200. For colour transparencies an increase of no more than three stops is recommended. Although it is possible to push the film to as much as eight stops, the quality of the transparency would be unacceptable.

Once you decide to up-rate a film, the entire film will have to be exposed at that rating. It is possible, however, if you are processing the film yourself, to process a section of it at a rating different from the rest, by cutting the film and processing the two parts separately. If you up-rate a colour transparency film you will need to send it to a specialist process house, for increased development, as most general colour services will not do this. You will need to inform the processor exactly what speed the film was rated at.

Any increase in development times will of course affect the grain structure of the film, the grain becoming more apparent as the development is increased. There are developers that have been created to give increased film-speed without undue increase in grain. These developers are designed by the manufacturers to match specific film brands. There are some that can be used with a wide range of film brands, and it pays to experiment with different combinations of film and developer to find one that suits your particular needs and personal taste. Faster films also have a softer contrast range than slow films, which helps to compensate for the extremes of light often found at night and with available light.

With night photographs where lights appear in the picture, or where lights are indeed the subject of the picture, it may be beneficial to give a slight increase in exposure, and reduce development by approximately twenty-five per cent. This will help reduce contrast, increase shadow detail and help decrease the halation effect from the lights. Halation is when the light source spreads and surrounds itself with a halo of scattered light. This effect is worsened by prolonged exposure or development.

Variations in exposure and development may also be

Film can be used at the manufacturer's recommended ASA rating or uprated to give extra shooting speed, and enable pictures to be taken under poor light conditions where photography would otherwise be impossible. It also gives the extra shutter speed needed for fast moving subjects. When the film is up-rated, increased development is required to compensate for the underexposure. With the increase in development, you will find a more noticeable grain structure and a loss in tonal range.

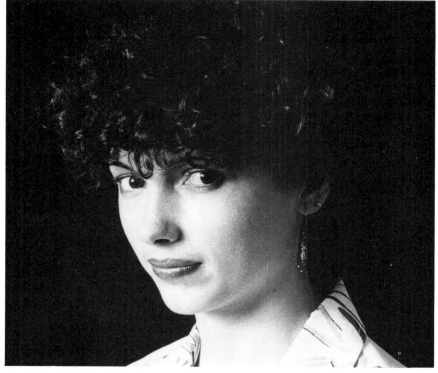

Tri-X rated at 400 ASA.

A section of the picture opposite, enlarged six times to show grain detail

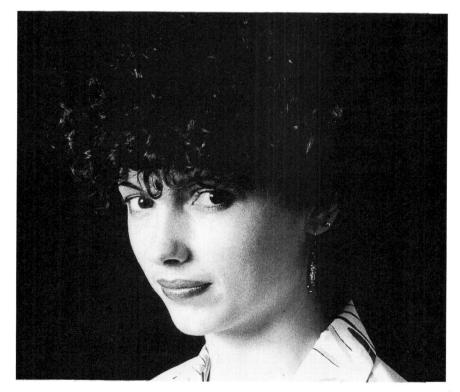

A slight increase in grain, and some loss of detail in the hair and on the dark side of the face. (Tri-X rated at 800 ASA)

A section showing grain detail.

For vitality, colour depends as much on placement as it does on volume. A small isolated area of colour can be just as effective as a large volume, as this picture demonstrates. (Ektachrome 200, Nikon 50mm: 1/125 sec – f4)

necessary with black-and-white film to give the right contrast and density of negative to suit a particular type of enlarger. Enlargers can vary tremendously, depending on their type of light source and whether they have condensers or not; the right negative for one enlarger may be unprintable on another. With low-light and night photography the right combination of exposure and processing can be even more critical, as the end results can be changed radically by judgements made while exposing and processing.

When increasing the development time on any film there is a point when chemical fog will start to occur, and as the development increases so will the chemical fogging. This can reach a point where the negative will be rendered unprintable. Chemical fogging causes a drop in contrast, and is noticeable on the clear unexposed areas of the film, which will start to go grey and become less clear.

As an alternative to increasing the development time, the developer can be used at a higher temperature, but with standard black-and-white films there is a limit to how high the temperature can go. Using a higher temperature increases grain and contrast, and care must be taken to avoid reticulation, which happens when the temperatures of the developer and fixer are incompatible. The fix should be within 3°F(2°C) of the developer. Reticulation distorts the film emulsion, giving a crazed effect on the negative.

Development times are found in the instructions on film or developer packets, and increased development times can be based on these. If you are in any doubt about the correct development time or have exposed a film by pure guess work, cut the first few frames from the film, allowing 8in (20cm) for the leader, and use them for trial processing. It is better to lose a few frames than the whole film.

There is a new range of black-and-white films, which have a variable speed range, giving high speed and fine grain. These films are based on the application of colour-dye technology to black-and-white film and, unlike the standard black-and-white film, the negative has a non-silver image. This gives the film its wide exposure latitude, allowing the same film to be exposed at different speed ratings using a standard development time throughout. The recommended range of film speeds extends from 50 to 800 ASA, and it is possible to increase this to 1600 ASA with a slight adjustment to the development time. As well as giving a variable speed range, the film also has a greater tonal range at the higher speeds than does standard film, giving better picture-quality. Because the film is based on colour technology it has to be processed in a special developer, similar to the standard colour negative process, and can, if required, with a slight loss of quality, be processed along with colour negatives.

This film is very well suited to photography in extreme and variable light-conditions,, and will be of particular interest to the low-light and night photographer, allowing as it does the use of one film-type for every occasion.

COLOUR FILM

There are two ways of creating colour photographically: the additive method, which uses the three primary light colours – blue, green, red – to produce other colours; and the subtractive, which starts with white light (a mixture of all the spectrum colours) and, by taking away some colours, leaves the desired ones. The additive process was the one first employed to produce colour photographs. The first full-colour picture using the subtractive method, on which modern colour photography is based, was made by Louis Ducos du Hauron in France in the late 1870s. At the time the process proved too impractical, and it was not until the mid-1930s that it was reintroduced as the basis of modern colour photography.

There are two main kinds of colour film: the negative, which produces colour prints, and the colour reversal film, which produces transparencies. Most films are balanced for daylight, but tungsten versions are available, particularly for transparencies. It is now also possible to get reversal colour prints from transparencies at no great cost.

Colour negative film-speeds range from 50 to 1600 ASA. Most film is balanced to daylight, as any colour correction can be made at the printing stage, although there is a professional film made to balance for short exposures, 'S' type and long exposures, 'L' type. The 'L' type is balanced for exposure to tungsten light from a thirtieth to one second.

For the serious photographer, colour transparency offers a wider range of possibilities, as it can be used for both projection and prints. It is possible to up-rate and extend the processing to a maximum of six stops, with film-speeds ranging from 25 to 100 ASA. This gives plenty of scope for the low-light and night photographer.

At night and in low-light colour film is likely to show some colour change due to differences in colour temperature. Daylight and tungsten film are manufactured to specific colour temperatures; daylight at 5500 K and tungsten at 3200 K. The K stands for Kelvins, the scale used to measure colour temperature.

Colour film used in any light conditions that vary from the given colour temperature of the film, will have some colour change. Pictures taken in the early morning and late afternoon will have an orange tinge, as the sun's rays have to pass through more of the earth's atmosphere, which absorbs more of the short wavelengths of light (blues and greens), leaving the reds. With tungsten light there is an even greater chance of getting a colour cast, as very few artificial-light sources

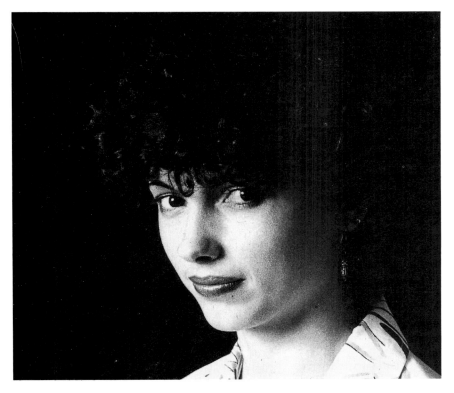

A section showing grain detail.

The increase in the grain becomes more noticeable and there is more loss of detail in the darker areas. The skin tone is not as smooth as the film rated normally.

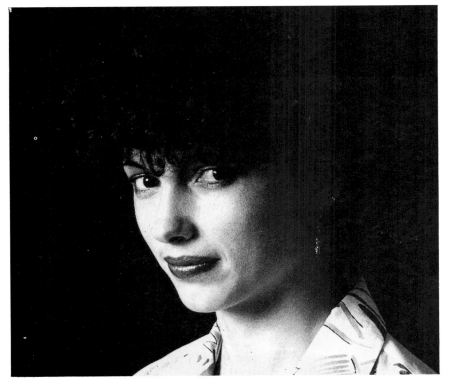

A section showing grain detail.

Grain has increased, and the hair and shadow side of the face are blending into the background. There is more loss of skin tone. Although there has been an increase in the contrast, the increase in development has caused chemical fogging in the clear areas of the negative. This flattens the negative, and demands a harder grade of printing paper. (Tri-X rated at 3200 ASA)

OVERLEAF These pictures all come from one roll of XP1 film, which was given the recommended development time using XP1 chemicals. The film was exposed at four different ASA ratings from 100 to 800, but processed as for 400 ASA. An acceptable print was gained from every rating, although some negatives were overexposed and some underexposed.

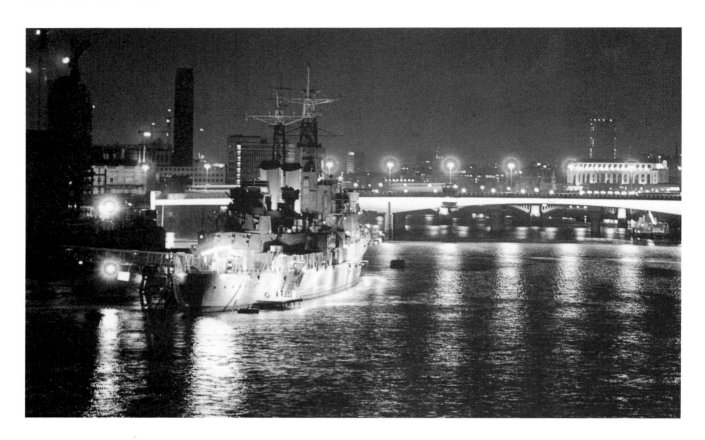

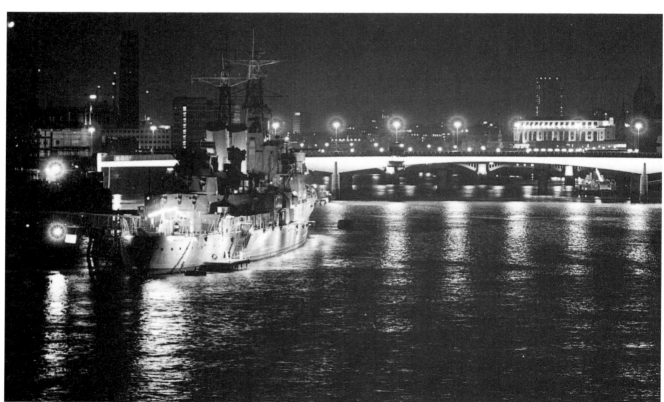

TOP *Rated at 100 ASA. Here there is detail in the skyline, and although the ship was dense on the negative because of the floodlights, I had no trouble printing it in. (Nikon 135mm: 1 sec – f4)*

ABOVE *Rated at 200 ASA. The contrast is increasing and there is less detail in the skyline. Some printing in on the ship was required, although not as long as for the first picture. (Nikon 135mm: ½ sec – f4)*

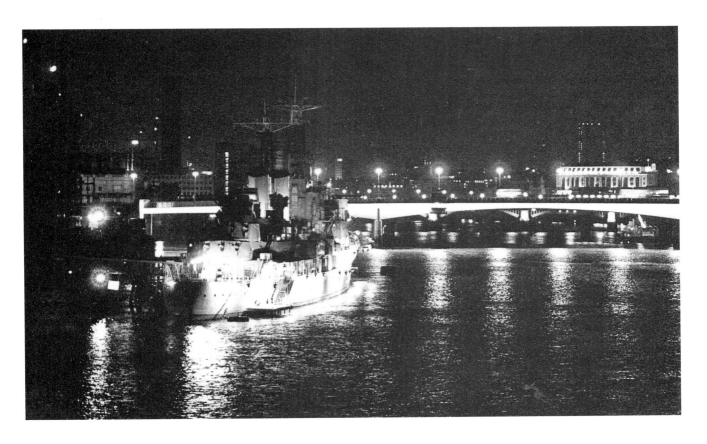

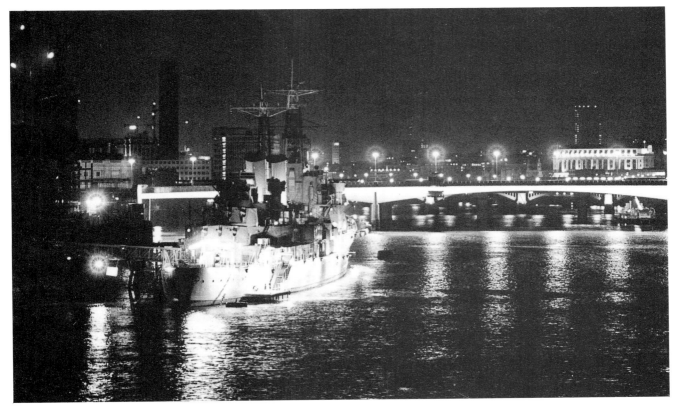

TOP *Rated at 400 ASA. Again the contrast has increased and there is less detail in the skyline, but this picture had no printing in. (Nikon 135mm: ¼ sec – f4)*

ABOVE *Rated at 800 ASA. All the skyline detail has gone except for the highlights. There is also a loss in overall quality, but the print is still acceptable. (Nikon 135mm: 1/8 sec – f4)*

match the colour temperature of tungsten film, except those specifically made for colour photography.

This is why most photographers depend on electronic flash when shooting colour in the studio. The electronic flash is made to match daylight colour temperature, and when the same equipment is used regularly, any colour change can be corrected with colour-correction filters.

It is very difficult to make accurate corrections when working with a number of different colour temperatures from different light sources. A colour-temperature meter can be used, but it would require with it an extensive range of colour filters, and exposure corrections to compensate for the filters used. All this takes time, and the equipment costs are prohibitive. Moreover, colour cast can often contribute positively to the overall effect of a picture.

Fluorescent light tends to give the most unattractive colour cast. There are a number of different types of tube, all with different colour temperatures, so it is difficult to know which filters should be used, until after the film has been processed. As a general rule though, if the light appears to give a certain colour cast, say red, then a filter of its complimentary colour is required; cyan in the case of red.

As you will often be working in a combination of daylight and artificial light the main problem concerns the type of film you should use – daylight or tungsten. It is not just a matter of taking a light reading and deciding which is the dominant light source, the factor of personal taste is involved.

Because daylight film has a red colour cast when used in artificial, tungsten light, most people prefer it to tungsten film, which has a blue cast in daylight. These colour casts can be used deliberately to create effects. By using tungsten film outside on a cold, rainy day, the resulting picture will look even colder and more bleak.

Extra-long exposure will also distort the colours in colour film. Daylight colour film is designed for exposures of a tenth of a second or less, although many films will allow exposures of up to one second before showing any real colour change, or reciprocity failure, as it is termed. In low-light and at night, colour is probably used more for effect than for accuracy.

When using flash with colour, if you find you are getting a constant colour cast on all your films, it is probable that the flash tube has a slight colour bias. It is possible to correct this with a colour-correction filter. These are used in front of the lens like any other filter,

GUIDES FOR INITIAL TEST WHEN EXPOSING COLOR FILMS WITH FLUORESCENT AND HIGH INTENSITY DISCHARGE LAMPS

Note: Red or blue filters have been included to limit the number of filters to three.

Type of Lamp	KODAK Color Film			
	KODACOLOR VR 100, 200, 400, and 1000 KODACHROME 25 and 25 Professional (Daylight) EKTACHROME 100, 200, and 200 Professional (Daylight) VERICOLOR III Professional, Type S VERICOLOR II COMMERCIAL, Type S	KODACHROME 64 and 64 Professional (Daylight). EKTACHROME 64 and 64 Professional (DAYLIGHT). EKTACHROME 400 (Daylight) EKTACHROME P800/1600 Professional	EKTACHROME 50 Professional (Tungsten). EKTACHROME 160 160 Professional (Tungsten). VERICOLOR II Professional, Type L	KODACHROME 40 (Type A)
● Fluorescent				
Daylight	40M + 40Y + 1 stop	50M + 50Y + 1½ stops	85B† + 40M + 30Y + 1½ stops	85* + 40M + 40Y + 1½ stops
White	20C + 30M + 1 stop	40M + ⅔ stop	60M + 50Y + 1½ stops	40M + 30Y + 1 stop
Warm White	40C + 40M + 1½ stops	20C + 40M + 1 stop	50M + 40Y + 1 stop	30M + 20Y + 1 stop
Warm White Deluxe	60C + 30M + 2 stops	60C + 30M + 2 stops	10M + 10Y + ⅔ stop	No Filter None
Cool White	30M + ⅔ stop	40M + 10Y + 1 stop	10R + 50M + 50Y + 1½ stops	50M + 50Y + 1½ stops
Cool White Deluxe	20C + 10M + ⅔ stop	20C + 10M + ⅔ stop	20M + 40Y + ⅔ stop	10M + 30Y + ⅔ stop
Average Fluorescent§	10C + 20M + ⅔ stop	30M + ⅔ stop	50M + 50Y + 1½ stop	40M + 40Y + 1 stop
● High Intensity Discharge Lamps				
General Electric Lucalox ‖ ‡	70B + 50C + 3 stops	80B + 20C + 2½ stops	50M + 20C + 1 stop	55M + 50C + 2 stops
General Electric Multi-Vapor ‖	30M + 10Y + 1 stop	40M + 20Y + 1 stop	60R + 20Y + 1½ stops	50R + 10Y + 1½ stops
Deluxe White Mercury	40M + 20Y + 1 stop	60M + 30Y + 1½ stops	70R + 10Y + 1½ stops	50R + 10Y + 1½ stops
Clear Mercury	50R + 30M + 30Y + 2 stops	50R + 20M + 20Y◆ + 1½ stops	90R + 40Y + 2 stops	90R + 40Y + 2 stops
Sodium Vapor	Not Recommended	Not Recommended	Not Recommended	Not Recommended

†KODAK WRATTEN Gelatin Filter No 85B *KODAK WRATTEN Gelatin Filter No. 85

§Use of these filters will yield results of less than optimum correction. They are intended for emergency use only, when it is impossible to determine the type of fluorescent lamp in use.

‡This is high-pressure sodium vapor lamp, however, the data may not apply to other makes of high-pressure sodium vapor lamps due to differences in spectral characteristics.

◆For KODAK EKTACHROME 400 and P800/1600 Film, use 25M + 40Y and increase the exposure 1 stop

This chart produced by Kodak gives fluorescent lamp filter data for use with their colour films.

and are made of a gelatin. They come as a square, to be cut to fit any lens, have a density range from 05 to 50, and are available in cyan magenta, yellow, red, green, and blue.

It is also possible to place a filter over the flash head. For this job the cheaper acetate colour-printing filters can be used. The advantage of filtering the flash is that the filter need not be removed, whereas on the camera the filter has to be removed when the flash is not being used.

4 LOW-LIGHT PHOTOGRAPHY

INTRODUCTION

The quality of low light has long fascinated artists and photographers. Painters through the ages have struggled to capture and re-create the effects of low light. For many photographers too, this is a major aspect of their work, a subject being used merely as a vehicle to show the effects of the light.

In the area of available-light documentary photography, low light features quite often. The development of the 35mm camera, high-quality fast lenses and faster film materials, stems from the demands of the available-light photographer. The documentary photographer's main interest lies in recording things as they are, without any interference. This is what distinguishes him from the news photographer, whose prime aim is to get the picture at any cost. Hence many news photographers will use flash even in daylight, to ensure they get a printable image, whereas the available-light photographer sees low light as an integral part of the picture, creating atmosphere, and adding to the overall realism of the photograph. The other main difference between news and documentary photography is that the news photograph is usually a single image, while the documentary will be made up of a number of related images.

Today, with modern photographic equipment and materials, it is possible to photograph almost anything, in either black-and-white or colour, no matter what the condition of the light. The choice between the two is no longer a practical one, but one of aesthetics and personal taste.

As we normally see the world in colour, in black-and-white photography we have to learn to interpret what we see in the viewfinder with regard to the capabilities of our equipment and materials. We need to know the black-and-white tonal values of colours, and how photographic materials respond to them under different lighting conditions. Many photographers, particularly photojournalists, prefer to shoot in black-and-white, as they see this as a way of concentrating the viewer's eye on the subject. It can also be used to emphasize the effects of light.

Over the last twenty years colour has become the medium for the amateur photographer. As we view the world in colour, it is quite natural that when we take a photograph we should use colour film. With the advent of new colour materials and processes, even the simplest camera can produce acceptable colour pictures. Colour is now the norm in photography, and black-and-white the exception. This automatic acceptance of colour can all too often produce pictures that are nothing more than ill-considered records of reality.

There are no set aesthetic rules concerning the relationship of colours; most colour combinations appear in nature. It is not the relationship of one colour to another that matters, but rather the balance between the areas of each colour. An object has no true colour, because the light alters a colour. As the hue of a colour changes, so will its relationship with other colours. Striking divisions of harmony and contrast can be used when creating, or looking for, a colour subject, but these can be further divided into high- and low-key (light and dark), strong and muted, dominant and isolated. A picture can also be made up from the hues of only one colour. In low-light conditions you will find this monochromatic effect occurs quite often. With colour photography we can also distort colour, by using filters and special film materials, like infra-red.

In photography we can alter colour quite easily, using camera angle, and exposure, to alter the relationship of the light to the camera or subject. Photographically, the colour can also be altered by mismatching colour film with light of a different colour temperature. Indeed, this mismatching is often a problem when shooting in low light. In some cases a good match is possible, or filtration can be used to correct any bias, but in the majority of cases the sheer variety of light sources in a picture will defeat any attempt at accurate colour, particularly with transparency film. With flash, which has a constant colour temperature, it is possible to produce more accurate colour, but even here some filtration may prove necessary. Taking colour photographs at night or in low light is always a voyage of discovery, and can often lead to interesting and unexpected results.

ABOVE *Colours that contrast with one another can have a dynamic effect in a photograph. Colour creates a strong sense of design in this picture. The eye is led into the scene, from the green road-roller by the yellow road-markings, and up to the yellow sand-bin, which directs it towards the red mailbox. (Fuji 400, Nikon 24mm: 1/60 sec – f5.6)*

RIGHT *Allowing a single colour to dominate a picture can be just as interesting as combining a multiplicity of colours. This picture relies on formal design as well as colour. The blue engine, with all its intricate detail, is broken by the silver exhaust in such a way as to turn an otherwise static picture into a dynamic one. (Kodachrome 64, Nikon 50mm: 1/30 sec – f2.8)*

OPPOSITE ABOVE *Colour can also be used monochromatically. Very often a picture draws its effect from a range of different hues of the same colour, as shown in this picture.*

OPPOSITE BELOW *With colour photography there is a great temptation to look for bright or multi-coloured shots, the results of which are often disappointing. Colour should have meaning and add content to a photograph. In the picture of a flower-drying loft there is a natural relationship of colour and texture that is strengthened by the strong directional side lighting. (Kodachrome 64, Nikon 24mm: ½ sec – f5.6)*

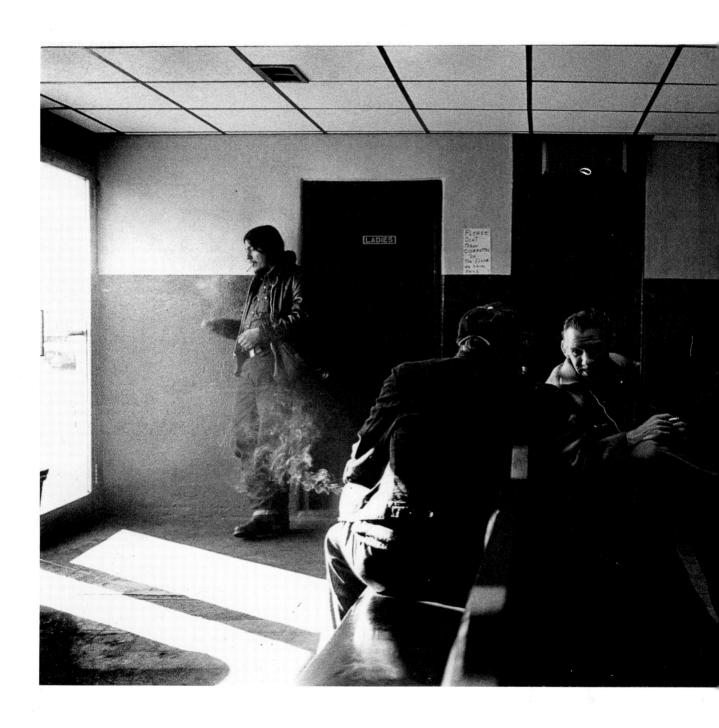

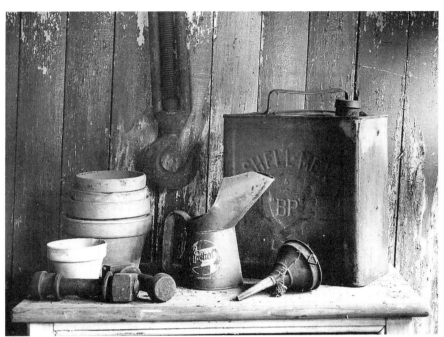

ABOVE *This found still life has all the right elements for a good black-and-white photograph: shape, texture, tonal range and effective lighting. (FP4 rated at 125 ASA. Nikon 50mm: 2 secs – f11)*

LEFT *The light has been used as part of the structure of this picture, adding to its mood. The way the men are composed in the shot, and the starkness of the interior, indicate quite clearly that we are looking at a waiting-room.*

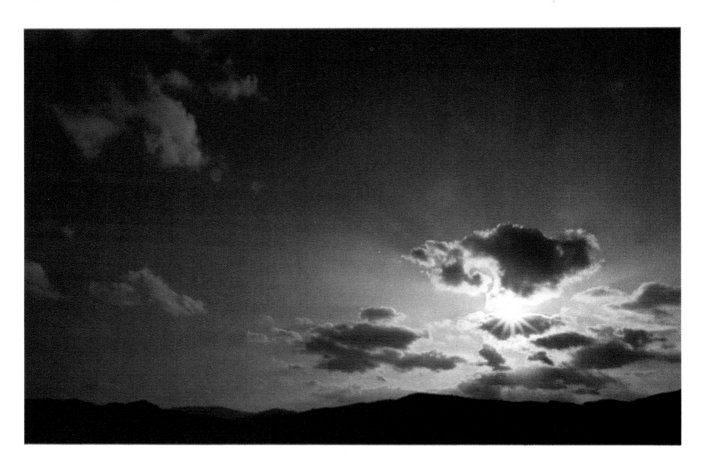

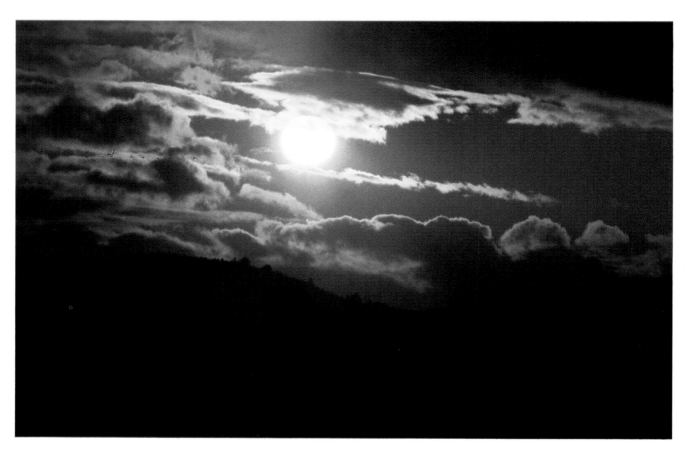

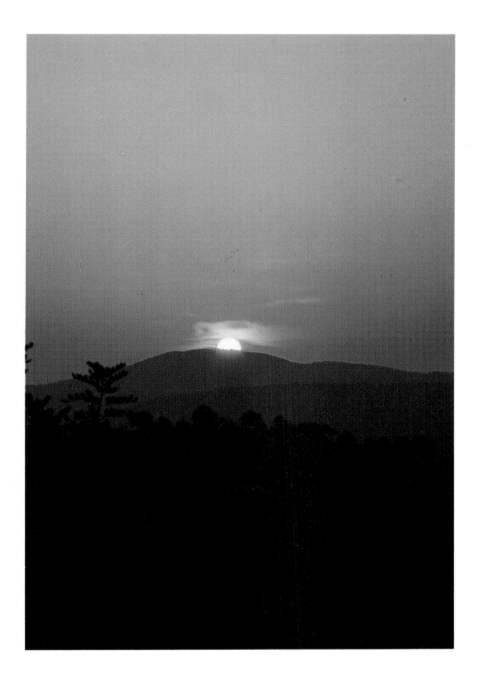

ABOVE *At sunset the light changes rapidly. When photographing into the sun at this time the sky is the only area where detail is possible, and some cloud is usually necessary to give interest. In this picture the lack of cloud is offset by the layering of a number of horizon lines, leading the eye up to the setting sun. (Ektachrome 200, Nikon 35mm: 1/15 sec – f11)*

OPPOSITE ABOVE *The clouds in this picture seem to boil up from the dark horizon line, connecting the two elements of earth and sky. A number of exposures were made at different exposure values and with the clouds in different positions to the sun. This picture was selected for its balance of composition and exposure. (Ektachrome 200, Nikon 24mm: 1/125 sec – f3.5)*

OPPOSITE BELOW *An orange filter was used to create this false sunset. (Ektachrome 200, Nikon 180mm: 1/250 sec – f5.6)*

47

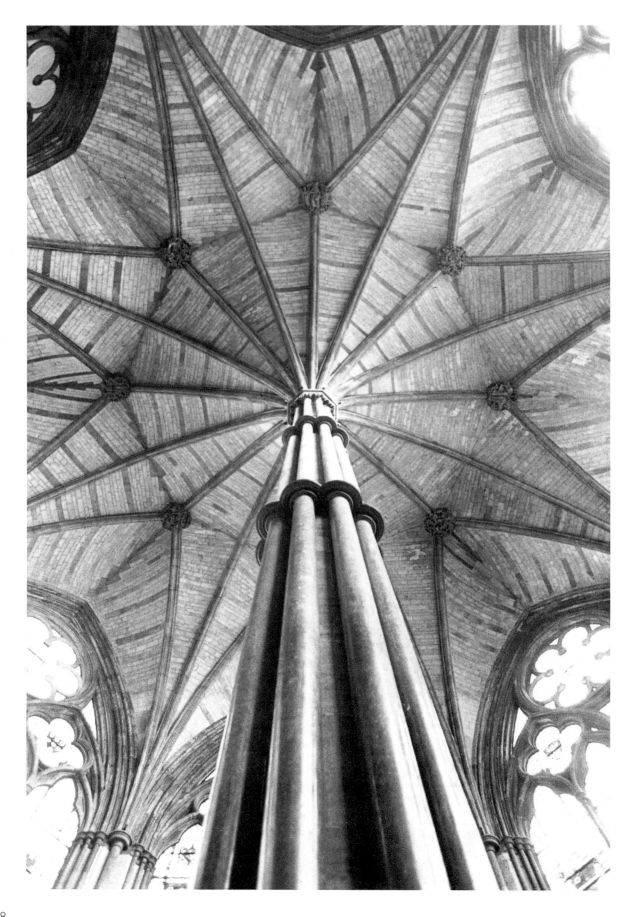

Most of us have stereotype views and responses to colour – trees are green, the sky is blue – and these views are often expressed quite strongly. Nevertheless we have a limited knowledge of, and sensibility to, colour. The time of day and year, or the state of the weather, can change an object's colour quite radically. As photographers we must become more sensitive to this, and make conscious use of it. The qualities of light, both artificial and natural, that you are likely to encounter in low light, night and adverse weather will produce colour that can be extreme or subtle, and in most cases offer real creative possibilities for colour photography. Under these conditions we are free of the objective world of colour, and are able rather to explore our subjective responses to it.

The subject areas available for low-light photography are endless, and there are many different ways of approaching any one area. With so many possibilities available, try to work out in advance what it is that you want from the subject. You can then set about deciding on the best combination of equipment and materials to help you achieve this aim. Even with limited aims you will find that there are a great many photographic possibilities to explore. Be prepared to spend time either lighting the subject in many different ways, or waiting for the existing light to change, so that you can explore its effects upon the subject. Try to cover as many angles and viewpoints as possible.

Keep your pictures simple. A great many photographers try to include everything in one picture, ending up with a photograph that has no focal point and little meaning. If you are faced with a complicated or busy picture, break it down into a series of simpler pictures, as well as taking the overall view. You may well find that a part says just as much as, if not more than, the whole scene. When you look at the work of great photographers, simplicity and understatement is often the essence of their best pictures.

LANDSCAPE

From the earliest days of photography the landscape has provided the photographer with one of his richest subjects. From the mid-nineteenth century photographers roamed the world enduring the hardships of climate and terrain to record every notable view or historic site.

One of the most prolific and widely travelled was the Englishman Francis Frith. In his long life Frith produced a huge collection of photographic views covering near-

ly all of the British Isles and a great part of Western Europe and the Middle East. His most impressive series of pictures was taken on an 800-mile trip up the Nile. He photographed the Great Sphinx and other historic sites using the wet-collodion process. This process requires the coating of glass plates immediately prior to exposure; the plate then has to be processed before it dries. Frith had to do this in temperatures of up to 130°F, and also contend with the problems of dust and sand getting onto the plate. In spite of all these difficulties many of the photographs he took were very successful and are still with us today.

Similar work was carried out in many parts of the world. The Bisson brothers in France endured opposite conditions, taking pictures by the same process in the Alps, where the problem was freezing chemicals, not heat. Many American photographers followed in the footsteps of the early explorers and settlers, to record the landscape, Indian tribes and natural history of their vast continent. The low light of dawn or dusk casts a dramatic veil over a landscape, and was often popular with these early photographers for this reason.

With landscapes the choice of film depends on what you are trying to achieve, and of course on the condition of the light. If there is not a need to stop movement, a medium-speed film can be used to gain picture quality. The new variable-exposure films are at their best at around 400 ASA, which allows a good exposure range, plus quality negatives in low-light conditions. The grain effect of up-rated fast films, both black-and-white and colour, can add interest to some pictures. It is particularly effective in fog and mist, adding texture to the muted tones, giving a rocky landscape or industrial scene a gritty effect.

At the time of day when the daylight and night start to merge, and you also have artificial light in the picture, a decision has to be made when using transparency film, between artificial light film and daylight film. This choice is a subjective one, to do with personal preference and the mood you wish to create with the picture. As a rule of thumb, choose the film that matches the dominant light source. Daylight films seem to be preferred by most people, as with this film artificial light sources have a yellow or orange glow, giving a warm feeling to the shot. The blue cast given when tungsten film is used in daylight, can, however, be used effectively on some pictures, where a feeling of alienation or chill is required.

In an urban environment there is often a great mixture of light sources; street lights can be sodium – or mercury-based, while tungsten and fluorescent light shines from windows. Mercury-vapour lights give a blue cast, the sodium gives an orange, and the fluorescent a green cast. Fluorescent and mercury lamps respond better to daylight film, while sodium light is better suited to tungsten film. With such a variety of colour casts it is impossible to correct a film without

OPPOSITE *In some interiors the floor or ceiling can be as interesting as the more obvious parts of the room. Here the camera was placed on the floor at the base of the central column to record the star-shaped roof structure. (Plus-X rated at 125 ASA, Nikon 24mm: ½ sec – f4)*

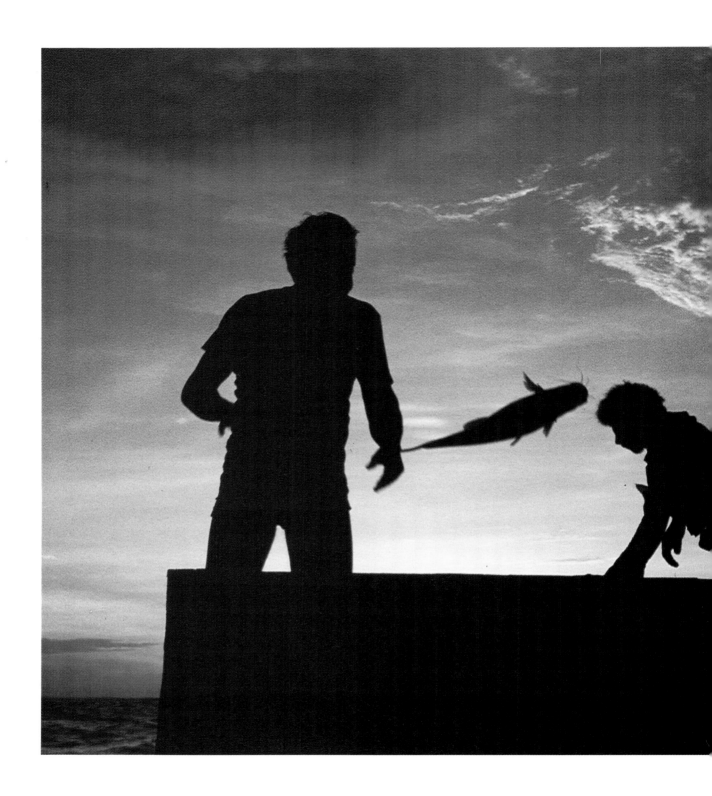

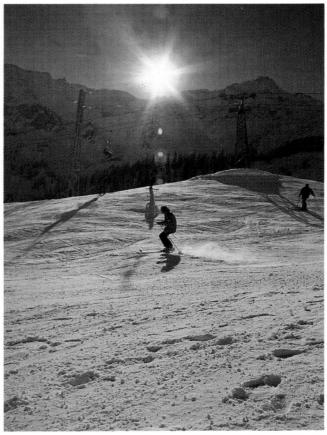

ABOVE *Shooting directly into the sun can often result in flare. Here the line of ghost diaphragms has been used to lead the eye down to the skier. The exposure has been calculated to give some colour and detail to the figure. When photographing into the light, or with any snow scene, the resulting pictures can often be under- or over-exposed. (Ektachrome 200, Nikon 35mm: 1/250 sec – f4)*

LEFT *The silhouette plays an important role in sunset and dusk pictures. The relationship of the fishermen and their catch is far more potent as a silhouette against the sky at dusk, than if it had been captured in colour and detail.*

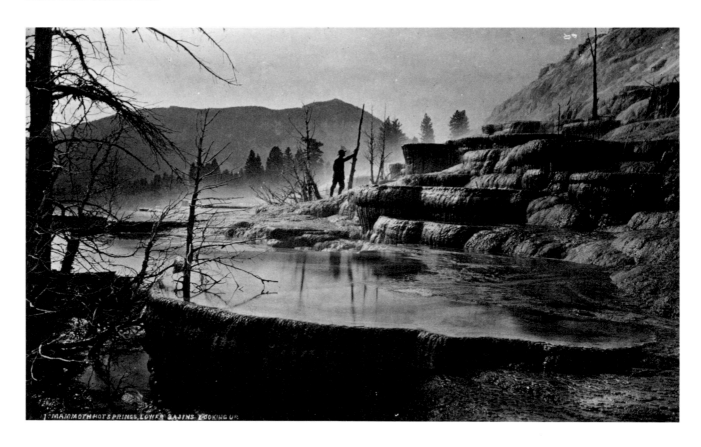

Working in the 1870s, William Henry Jackson undertook many arduous journeys to record the splendour of the American landscape. He often used figures to give the landscape scale as in this shot of the Mammouth Hot Springs.

extensive tests, and even then the finished result is likely to be something of a compromise. It is yet another instance when colour must be used subjectively, rather than objectively.

Sky

The sky plays a major part in many landscape photographs, either for its compositional value or for its effect on the colouring of the scene. For certain pictures, a clear sky can provide a useful background, providing a foil for a complex foreground subject, or emphasizing the outline shape of an object, like a figure in silhouette. It can also give an empty feeling to a photograph that, with certain types of landscape or seascape, will add to the picture a sense of vastness and desolation.

For the vast majority of pictures in which the sky appears, cloud will give added interest to the photograph. Clouds give life and colour to the sky; without clouds there would be no golden sunset or dawn. Heavy, broken cloud, the kind of cloud that precedes or follows a storm, will add great drama to any photograph. The different layers of light and dark cloud that this type of weather brings, will give a greater feeling of depth to a landscape. The colours and tones in the sky at these times make the sky a worthwhile subject in its own right. Using an orange, red, or yellow filter will, when using black-and-white film, exaggerate the contrast already present in the sky. With colour, a polarizing filter can produce a similar effect. Shooting a landscape or seascape against this kind of sky, it is possible to use a colour-graduated filter to change the colour of the sky only. With through-the-lens metering a reading should be taken without the filter, and the exposure given then used when the filter is on the lens.

Very often with this type of sky following a storm, the sun will pierce the clouds, illuminating part of the scene as if by a spotlight. Any areas of water or wet road will catch the light, giving extra highlights to the darker areas of the picture. An expanse of water can make a good foil for the sky, particularly in seascapes where the sea is mirroring the sky in colour and tone.

Any photograph that contains an obvious horizon line needs to be composed with care, as the horizon, particularly if it lacks variation in height, cuts the picture into two parts. Avoid having this division in or near the middle of the picture. Allow instead one or other of the two elements to dominate the scene. As a general rule of thumb, position the horizon line in the top or bottom third of the frame. Very often a sky picture can be given more feeling of space by anchoring the sky to a thin strip of land at the bottom of the picture.

The sun itself can be an interesting subject to photograph, and one well-suited to low-light conditions. The best times for sun pictures are the beginning and end of the day, when the light, being less intense, is unlikely to damage your eyes, and exposures are more controllable. It is best to relate the sun to a landscape or to some foreground detail, as this will give the picture perspective and scale; with careful camera positioning the sun can be made the focal point of the picture.

When photographing into the sun, flare often results. This can be prevented by fitting a lens hood, or used creatively as part of the picture, light either being spread across the scene to create a misting and fogging of the image, or appearing as a star burst. The other effect of flare is to create a series of ghost diaphragm shapes in the picture. The misty type of flare usually occurs at wider apertures, whereas the flare spots or ghost diaphragms appear when the lens is stopped down. Flare, however, is difficult to control, as the slightest camera movement will alter the result.

With sun and sky pictures, getting the right exposure is a problem. Calculating the exposure from the sun or sky alone may lead to underexposure in the foreground. The difference in exposure value between the sky and the landscape below it can be as much as four stops. Therefore exposing for the foreground will leave the sky bleached out, while exposing for the sky will lose all detail in the landscape. Any compromise between the two extremes may not prove satisfactory. A decision has to be made as to the importance of the different picture elements, and the exposure made accordingly. For a sun picture, the exposure should be taken from the subject and bracketed – indeed it is worth bracketing on all pictures where there is dominant light source and the subject is backlit, as often the correct exposure may not give the best picture. If detail is required in both sky and foreground, a graduated filter can be used to equal out the exposure.

Backlighting is when the subject is placed between the camera and the sun or any other light source. When photographing backlit subjects, flare can be prevented either by placing the subject directly in front of the light source thus shading the lens, or by careful camera positioning to exclude the light source from the picture. In both cases silhouette can result. To ensure detail in the foreground subject, increase the exposure by at least two stops, or move in close to the subject so that a reading can be taken without incorporating the back light. Again, many different results can be obtained from the same shot by varying the exposure.

Landscape

Landscape photographs should, like any other interesting pictures, convey not only an objective view of a scene, but also a sense of place, creating in the viewer an emotional response – a sense of feeling and mood. Standing in a spectacular landscape can be awe-inspiring, but how do you capture this on film? The human eye scans a scene, picking out particular points of interest, very often at random, and putting them together to make up the scene. The camera cannot do this. Where a scene viewed with the naked eye will have no real perimeter, the camera puts a frame around the scene, and everything that appears within that frame has reference to it. How then do we capture a continuous panorama on film to make an interesting photograph?

First a point of view needs to be established, not just in terms of camera position but also in your personal response to the scene. The state of the light and weather are the main factors that change the landscape. Many photographers who specialize in shooting landscape or architecture visit a location at different times of the day or year to find the right camera position and state of light. Different views of the same scene may be suited to particular conditions of light, and it may be necessary to visit a location more than once to get the pictures you want.

Instead of trying to capture the full grandeur of the landscape in one picture, look for those interesting points in the scene that might encapsulate the whole in a simpler form. Look for a key element to build the picture around. This might be a group of trees, or the line of a fence – anything that will draw the eye into the picture and give it a point of focus. With a landscape, seascape or cityscape, a feeling for space is important, whether it is enclosed space or open space. This is one of the most difficult illusions to create in what is essentially a two-dimensional medium.

Perspective is the most effective way of creating a feeling of depth or space between the camera and the horizon. This can be achieved in a number of ways – by taking a linear element, like a road or river, that leads towards the horizon, by use of diminishing scale; by the recession of shape or pattern, leading the eye towards the horizon. Exaggerated scale will create a great feeling of depth. Having an object very close to the camera in a particularly empty landscape, with perhaps some detail on or near the horizon line, creates an imaginary line that the eye will follow.

The photographic effect of aerial perspective can also be used. This is when atmospheric conditions create a lighter tone as the picture progresses towards the horizon. Atmospheric haze, mist, fog or smoke, scatters the light as it travels towards the camera, diffusing the view. This effect is accentuated when a series of ridges or valleys and hills appear in the picture, as they will separate into bands of diminishing colour or tone, giving a strong feeling of depth. The early morning or late evening are the times when the atmospheric conditions necessary for this effect regularly occur.

The nature of a landscape picture can be changed by foreground framing. The effect that foreground

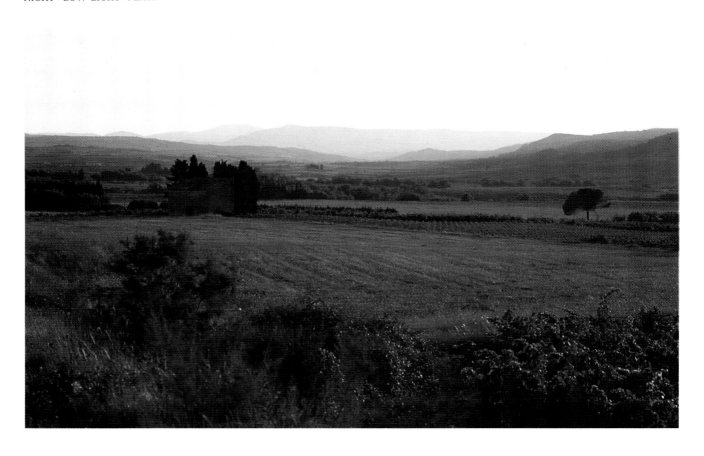

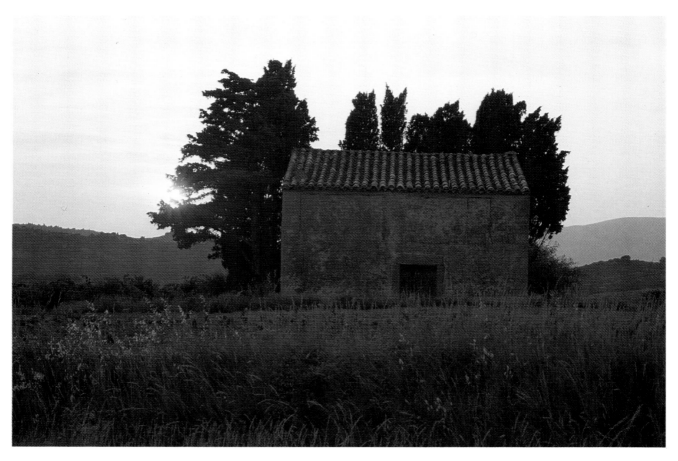

ABOVE *The track plays an important part in this picture: it not only leads into the landscape, but also crosses it again in the background. The mark of man is seen also in the way the trees follow the path. (Kodachrome 64, Nikon 35mm: 1/15 sec – f5.6)*

OPPOSITE ABOVE *In this landscape the bands of colour and detail lead the eye up the picture to the house and trees, behind which the atmospheric effect leads it on to the horizon. Taken in the late afternoon the strong, low, side light gives texture to the lower part of the picture. (Ektachrome 200, Nikon 35mm: 1/30 sec – f8)*

OPPOSITE BELOW *The same group of house and trees are used in this picture. The regular shape of the building stands in contrast to the natural outline of the trees. Keeping the tree between the sun and camera allows for an exposure that gives detail in the foreground and building, without the risk of causing flare or burning out foreground detail. (Ektachrome 200, Nikon 80mm: 1/8 sec – f8)*

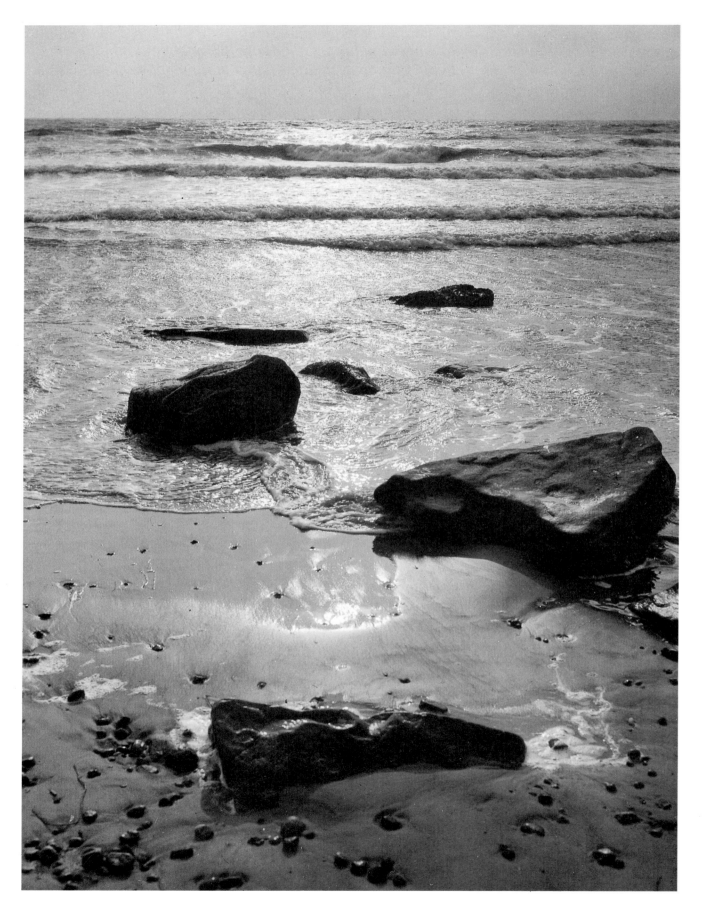

framing gives to a picture is that of looking into the scene rather than being part of it. Rather than shoot the landscape as a totally open picture, position the camera to take in some foreground structure, natural or man-made. This will help break the rigidity of the camera framing. With a natural foreground framing like woodland, which is irregular, the growth can be used as pointer, directing the eye into the picture. With an artificial opening, such as a window or door, the idea of a frame around the picture is emphasized. If you use such a regular, geometric foreground frame, make sure there is enough dark area between this frame and the edge of the picture; if this is too meagre it will not hold the scene within the frame.

Seascape

Seascapes are generally rather empty pictures in terms of detail. The scene usually contains the three basic elements of sea, land and sky. It is the balance in composition of these three elements that makes the picture. Often the introduction of another single element, like a boat or figure, will strengthen the feeling of space and emptyness. Clouds in the sky will add depth to the picture, and change its tone and colouring, while the sea acts as a mirror for the sky.

The way the light reflects off the water can be varied according to camera angle; the brighter the reflection, the more dominant the water becomes in the picture. In an almost totally dark landscape a small area of reflection can be made to dominate the picture.

As with sky pictures, exposure is problematic. Often an exposure other than the one indicated by the meter will be more successful, so once again bracketing is advisable. Isolated elements that appear on or close to the water will invariably be rendered as silhouettes.

Photographing water, and particularly the sea, against the light can produce a variety of interesting results. A slightly choppy surface will produce a pattern of points of light, which can make an interesting background for elements close to the camera. The out-of-focus points of light create circles of confusion in the background, where the individual points start to merge as a pattern of overlapping rings. A silhouette can be enhanced in this way. If the object is thrown out of focus against a background of sharp points of light, its outline will appear to vibrate. Here focus, as well as exposure, becomes a vital part of picture control.

OPPOSITE *The breakers echo the horizon line, while at the same time breaking up the reflection of the sun on the sea. The foreground rocks give scale to what would otherwise be an empty picture. The random formation of the rocks plays against the regular pattern of the breakers, creating a tension in the scene.*

Industrial landscape

The landscape of industry can provide us with very interesting and exciting subject matter. It is often seen at its most powerful in low light and adverse weather. Industrial sites are often a bridge between the country and the town, although the older sites, originally located on the outskirts of a city, have now been overtaken by suburban housing. These contrasts can be used in selecting locations; the stark factory in the countryside, or the difference in scale between factory and town houses.

Here again the difference between an open and a closed landscape is important. For the open landscape with industrial building, power-stations and refineries perhaps provide the most potent subject matter. Such installations are often located on or near an area of water. They also emit smoke or steam and burn off gas, all of which can add variety to the picture. Refineries and distilleries have metal tanks and spheres that catch the early morning and late evening light, and they are likely to have floodlighting on the installation, which will create further visual interest. Colour abounds in such places, as it is used to identify pipework or containers as well as vehicles.

Like any other landscape, the industrial installation can be explored in terms of camera angle, point of view, and changing light and weather, allowing many different pictures from one particular location.

Other worthwhile locations include airports, docks, bus and railway stations. All these places are usually operating on a twenty-four-hour basis, so that pictures can be taken in any light condition and time of day or night. Although such sites are generally open to the public, there is often a restriction on taking photographs, and you may need permission to allow you to use a camera. It is well worth getting, as you will find many exciting pictures in such a location.

Cities and towns

As you move into the more confined space of the city or town, open vistas become limited, and to photograph a large building or group of buildings from any distance becomes difficult, requiring a search for camera positions. The advantage of a built-up area is that you are more likely to find a high point to shoot from, and high or low camera angles are well suited to the urban landscape.

With the urban landscape, pattern and geometry come into play, and accentuated camera angles can enhance these. You may find an interesting aspect, or perhaps the only clear view of a building, is from some distance away. When constrained by the restricted view, the telephoto, as well as the wide-angle lens, can be employed. The stacking effect of the telephoto lens gives a feeling of a restricted view, which the wide-angle lens does not.

Even with the widest of lenses, however, you may not

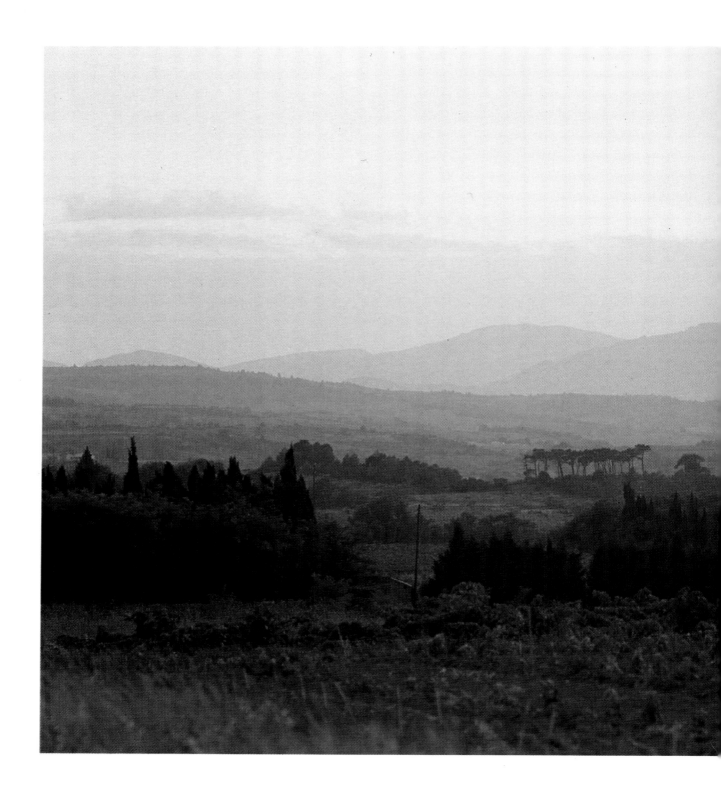

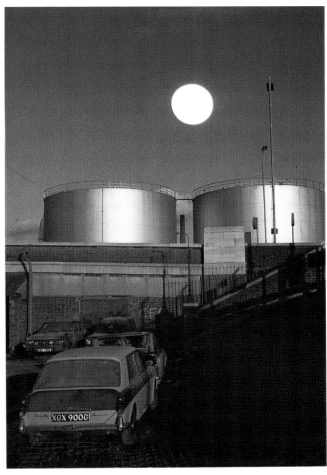

ABOVE *A polarizing filter was used to get this unusual picture. It darkened the sky, giving greater contrast to the rising moon and the metal storage tanks. The strong, direct sunlight was essential to the use of the polarizing filter. (Fuji 400, Nikon 80mm: 1/125 sec – f5.6)*

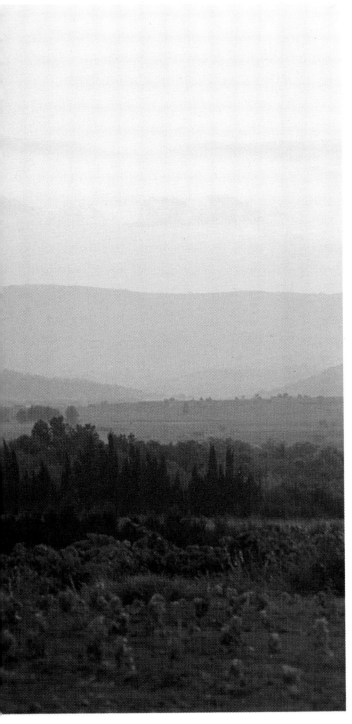

LEFT *For a short while after sunset the light creates a world that is soft and muted, yet at the same time has a saturation of colour. This combines here with aerial perspective to give a feeling of depth and space. (Ektachrome 200, Nikon 135mm: ½ sec – f5.6)*

always be able to get the view you want. If this is the case, look for a reflection of the view in an adjacent window or other mirrored surface, like a puddle of water; you may even find a conveniently parked car or motorcycle, with the view reflected in its wing mirror. There will also be occasions when you will be forced to include some unwanted foreground. If this is so, make a virtue of necessity, relating it to the rest of the scene rather than trying to reduce it to a minimum.

When it comes to shooting individual buildings, approach them in much the same way as a portrait: decide what it is that interests you about the particular building. Your physical approach to the building can be used as a way of making a photographic analysis. First show the building with its immediate surroundings, then move in to make a series of studies of its details – the materials it is made from, details of decoration, doors and windows. Finally, if possible, move inside to take a series of interior shots.

As with landscape, buildings gain their character not only from their use and immediate surroundings, but also from their relation to the changing light and weather. In the city the changes of light, and the effects they have, are more rapid. One building can shadow another, the oblique light of dawn and dusk making longer and deeper shadows, which make dramatic and interesting scenes. There are situations both in the country and city where this can be put to use. When part of the scene is lit by a hard, direct light, and another is in total shadow, the silhouette can be employed. This happens quite often in a built-up area, where the light travels down a space between buildings and there is an opening at right angles to the lit area, giving a bright patch of colour or tone. Almost invariably something will cross this patch of light, creating a silhouette; it is just a matter of waiting.

Adverse weather

Adverse weather can produce dramatic and startling photographs. They derive much of their effect from the fact that they often present a new view of a perhaps familiar subject, as most people are intent on avoiding the bad weather, rather than looking at its effect on the world around them.

Rain is not an easy thing to record. Quite a fast shutter-speed, at least 1/125, is required to freeze the action of the rainfall. It is easier to show the effect of the rain upon a surface – the pattern it makes as it hits water, or the drops of rain on a window. If there is enough light to freeze the motion of the rain, the raindrops will only stand out against a dark ground. Rain-soaked buildings or roads look dark, but if they catch the light, this reflects off their wet surfaces, making them bright.

Snowflakes are easier to photograph, as they fall slower, and they will show up against most backgrounds, other than white. Where rain diffuses the light,

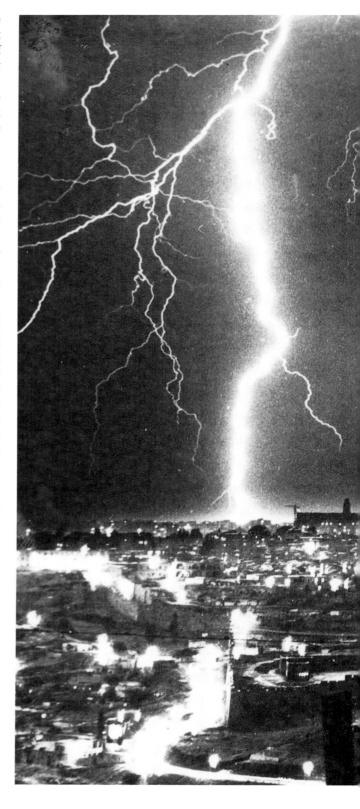

Photographing lightning does not require lightning reactions! The camera needs to be mounted on a tripod and set to 'B', leaving the shutter open for a number of flashes. Make several varying exposures to be sure of a good result. Aperture setting is not critical. A night shot is more effective and allows for longer exposures, as in this picture of Jerusalem.

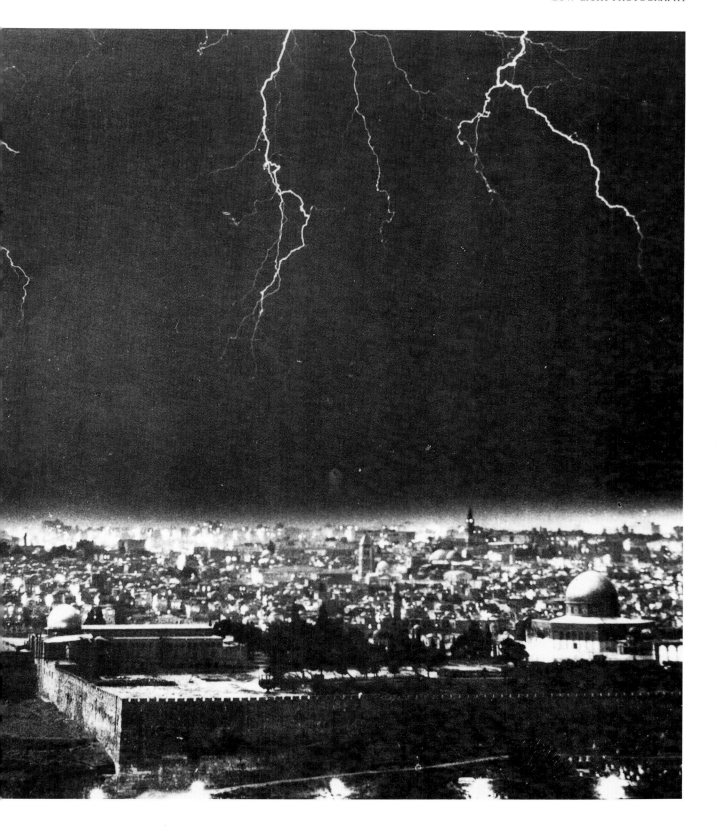

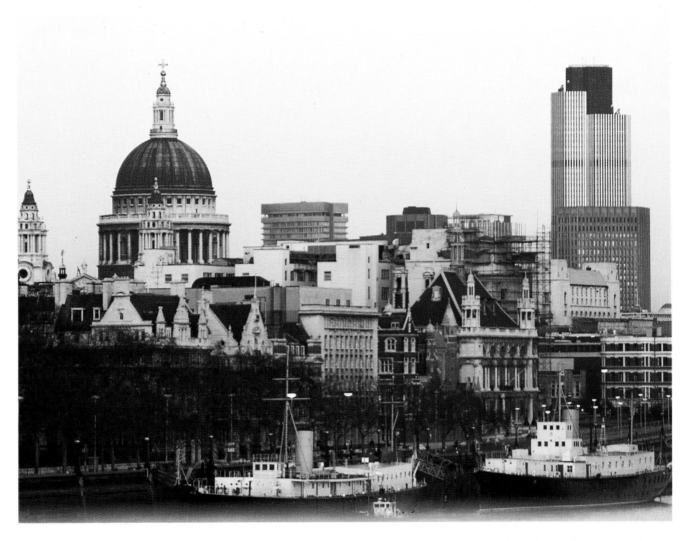

ABOVE *The jumble of the urban skyline is made more interesting by the pink light of dusk. This view is from the south bank of the Thames in London. In many cities rivers provide the only way of finding an open aspect. (Ektachrome 200, Nikon 135mm: 1/30 – f4)*

OPPOSITE *A skyscraper dominates the skyline, but to get an isolated view is impossible without using an oblique camera angle, which in this case proved to be very effective. (Ektachrome 200, Nikon 24mm: 1/60 sec – f5.6)*

Using flash during a snow fall will freeze the flakes, creating a random pattern across the picture. To give contrast this is best done at night or against a dark ground.

snow breaks up the picture with a mottled pattern, and, as it settles, emphasizes shape and form, making things like trees stand out against the stark white ground.

With fog and mist, the moisture in the air diffuses the light, reducing depth and softening shapes. They make any foreground object stand out, and give the picture a three-dimensional quality. In a very open landscape or seascape the horizon will disappear, and sky and land or sea will merge. A strong foreground feature, or something that is not too far from the camera, will be needed to hold against the flatness of the background.

In really adverse weather long exposure may be required, so a tripod and cable release will be needed. When working in rain or snow the camera and film need to be protected from the wet; if the camera is on a tripod, your hands are free to hold an umbrella. A lens hood will also help to keep rain or snow off the lens, and if the rain is driving into the lens, you can cover it with a skylight or U.V. filter. Make sure, however, that you

wipe this clean between shots, as any moisture on the filter will act like a soft-focus lens. If the camera is likely to get wet, place it inside a plastic bag with a hole cut for the lens, but take it out as soon as you have finished, as condensation can form in the bag if it is taken from a cold atmosphere into a warm one. If you have no protection from the rain and have to change the film, place the camera in a large, black plastic bag, and the camera can then be opened and the film changed.

In rain and storm the light drops, necessitating longer exposures. The combinations of shutter speed and aperture that you use will depend on what you require of the picture. In a land, sea or cityscape, where there is no need to capture movement, a long exposure can be used. Remember, however, that falling rain will blur, creating a soft-focus effect. Fog and mist scatter the light and, as there is a limited depth of visible picture, make wider apertures quite adequate in these conditions. Because of the lack of contrast, some overexposure, may help to penetrate the fog or mist; a U.V. filter may help a little.

Snow scatters the light in a different way: the light reflecting off the snow creates extreme contrast in the scene. Once the snow has stopped falling, giving exposure problems similar to sky pictures where the

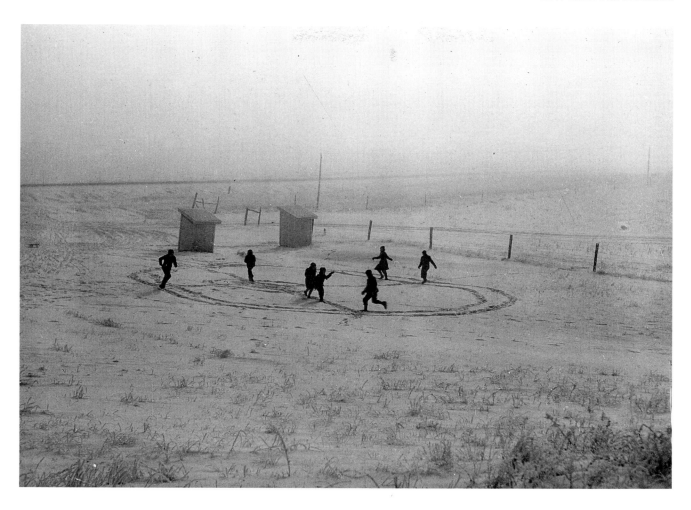

Snow can completely change a scene. The prancing figures, static fence posts and ghostly sheds are given dramatic impact as a contrast to the surrounding whiteness of the landscape.

light gives a false reading and causes underexposure, it is necessary to increase the exposure by at least fifty per cent to give detail in the areas other than snow. Photographing during the snowfall will give results similar to dense mist or fog. Here again the sky and land will meet in almost the same tone or colour. Having something on the skyline will help define the horizon.

Using colour in adverse weather will result in a colour cast in the finished photograph. There is no real need to try to correct this, as the colour cast will often add to the effect of the picture.

NATURE

The world of nature can be explored both in the country and in the city. It provides plenty of subject material for photography, and the low-light hours and low-light habitats are particularly rich in opportunities. For the naturalist the camera has become an invlauable tool for recording his finds and observations, and for such objective recording purposes, accurate colour is essential. Flash is therefore used extensively by nature photographers, to achieve accurate colour, to freeze

motion, and to provide light where the existing light is insufficient or non-existent.

The naturalist's approach to photography is therefore an objective one, whereas the photographer's approach is more subjective – the attractive qualities of nature being sought out for subject material rather than merely recorded. There are, of course, many specialist nature photographers who combine the objectivity of the naturalist with the creative eye of the expert photographer to produce beautiful and sometimes astounding pictures. Some of the techniques used by the specialist nature photographers can be employed by the interested amateur without specialist equipment. Existing equipment can be adapted, and some basic additional items made at little cost.

As you will have already gathered from this book, patience and perseverance are important qualities for the photographer interested in taking good photographs, and these qualities are essential for the nature photographer.

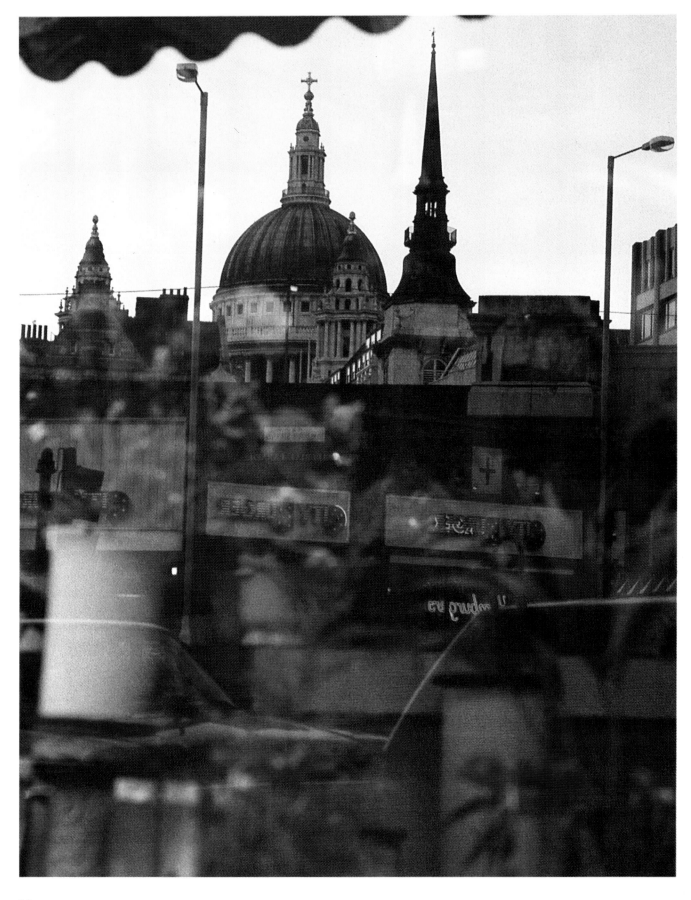

ABOVE This poppy was photographed in low light, and working close up made focus critical. The camera was hand-held, which meant a reasonably fast shutter speed was required, limiting the choice of aperture. Although parts of the flower are out of focus, the overall effect is pleasing. (Kodachrome 64, Nikon 55mm Micro: 1/60 sec – f4)

RIGHT Backlighting brings out the delicate pink of this fungus, which stands in contrast to the solid colour and texture of the dead leaves. (Fuji 400 rated at 800 ASA, Nikon 50mm: 1/125 sec – f5.6)

Sometimes the reflection of a building can be as interesting as an ordinary view. This picture of St Paul's Cathedral, taken on a very dull day, is a reflection in a flower shop window. Colour is added by the out-of-focus roses in the window. (Fuji 400 rated at 800 ASA. Nikon 80mm: 1/60 sec – f5.6)

Finding your subject can be an intriguing part of nature photography, as many animals, insects, birds and plants do their best to remain hidden, and are only to be found at certain times of the day or night, or in particular weather conditions. For the naturalist, these problems are a fascinating part of nature study; for the interested photographer, some of these problems can be solved by using field guides, or by taking pictures in places that have been created for the observation of nature under controlled conditions. If you have a garden, or even a window box, you can create your own nature reserve, designed with specific regard to the problems of taking pictures.

Before going too far afield, acquire a basic understanding and develop a technique for taking nature pictures in your own garden, a local park or, better still, on a piece of waste ground that has reverted to nature. As there are many different areas within nature photography, each demanding its own particular technique and equipment, working close to home will help you to decide firstly, what interests you in nature – plants, insects, birds, animals – and secondly, how best they can be photographed, given the limits of the equipment you have.

Plants

Of all nature subjects available to the photographer, flowers are the most popular and accessible. They range from the formal regiments of a well laid-out garden to the lonely wild flower hidden among grass and leaves. As with other subjects in nature, the environment can play an important part in the picture, but in most cases concentrating on the individual flower or cluster of flowers is perhaps the best way to capture the beauty of a specimen on film. A close-up gives detail and isolates the subject from its background. With close-up photography the use of selective focus and limited depth of field will help to reduce the background to an undistracting blur.

Colour and light will also help separate a bloom from its background. Apart from the pattern effect of a bed or field of flowers, which is perhaps best photographed in direct sunlight, most flowers are better photographed in back- or subdued-light. The colour of the bloom becomes vibrant if the light is caught coming through the petals, as it does in the early morning or late evening. This low-angled light will also darken the background, or make it an intriguing pattern of light and dark. With indirect low light the flower's colours become more saturated, giving a quality of colour different to the translucency of a backlit flower.

Movement can be a problem with flowers, particularly when photographing them close up. It is not just a matter of stopping movement by using a faster shutter speed. If the flower is moving, it is changing its position, and hence its distance from the lens. As depth of field is limited when the lens is focused for close-up work, the lens-to-subject distance is very critical.

There are a number of ways to stop or reduce the subject's movement: the specimen can be carefully tied to a stake, out of the picture; or held by the hand, if the camera is on a tripod; or a windbreak can be erected either on the wind side, or all around the plant if necessary. A windbreak can be made out of a length of white fabric, with five stakes sewn into it at equally-spaced points. This will form a complete square around the plant if required. The white fabric can act as a reflector. You can also carry a piece of black fabric, which, attached to the stakes, can make a backdrop to obliterate any unwanted background. A windbreak can be made to any convenient size; as the fabric will roll around the stakes, it is quite transportable.

Even when you are not working close up, you can still exploit the qualities of limited focus to create interesting pictures – photographing through foliage to create an out-of-focus foreground, or focusing on one bloom in a group, allowing the others around it to fall out of focus, thus creating a diffused frame of a similar colour around the subject.

As most plants are close to the ground, you will need a tripod or some other type of camera stand that will allow you a ground-level view. A tripod with a reversible centre-column will do this, but a full-size tripod may prove cumbersome, and a smaller table-top one might well be more effective. A ball-and-socket head can be fitted to a ground stake to make a firm stand in soft ground. If you are working at higher levels a G-clamp or mole-grips with attached ball-and-socket head will be useful. A tripod also prevents camera movement, which upsets focusing as much as subject movement.

A telephoto lens will be needed for the times when you cannot get close to a subject; many zoom lenses are now made with a close-focusing facility which allows close-up photography from a distance. Some subjects can be practically impossible to photograph because they are hidden or inaccessible. By using a surface-silvered mirror, you can sometimes gain an otherwise impossible shot. The mirror is placed in a more open position reflecting the subject and the subject is photographed from the mirror. A surface mirror – silvered on the surface of the glass, rather than at the back as on a normal mirror – is required to avoid double image or distortion. Such a mirror can be put to use on other occasions; to overcome impossible camera positions when photographing buildings and interiors.

Exposure should not be a problem, and in most cases, as a tripod is being employed, a slower film can be used to gain better quality. Bracketing is, however, still advisable.

There will be times when a workable exposure does become impossible, and flash is required. One of the problems when working close up is that there is so little room to position any form of lighting or reflector. There is a specially designed flash-head that fits in a ring

around the lens of the camera, giving a direct frontal light, which is ideal for straight recording purposes, as any shadow falls behind the subject. The light effect is, however, much the same as on-camera flash – very limited. By bouncing the flash, and using a reflector as a fill-in light, you can get an effect more akin to daylight. Flash may also be needed as a fill-in light on backlit subjects, or to freeze exaggerated movement.

Insects

Insects are not as difficult to photograph as may at first appear. Again you are entering the world of close-up photography, only this time, unlike the relatively still plant or flower, the subject is almost constantly on the move. Nevertheless it is still possible to get interesting pictures with existing equipment. As well as working outside, with insects it is also possible to work in a controlled studio environment, using electronic flash.

In the open, insects are likely to be less active, and therefore easier to photograph, in low light. This is because low light also means low heat. With the help of a field guide you can establish likely habitats, and the time of day or night and in what weather conditions an insect is most likely to be seen.

The studio photograph of an insect can be made to look like an outdoor flash picture with very little effort. Close-up photography allows only limited depth of field, and the fall-off of the flash illumination results in a dark background. Construct an environment for the insect at table-top level, using the camera viewfinder to make sure that the construction looks interesting as well as natural. The lighting can be rigged in advance, and the exposure checked before the insect is introduced into the picture.

Because of the limited depth of field, subjects are better photographed from the side. With the flash, you will need a working light to focus by, but make this as weak as possible to avoid any colour cast, as you will be using daylight film. Backlighting is very useful when photographing insects, to show transparent parts of their body structure, to give shine to a body shell or to help separate them from a dark background, particularly if they are themselves dark in colour. Even under the controlled conditions of the studio, many exposures will have to be made in order to get a satisfactory picture.

Birds

Birds, creatures famously active at dawn and dusk, can be photographed from the comfort of your own home if you fix a feeding-shelf to an outside window. Leave the window open, but cover it on the inside with a blind that has a hole cut in it for the camera lens. The camera should be placed on a tripod to avoid any unnecessary movement, which might scare the birds. A window well above ground level is best, as the birds will feel more secure, and the light is likely to be better. With a

window above ground level, the background is likely to be out of focus, fixing attention on the subject.

A flash can be rigged on one side of the window if extra light is needed or if you wish to try to freeze the bird in flight. Bounce the flash if you can to avoid harsh lighting, and try to balance the flash exposure to daylight to avoid dark backgrounds.

If you want to photograph birds in the wild, you will need to go further afield and also consider building a proper hide. There are bird sanctuaries that have permanent hides, which can be used if you wish to try this type of bird photography. In a hide you will, of course, need a telephoto lens and medium-fast film. Sometimes a car can make an effective hide, as some birds and animals do not seem to associate it with humans. The door window can be lowered just enough for the lens, and the remainder of the windows covered to hide the photographer's movements.

Pictures of birds in flight are difficult to take and require a great deal of skill and practice. If you locate a nesting or feeding place you will find that the bird will circle or make passes over it before landing. This is the easiest time to catch a bird in flight, but it takes a great deal of patience. Waterbirds are seen much more in the open, and it is possible to get pictures of them as they land and take off. Being on or over water, the light will be better and the aspect more open, giving more chance of an uninterrupted view when tracking with a telephoto lens. A motor-drive and a zoom lens are assets for flight photographs.

Animals

There are now very few wild animals to photograph in their natural habitat, and those that are left can be extremely camera-shy. The tamer ones, like squirrels and hedgehogs, can still be found in city gardens or parks, and food can be used to lure them into camera range. There are domestic animals that make interesting pictures, and some of them are exceedingly photogenic.

Zoos, safari parks, aviaries and aquariums are all places where interesting pictures can be taken and, if care is used, it is possible to make the animals look as if they are in their natural surroundings.

Lighting is a problem when photographing fish or reptiles behind glass. There may be enough available light in a reptile house, but the reptiles are usually kept under artificial light which will have to be taken into consideration if you are using colour. In aquariums, flash should be used as fish are constantly on the move, and the water and thickness of glass cuts down the light. If, however, the flash is used incorrectly, it will bounce straight back into the camera lens. You should put the flash on a bracket to one side of the camera, turning it to an angle of 45°. Also be careful that the glass does not act as a mirror, reflecting you and the camera. By selecting the right camera angle, and

ABOVE *Photographing through foliage can have the effect of a coloured diffusion filter, giving a soft-focus look to a picture. (Ektachrome 200, Nikon 135mm: 1/30 sec – f2.8)*

OPPOSITE ABOVE *To get this picture of a swallowtail, I followed it for over an hour, photographing against many kinds of background, until it settled on this one, which seemed a perfect foil for its markings. (Ektachrome 200, Nikon 55mm Micro: 1/60 sec – f5.6)*

OPPOSITE BELOW *To photograph this dragonfly took many evenings of waiting by a small pool with the camera focused on this particular plant. The plant was chosen because of its relationship to the sun at the time of day and for its background. (Ektachrome 64, Nikon 55mm Nicro: 1/60 sec – f5.6)*

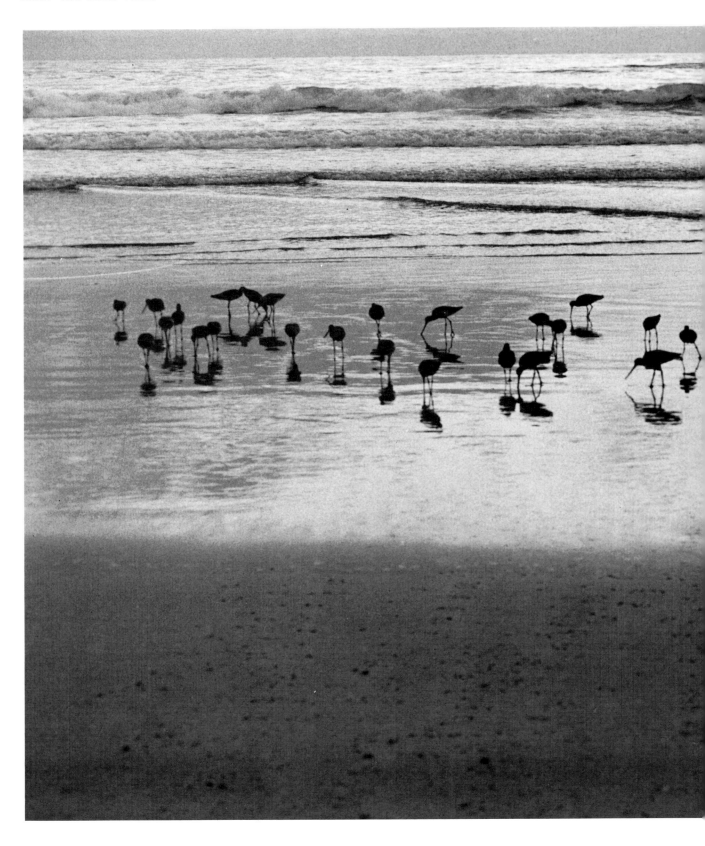

Many birds and animals can be recognized by their profile or silhouette, as with these sandpipers. The exposure value was taken from the highlight areas. Any attempt to retain detail in the birds would probably have resulted in the silhouettes being eroded by the backlight.

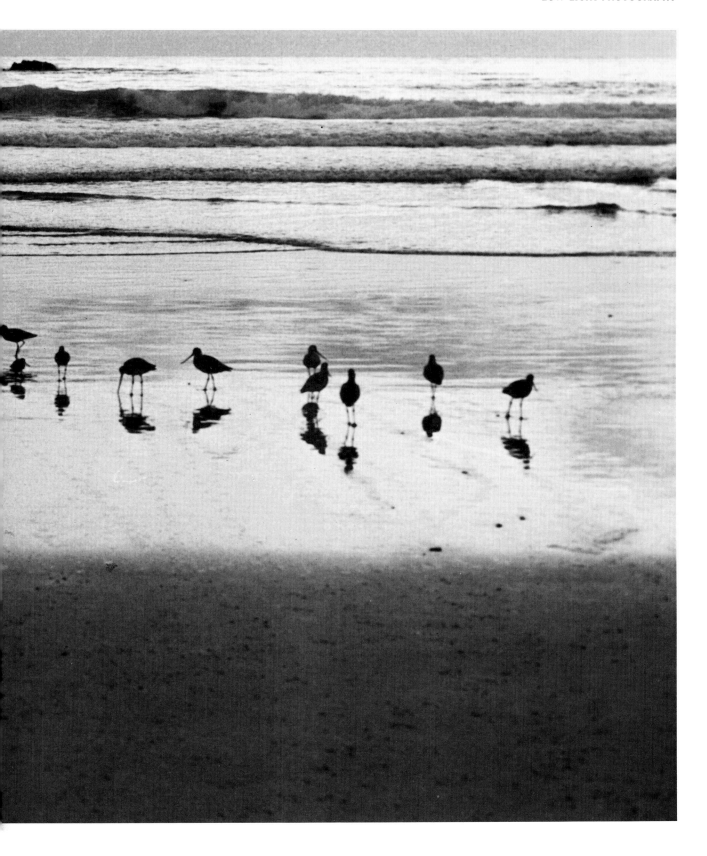

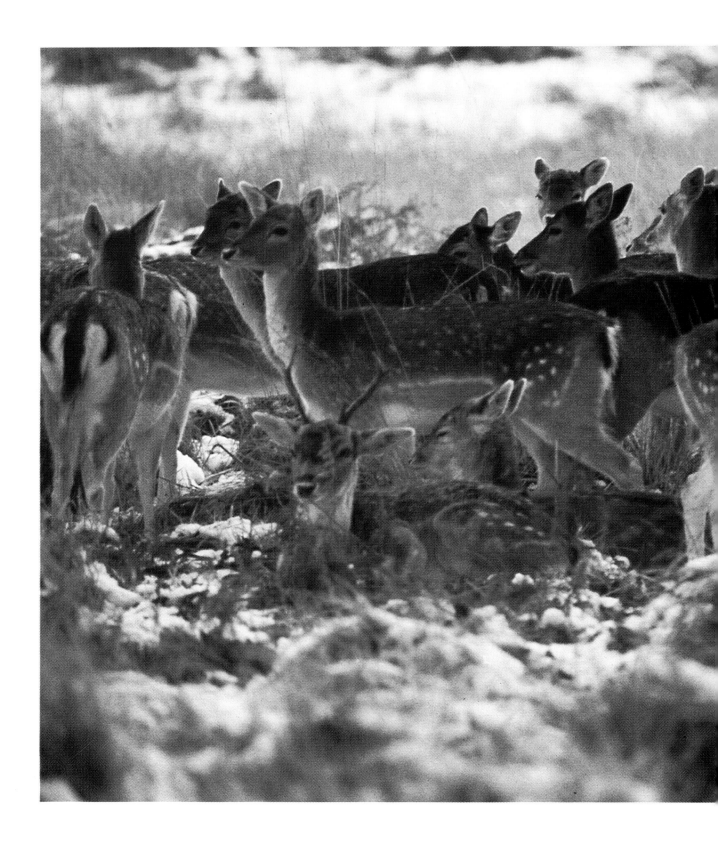

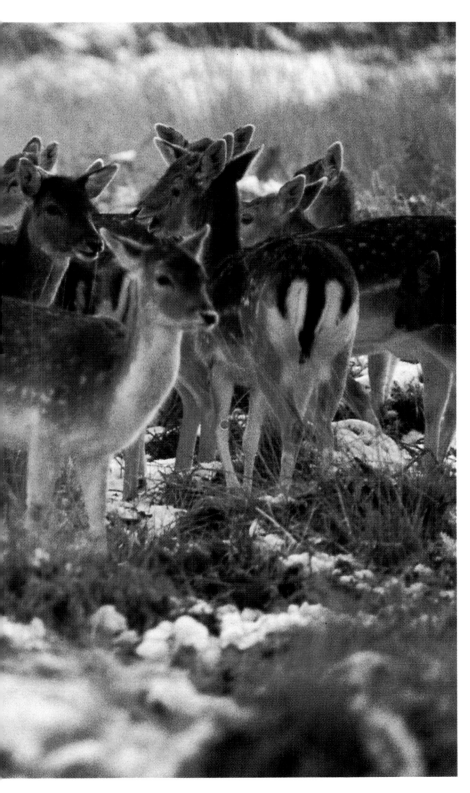

Even though these deer were photographed in a park they proved extremely camera-shy. Taken between snow falls, the light was soft and blue, and the snow proved to be a bonus, as it reflected back what light there was. The dead bracken echoed the colouring of the deer. (Fuji 400 rated at 800 ASA, Nikon 180mm: 1/125 sec – f3.5)

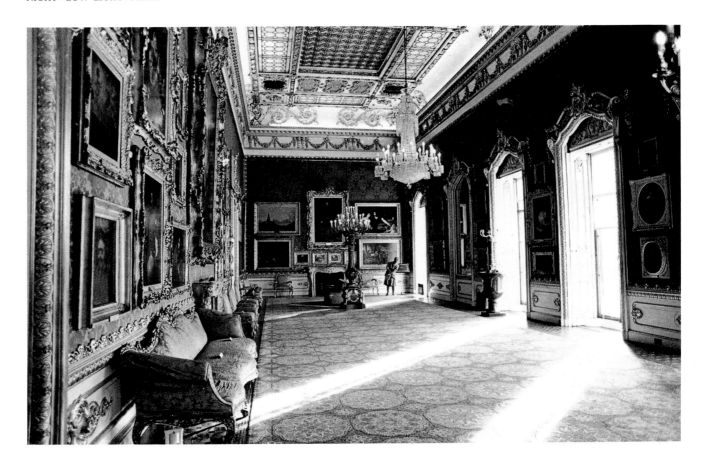

Like many stately homes and historic buildings, this interior has a fairly empty floor area. Here the shafts of direct sunlight have been used to add interest to this empty space. The interior was decorated predominantly in red, which can be difficult to capture when using black-and-white film. I used one of the new chromogenic films that are more sensitive to red than the normal black-and-white film. (XP I rated at 400 ASA, Nikon 24mm: 1/30 sec – f4)

wearing dark clothes, this can be avoided. Another option is to place the lens hard against the glass, to reduce the chance of reflection and flare; this will also help steady the camera on a long exposure.

When it is impossible to overcome reflections or parts of the enclosure, try to make use of them by incorporating them into the composition of the picture.

When taking bird and animal photographs you should avoid making noise and unnecessary movements. Most SLRs are quite noisy, so if you intend to take up this type of photography it would be a good idea to make yourself a blimp. A blimp is a padded case that fits over the camera, allowing only the lens to protrude from the front, and reducing the noise of the shutter and mirror.

On field trips you can expect to do a lot of leg work, and are likely to be out in adverse weather conditions. Decide before you go, if you can, exactly the type of photograph you are after, and take only the equipment

that is suited to that purpose. It is well worth having a separate bag for auxiliary equipment, and if you intend to work at ground level, a ground mat is also desirable.

The choice of film relates once again to subject, but as most nature subjects are fairly mobile, including plants and flowers, a medium-fast film is best. Be prepared to use a lot of film on a field trip, covering as many angles and aspects of a subject as you can. If you have spent time finding a subject, you should make the most of it.

INTERIORS

The interior of a building reveals its character; it reveals its function and the kind of people who use it. The design of most buildings has been deliberately decided upon, and the lighting arranged to suit its specific function. Care should therefore be taken to retain the effect of the existing lighting, the balance of which will change according to the time of day and the varying function of a room.

Most interiors are a mixture of light and dark areas, and the way light enters a window or door, lighting only a portion of a room, or the uneven effect of the interior lighting, are subjects in their own right. If detail is required in the shadow areas, it will be necesary to

bring the light levels in these parts to within at least one and half stops of the highlight areas. To a certain extent this can be done when printing with negative film, but the detail must be present in the negative. This means that the exposure must encompass enough of both the high and low light areas of the subject. If the extremes of exposure are too great, allowing for overexposure in the highlights and underexposure in the shadows, you will not achieve a satisfactory result.

If a balanced view of the interior is required, take the picture when the daylight is not falling directly on that part of the building. The ideal light is a slightly overcast day when the extremes of light are not too great. To achieve an evenly lit interior it may, however, be necessary to wait until the daylight has gone, and then use artificial lights to get the result required. Either electronic flash or tungsten light can be used.

Both of these can be mixed with daylight. Using black-and-white there is no problem with mixed light, and you may find that the existing room lights are sufficient to balance out the daylight. If not, a photoflood or electronic flash can be used as a fill-in. It is best to bounce these lights, giving them the appearance of natural light, and avoiding hard shadows. When shooting in colour, use electronic flash to balance with daylight, and tungsten light and film if the interior is artificially lit.

If the interior is not too large, it may be possible to use reflectors to bounce back the existing light. I use a white, double-bed sheet that can be fixed with masking tape to a wall opposite a window or door. It can also be used as reflector with supplementary lighting. When using supplementary lighting, try to keep the existing balance between the light and dark areas; the lighting should bring the two extremes to within the workable latitude of the film you are using.

When using lights or reflectors, be sure that they do not appear in the picture; the 35mm viewing frame is quite small and the odd leg of a light stand, or corner of a reflector, is easily missed. Look out also for reflections, particularly if you have glass in the picture. These can appear as shine on a painted surface, or even as flare on a window or picture. One of the problems of using electronic flash is that you never see this flare until after the picture has been processed. It can, however, be checked for by placing a flashlight or pocket torch in the same position as the flash head.

There are occasions when an interior has no practicable available light, as in a church. Here a single, portable light source can be used systematically, to paint the interior with light. To do this the camera should be placed on a stand and the interior must be dark enough for the camera shutter to be left open for a period of time. With electronic flash, an exposure is calculated in the usual way from the distance between flash and subject, the aperture is set, and the shutter locked open on 'B'. Using a cable release, each area of the interior is then covered with one or more flashes. Make sure that you keep yourself and the flash out of the shot. A constant distance must be maintained between the flash and the subject. Care should also be taken not to have either too great or too small an overlap as each separate area is exposed, as this creates either overexposed or dark areas on the finished picture. This method can be used with both black-and-white and colour, and although it seems complicated at first, it can soon be mastered.

The technique can also be used with a portable photoflood, if there is a power point available. The exposure method is the same, although now the time of exposure is also critical. Each area has to be exposed for a given time, calculated with a light meter, and the total volume of the time becomes the overall exposure. The method of using the light is similar, except that the light is moved during the exposure to blend the edges of the area covered. In this way it is possible to get a shadowless light. The term 'painting with light' comes from this method, which was often used before electronic flash became available.

Another ecclesiastical subject is the stained glass window; it is less of a problem to photograph than one might expect. If you wish to record just the window, with as little of the surround as possible, it is easier to shoot from a distance, using a telephoto lens, rather than from close in with a wide angle, as the wide lens will accentuate any distortion resulting from your angle of vision.

Avoid direct sunlight; an overcast day is desirable, or at least a time when there is no direct light on the window. Use a tripod if this is permitted; if not, a fast shutter speed may be possible, there being no real need to stop down, as you are focusing on one plane.

With the aid of a camera stand, cable release and supplementary lighting, a medium-speed film can be used to gain better picture quality. Moreover, any unwanted people who appear in the picture can, as long as they are moving, be avoided by employing a long exposure.

With colour, mixed-light will be a problem; again the principle of the dominant light source can be applied to decide which type of film to use – tungsten or daylight, transparency, or 'L' or 'S' negative. The warm effect of daylight film mixed with a limited amount of localized tungsten light can enhance a shot, but there are no firm rules, and you will discover from experience which combinations you prefer. The most difficult light to deal with is fluorescent. You are likely to encounter it in most modern or public buildings; daylight film seems to respond best to it, but you will get a colour cast unless a correction filter is used (see page 40).

Museums and galleries

The majority of museums and art galleries are well lit, and you will find that with a medium-fast film, exposures

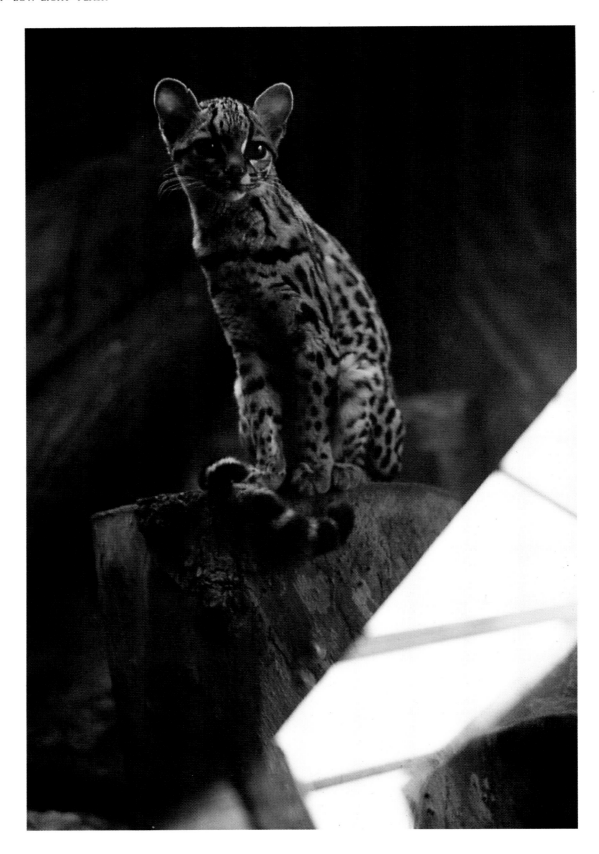

Rather than lose the reflection of the glass, it was used as part of the picture, partly to break the low-key, coloured background, and partly to indicate that the wild cat is in fact in a zoo enclosure. (Kodachrome 64, Nikon 50mm: 1/15 sec – f2.8)

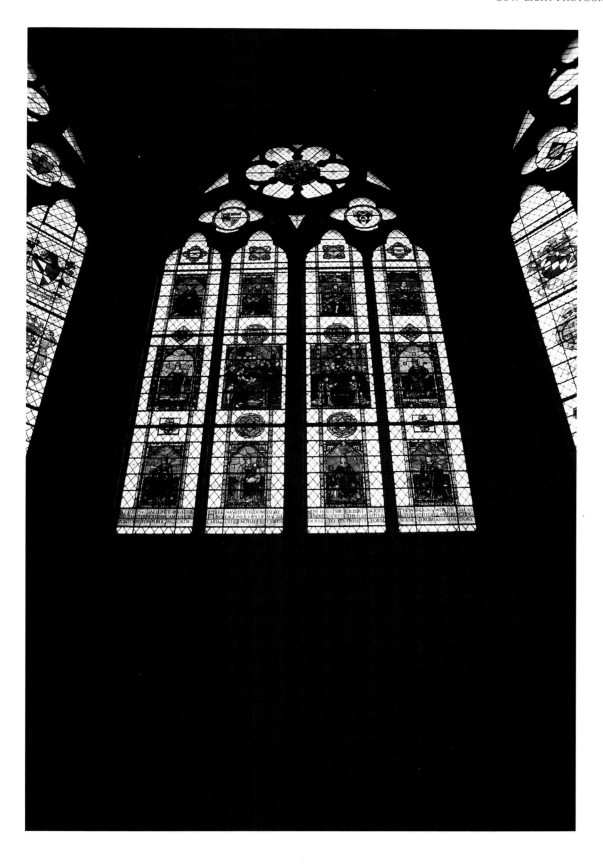

It proved impossible to get a level view of these windows because of the size and shape of the room. A wide-angle lens was used at an oblique angle, producing the soaring effect. (Ektachrome 200, Nikon 28mm: 1/60 sec – f5.6)

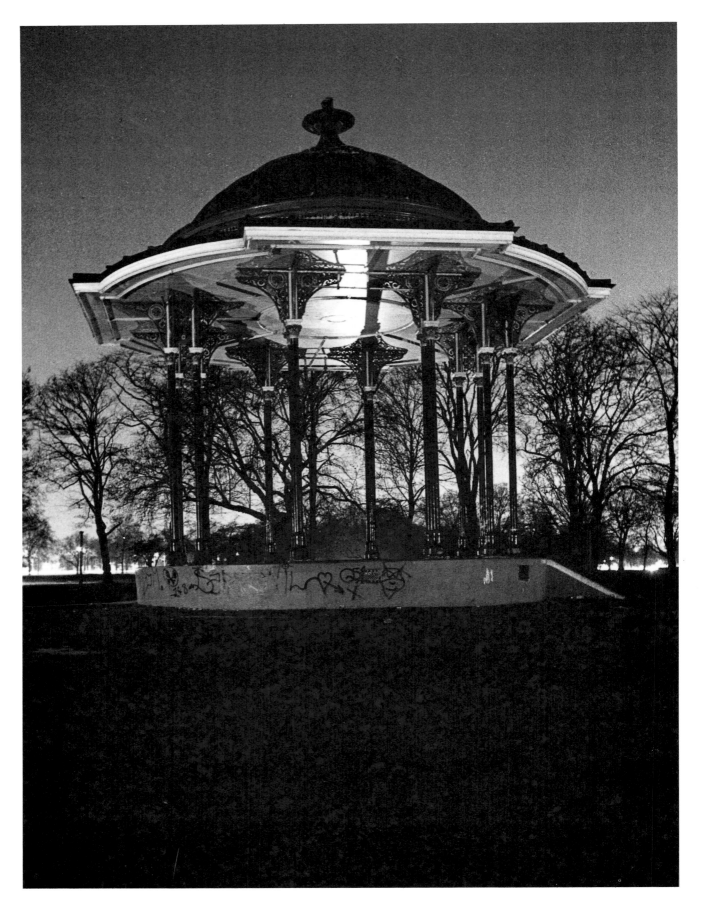

can be gained that allow the camera to be used hand-held. This is convenient, as most of the large public museums and galleries permit the use of hand-held cameras, but special permission is sometimes needed to use a tripod or flash gun. For overall views of the interiors, a hand-held camera is sufficient, and one can use a convenient showcase or column as a prop to steady the camera against if a slightly longer exposure is required.

Having enough light to get a reasonable picture of an individual exhibit can be less certain. If the exhibit is in a glass case, you may, if there is sufficient room between glass and subject, be able to press the lens hard against the glass to steady the camera. This will also reduce the chance of reflections.

Some glass cases completely surround exhibits, allowing them to be viewed from all sides; watch out for distracting backgrounds beyond the back of these cases. Reflections on the glass behind the subject may be a problem, and a polarizing filter may be required to overcome this or any other reflection. This will necessitate longer exposures or a larger aperture.

If you do use flash, make sure it does not bounce back off the glass, causing flare, nor appear as a highlight reflection in the picture. Having the flash off camera at an angle of 45° to the glass will stop this happening. With a dark background in or beyond a glass case, the mirror effect is likely. This will be lessened if you are wearing dark clothes.

For objective recording of exhibits, particularly in art galleries, colour accuracy will be a problem, unless there is sufficient daylight. Mixed light can be avoided, if the exhibits are spotlit, by shooting late in the day with tungsten film.

Do not forget the visitors as well as the exhibits; interesting pictures can be made of the 'viewer and the viewed'.

OPPOSITE *Painting with light can also be used outside to light a large area or intricate subject. When using this method the secret is not to overlight the subject; try to make the lighting look as natural as possible. This bandstand was in total darkness, so much so that a lit torch had to be placed on it to focus by. The street lights in the background help define the trees and the structure of the stand and the flash was used to provide detail without unbalancing the background.*

The bandstand was lit with four separate flashes. The flash was fired by hand at thirty feet (9 m) from the left, right and front. The final flash was from the ground behind the stand at about ten feet (3 m), pointing into the roof to give the highlight and shadows that create more depth. (Plus X rated at 125 ASA, Nikon 35mm: f4)

PEOPLE

It is fair to say that more photographs are taken of people than of any other subject; they range from the family snap-shot to the highly sophisticated, studio portrait. People can be photographed in many ways, both formally and informally, and with or without their knowledge; no matter which way you choose to photograph a person, the picture should convey their character, as well as giving an objective likeness. The candid picture has long been a favourite with photographers; catching people unawares to reveal a perhaps more intimate side of their character than the formal portait could ever discover. Candid pictures can be taken in the street or some other public place, and without the subject's knowledge, or they can be taken at a social gathering where people are aware of the camera but can be photographed unnoticed.

One of the advantages of taking candid pictures in low-light is that most people believe that a flash is necessary, and so tend to ignore the photographer. In the street people's attention is focused on what they are doing; they are unlikely to be very aware of what is happening around them, and this is an ideal time to take pictures. Even if you are seen, cameras are a familiar sight in the street today, and people pay far less attention to them than they used to. When photographing in the street, try to be as unobtrusive as possible, and have your camera ready at all times. Take a light reading as soon as you arrive in the area, and set the camera accordingly. Because there is likely to be movement, make shutter speed the priority, working at at least 1/60 or 1/125. Have the lens pre-focused at about nine feet (3m). With the exposure and focusing pre-set in this way, you can take a picture very quickly, and once a first exposure has been made you can then take time to check the exposure and the focusing, and make any necessary corrections for a second shot. This approach should be used any time that you are photographing in an unpredictable situation; in this way you can sometimes get a picture you would otherwise have missed. Moreover, the less time you spend taking a picture, the less likely you are to be noticed by the subject, thus allowing further opportunities.

There are plenty of places where you can take pictures of people, with or without them being conscious of the fact. You may wish to take general scenes, that involve a number of people, as well as individual portraits. If so, look for a place with plenty of activity, to give a larger variety of subjects and a greater chance of escaping notice.

Most activities follow a regular pattern, which means that you can observe what happens and decide when are the best times to take photographs. With more complicated activities this also gives an opportunity to take a second or third picture, if it is missed the first time. For shots where timing or tracking may be

ABOVE Today many museums have adopted more interesting approaches to showing exhibits, and many of these environmental displays are ideal for photography. This picture was taken in mixed light, but the result is fairly evenly lit, and has a good colour balance. Showing people is important in such a picture to emphasize the environmental nature of the exhibition. (Fuji 400 rated at 160 ASA, Nikon 35mm: 1/60 sec – f4)

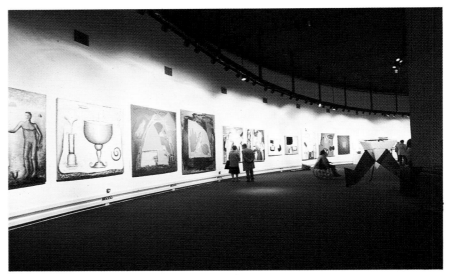

ABOVE Photographing in galleries can be difficult because of the lighting, which is mostly focused on the exhibits. With this picture I overexposed slightly to give some detail in the viewers. (Ektachrome 160 tungsten rated at 640 ASA, Nikon 24mm: 1/30 sec – f3.5)

OPPOSITE This unfinished piece of sculpture by Michelangelo is lit in exactly the right way to bring out the qualities of the carving. (Ektachrome 200, Nikon 50mm: 1/30 sec – f8)

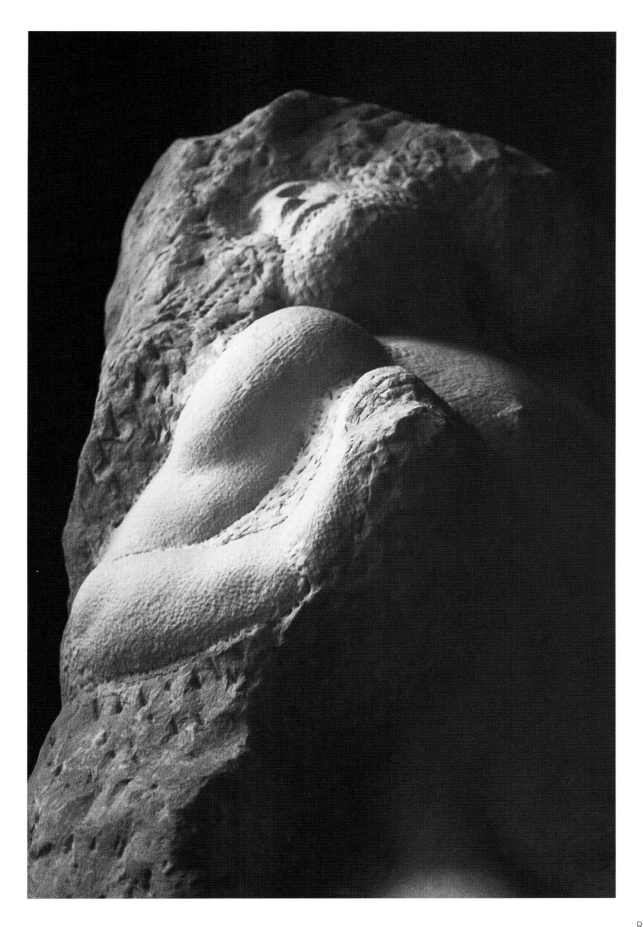

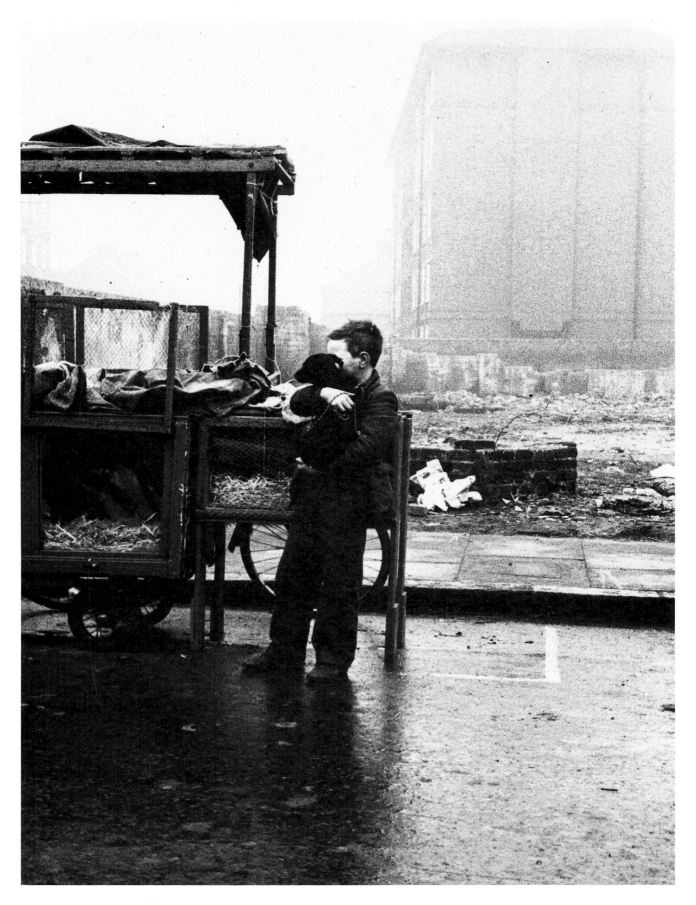

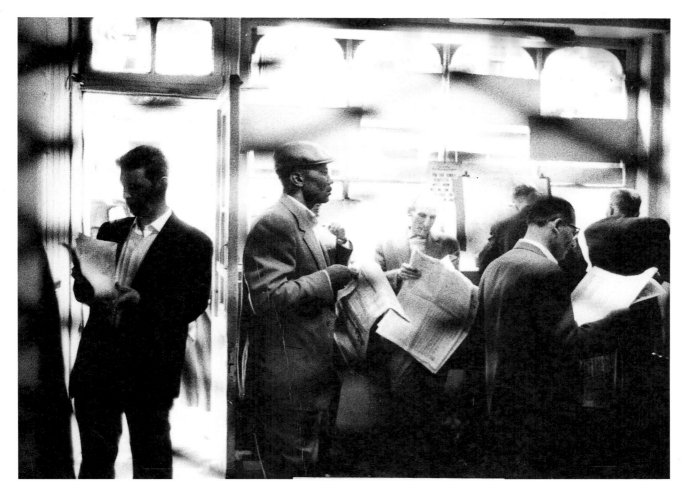

ABOVE *Setting the right exposure for this shot proved difficult because of the strong backlight and the fact that I had to shoot through the security grill. The pattern of the grill adds interest to the picture without obscuring any of the figures, and because of the backlight it disappears entirely in parts. (Tri-X rated at 800 ASA, Canon 50mm: 1/60 sec – f4)*

OPPOSITE *This pet stall in a street market was an ideal place to catch a good picture. The child is too interested in his new puppy to notice what is going on around him. The early morning mist obscures the buildings behind, throwing the attention on the foreground. (Tri-X rated at 400 ASA, Canon 50mm: 1/60 sec – f2.8)*

problematic, you can pre-focus and frame a shot in advance.

Alternative views of the same subject should be taken. Whenever the opportunity allows, cover a picture from more than one angle and with alternative framings, taking both vertical and horizontal pictures. It is a common failing to keep the camera in the same position when a series of pictures is taken, and too often the subject dictates the format – portraits vertical and landscapes horizontal.

If you are showing a general scene as well as the people in it, remember both the foreground and the background can be used to convey added information that can heighten the mood and impact of the picture. With this kind of photograph, care should be taken over the composition, ensuring that there is either a focal point drawing the eye into the scene, or some pattern or repetition in the picture to hold the eye. If the picture is too busy, it becomes difficult to look at and loses the viewer's attention. When photographing in the street there is also a tendency to keep the camera at eye level; be prepared to look for alternative high or low view points to take pictures from.

With this type of reportage photograph, it is often possible to predict, and wait for, a picture. Many

ABOVE *This bike rider relaxes after a scrambles meeting, and, although he knows he is being photographed, he acts quite naturally, as I had been photographing him and the other riders throughout the day. (Ektachrome 400, Nikon 80mm; 1/60 sec – f3.5)*

RIGHT *Using a frame within the picture's frame is a useful device, particularly with portrait or figure shots. Not only does the window here frame the old couple, it is also part of the overall design of the picture, which is made up of a series of geometric shapes. (Ektachrome 400, Nikon 35mm: 1/125 – f4)*

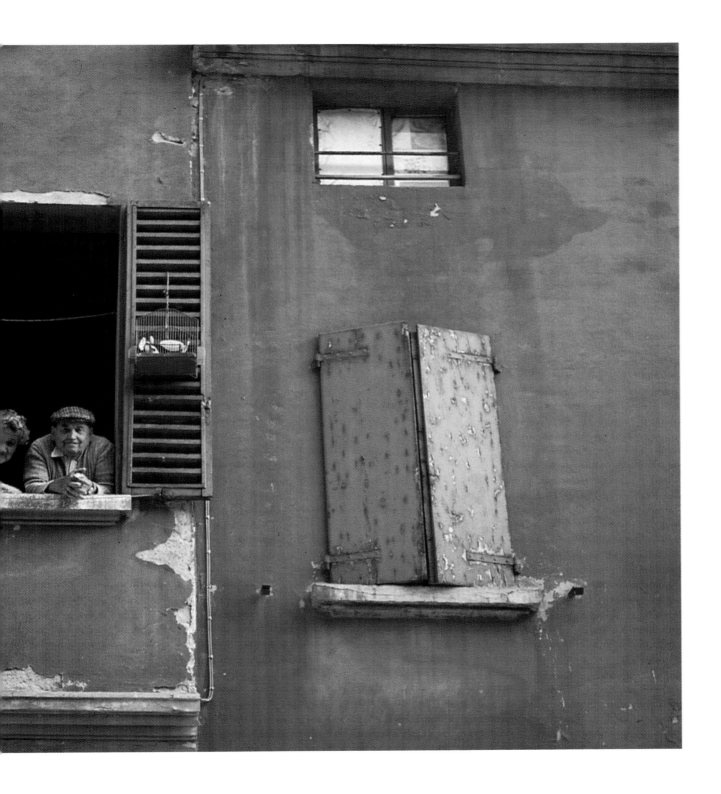

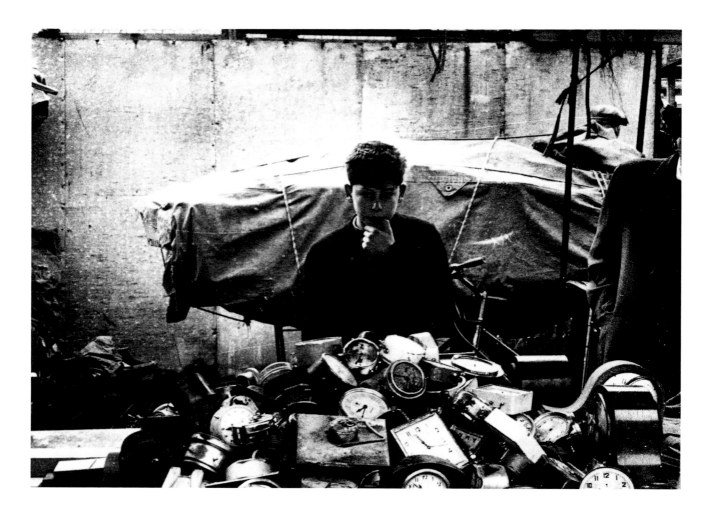

famous photographers do this, noting an interesting juxtaposition of elements that just need one other element to complete the picture, or a light change to cast a shadow in the right place and so complete the composition. Before setting out to look for such pictures, decide on a theme to follow. It is surprising how much this can help to concentrate the vision.

The choice of a lens for street photography is a matter of taste, and will often be dictated by the subject. Many people think that the telephoto lens is best for candid pictures, but many well-known reportage photographers work with a 35mm lens as their standard. They feel it puts the viewers right in the picture, making them more a part of what is happening, whereas the telephoto lens leaves viewers with the feeling of looking on.

The wide-angle lens has the advantage of a greater depth of field, making it better to use pre-set. The advantage of the telephoto is its narrow depth of field, making it easier to isolate the subject from either the background or foreground. It also has the stacking effect, so that elements in the picture foreground and background can be condensed.

In low-light street scenes you will be operating in the

ABOVE *In this street market picture the boy is aware that he is being photographed and responds to the camera. The light background throws out the foreground figures and acts as a quiet contrast to the busy foreground. (Tri-X rated at 400 ASA, Canon 50mm: 1/60 sec – f5.6)*

OPPOSITE *In this portrait props were used to add interest. Everything has been considered: the background, a grey sheet, was chosen to keep the picture simple, but allowed to drape so as not to be too severe; the music stand balances the subject and contrasts well with the curves of the French horn; and the message on the boy's tee-shirt tells us that, like any other teenager, he is interested in pop music. The lighting is daylight with a reflector filling in on the shadow side. (FP4 rated at 125 ASA, Nikon 35mm: 1/15 sec – f4)*

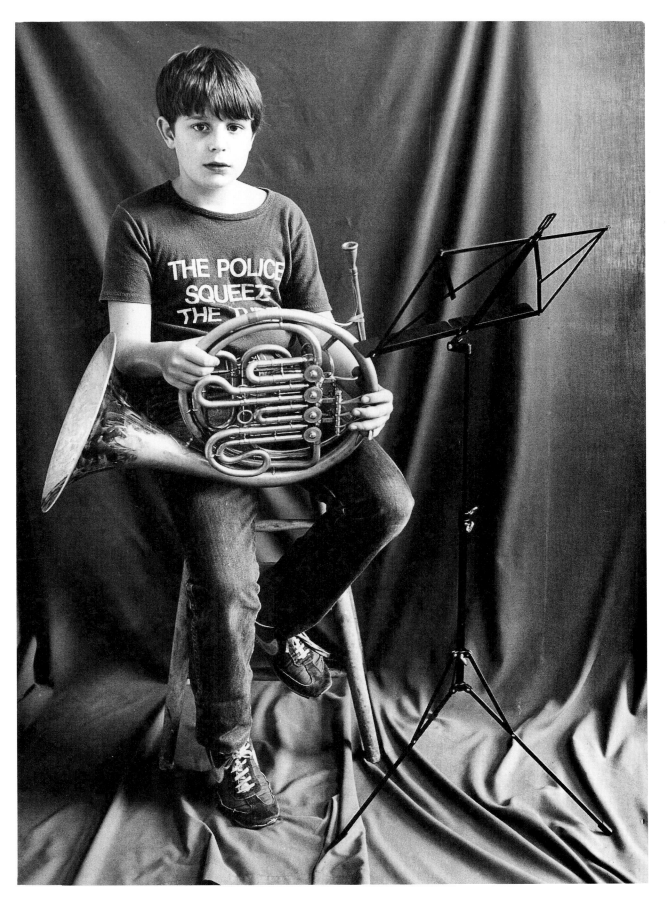

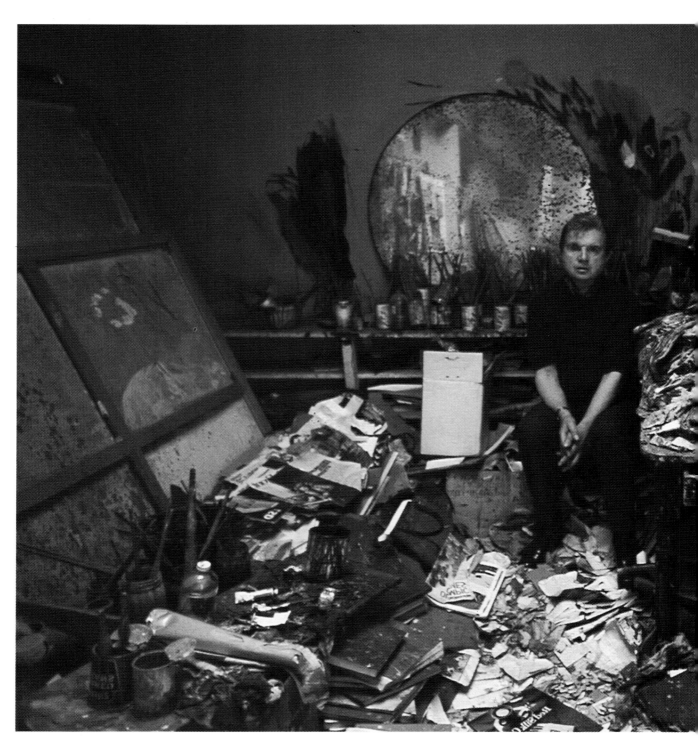

This series of portraits of the artist Francis Bacon, taken in his studio, shows just how many ways a portrait can work in relation to its background. The large picture shows the artist in his working environment, the second three-quarter length portrait relates the artist to his materials by using an unpainted canvas as a backdrop, while the third concentrates on the head alone, allowing the light to lift it out of the background. (Ektachrome 200 rated at 400 ASA, Nikon 28mm: 1/15 sec – f2.8)

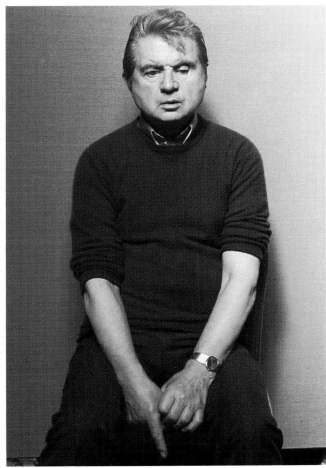

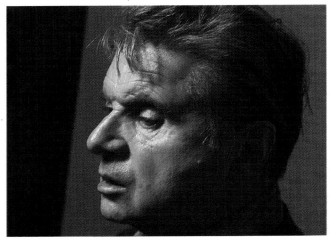

(Ektachrome 200 rated at 400 ASA, Nikon 35mm: 1/30 sec –f4)
(Ektachrome 200 rated at 400 ASA, Nikon 80mm: 1/60 sec –f2.8)

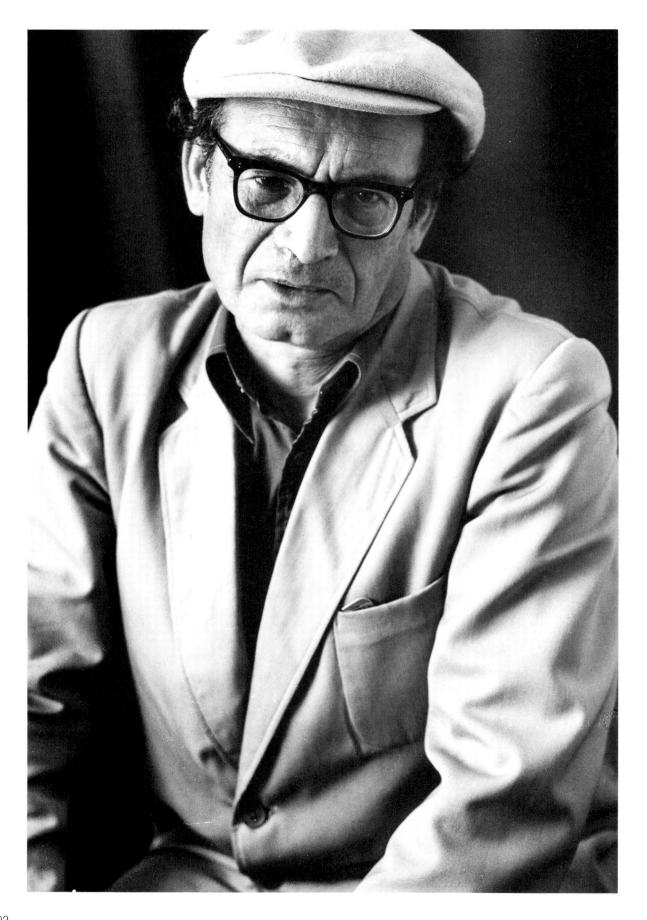

two extremes of light: it will be either flat or contrasty. In the early morning and late afternoon the sunlight will be hard on faces and figures, giving harsh shadows and dramatic effects. In the very early morning and late evening the light will be flat, and colours and tones will be saturated, giving a sombre and sometimes sensuous effect.

Inside public buildings the light will also vary in the same way. Modern buildings have a high light level, usually fluorescent, making pictures very flat. In older buildings the lighting may be patchy, giving pools of light in darker areas. Fluorescent lights are usually overhead and diffused, giving a flat top light and allowing little modelling in faces. On black-and-white film the skin tone darkens, while with colour it has a green look.

If you are shooting under fluorescent tubes, look at subjects either for their overall shape, rendering them as a silhouette, where facial detail is unimportant, or, if detail is required, look for some other light that is more directional, such as the light from a shop window.

Where the light is patchy it is a question of catching the subject in the right place. With the more direct overhead light that you might get in a bar or restaurant, watch out for harsh shadows on the face, or black eye-sockets. Silhouettes and body shapes can be as interesting and as telling as faces. Likewise pictures blurred with movement, or photographs taken against the light, to deliberately lose detail can also produce interesting results.

Portraits

The way a portrait is taken should be a matter of mutual consent between the subject and the photographer. At the outset some decisions have to be made as to the degree of formality or informality required in the picture. The sitter should be made to feel as comfortable as possible, unless a deliberately austere portrait is desired. The question of formality will affect the kind of background – familiar surroundings, in the home or at work; unfamiliar surroundings, a public place or space, or a plain studio background. The choice may also affect the way the subject will dress.

For any kind of portrait try not to over-direct your subjects. Allow them to take up their own position, and if you want them to move, get them to do so by an indirect method. With a portrait in a home or work enviorment, use the background, making the subject belong to it. Props can be used to strengthen this idea;

people often feel more relaxed if they are holding an object, or are engaged in doing something. Observing subjects while they are performing some task, and just taking pictures in a casual manner can produce some interesting results.

This is certainly an area where a working knowledge of low-light techniques is very useful. Being able to work in a restricted area with available light gives you the freedom to photograph almost anywhere you wish. If you decide to take the photographs with only available light, the portrait will have a documentary feel, and this aspect should be played upon. Bars and cafés are good locations for this kind of shot. The subject can then relax and talk to other people, giving a wide range of facial expressions.

The more formal pose can be used in a home or work setting, either indoors or out, using only available light. The exact location may well be chosen because of the quality of the light at a certain time. Here a direct relationship between the camera and subject is established, giving slightly more tension to the situation, and this should be reflected in the picture.

When possible, use natural light if a large amount of the background is in the shot. For any portrait the natural, soft north light is the ideal. There may be times, however, when a hard, directional light, either natural or artificial, will prove more interesting. For a more formal pose, lighting and reflectors can be introduced to supplement existing light, or to create an alternative. Experiment with both natural and artificial lighting. Find out when the subject is unrecognizable due to lack of light; you will be surprised how little needs to be visible for recognition.

When using available light place the subject opposite a window or open door; the position can be varied to give full-frontal lighting, side lighting or backlighting. If the light is too hard, the window or door can be covered with diffusing material, such as tracing paper or thin white fabric, to soften the light. With side or backlighting, a supplementary light source may be required to fill-in the shadow area. The easiest way to do this is with a reflector, placed on the shadow side opposite the light. Room lights can also be used to supplement daylight; a table lamp with low wattage can provide an interesting fill-in, even when using colour. Where the main light source is daylight, you will of course be using daylight colour film, so any artificial light source will give an area of colour cast, which can heighten the interest of the picture.

If you decide that a more even balance of light is required, an electronic flash can be used, but make sure it doesn't swamp the available light. Match the exposure to half a stop below the correct exposure, so there is still some difference between the shadow and the light side of the subject. The flash will need to be bounced off a reflector or light surface to prevent harsh shadows.

OPPOSITE *Here the same grey sheet is used, but this time the subject fills the frame, cutting all four sides. Although the lighting looks similar, this picture was lit with a single flash bounced into an umbrella reflector to the left of the subject, with a fill-in reflector placed to the right. (FP4 rated at 125 ASA, Nikon 80mm: f8)*

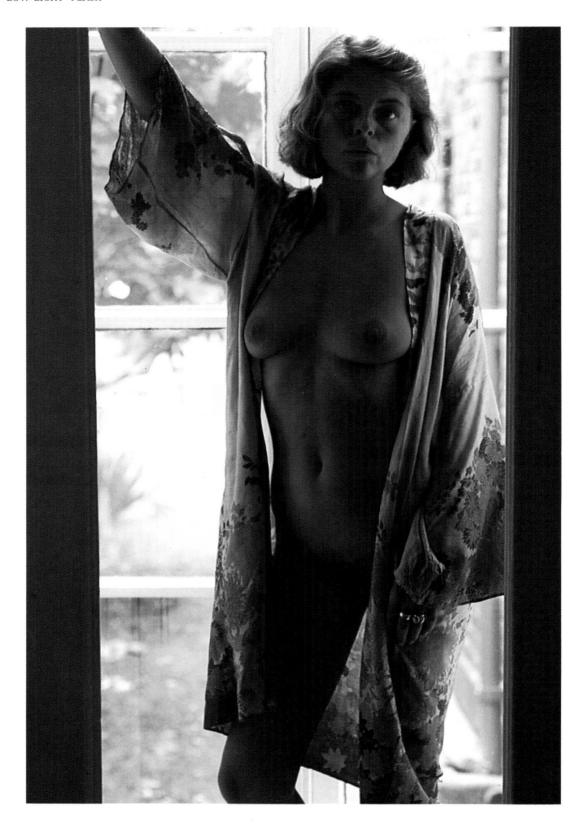

When using backlighting, different exposures can be made that change the mood of a picture. Here the exposure reading was taken from the kimono at the right shoulder. The daylight from the window bounces back from the white shutters on either side of the model, creating the subtle lighting on the face and body. (Kodachrome 64, Nikon 80mm: ½ sec – f4)

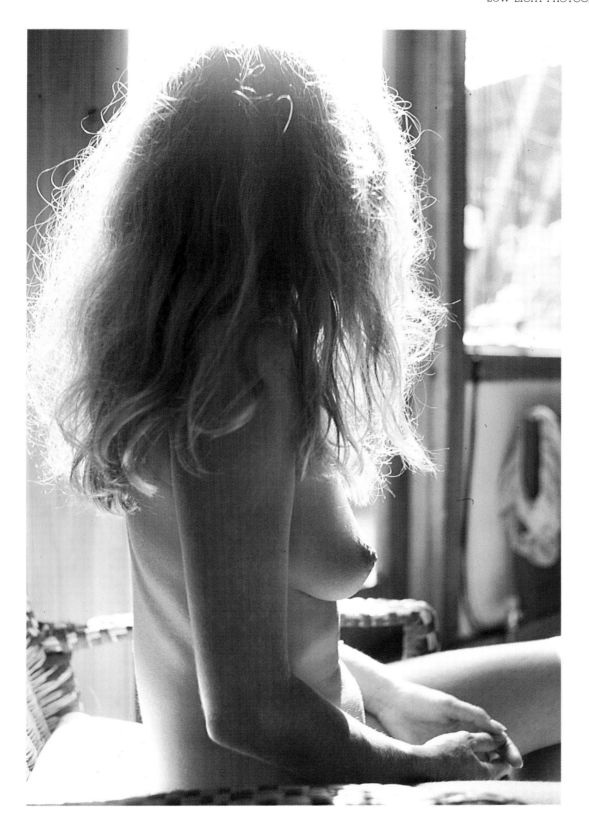

Here again the model is backlit, but this time the exposure has been taken from the dark side of the body, making the highlight areas overexposed. This general overexposure around the edge of the body and in the hair gives the picture a bright, summery look. (Kodachrome 64, Nikon 50mm: ¼ sec – f3.5)

If you intend to do a lot of studio portraits it is worth buying some large sheets of white polystyrene to use as reflectors. These are easy to handle and can be stored without taking up too much space. They can be used with either daylight or flash, but not with photographic lights, or any other overpowered tungsten light, as they can be combustible. Make the background as neutral as you can; it can be a painted wall, a roll of photograph background paper, or a cloth drape – John French, the fashion photographer, used his old army blanket. Choose a mid-tone, with a colour that will be useful in black-and-white as well as colour photography. Black or white backgrounds are good, but they do dictate the lighting somewhat, results being either low- or high-key.

Lighting is all important to the portrait, but it should not be obtrusive, unless you are deliberately attempting to produce a dramatic or theatrical effect. The various approaches to lighting are discussed in the chapter on 'Using Light', and whether you use natural or artificial light is something you will have to decide for yourself.

Whichever light you do use, and whether working on or against a plain background, always position your subject in a way that gives both you and the subject maximum manoeuvrability. Place the subject in the centre and away from the background, so that if you are using lights the background and the subject can be lit independently. If the subject is in the centre of the background the camera position can be altered to left or right, but take care that you do not run off the background – the edge of the background should not appear in the picture.

There are two schools of thought on preparing the lighting and setting. One suggests that the studio should be totally prepared in advance, so the subject can be photographed with the minimum of fuss, while the other says that nothing should be done until the subject arrives, as the subject dictates the lighting. Also it is argued that, as the studio situation is a false one, the involvement of the subject in the whole activity will add to the quality and mood of the picture. You must decide which approach is best suited to your and your subject's needs and temperaments.

As well as experimenting with lighting, experiment with camera angles and positions. Shoot from both high and low; go outside and shoot through a window or door.

Try to work with a medium-long lens – 80–90mm is ideal. This allows you to fill the frame without sitting in the subject's lap, and gives a slight flattening of the features, which usually enhances the subject's appearance. If you are including background, a medium-wide lens – about 35mm – is useful. This will not distort features, unless you are close to the subject, and it can be used safely for half- and full-length portraits.

The type of film used will depend on what you want from the session; a grainy picture can be just as valid in a studio setting as it is in a location reportage portrait. The advantage of the studio is that you have complete control over film, lighting, and subject. To achieve the Rembrandt-like lighting associated with natural-light portraits usually involves working with low-light levels; producing such lighting artificially takes much skill and more practice.

Group portraits

There are many occasions when photographers are asked to do group portraits, usually at a family gathering or event, and to get good or interesting pictures in these circumstances can be difficult.

You should avoid full sunlight; find a spot with indirect light and a background that is not too busy. Organize the group in an interesting formation, making sure that everybody can see the camera without straining; this will ensure that they can be seen by the camera. For the less formal groups, like sports teams, allow the subjects to find their own positions; equipment can be used to give added interest and information. With any group the photographer needs to be in command and give clear, decisive instructions.

If flash is used, the whole group must be equally lit. Remember that exposure is governed by distance, so make sure the group is not too deep. With a large group, lighting, particularly flash, should be avoided as you cannot tell in advance what the end result will be. Moreover, people tend to move about, and the slightest movement may lead to one person shadowing another.

Take plenty of pictures, as often there is someone looking the wrong way or with their eyes closed.

Human form

The human body is another subject that has always fascinated photographers. As a subject it encompasses the numerous activities that display the grace and form of the human figure. The nude is the classic representation of the human form in any visual medium, but there are many other ways of photographing the body that do not require a naked subject. When the body is in motion, either at work or play, it can display a whole range of shapes which, if isolated by the camera, reveal the grace or strength of the human physique.

Work activities, like digging and lifting, show the balance and strength of the body very differently from dancing or gymanstics, where the aim of the art is to reveal balance and strength in a studiedly graceful flow of movement. Children make good subjects, as they have a natural grace, being as yet unconscious of their bodies. It is the self-awareness of the body that makes photographing the human form, particularly the nude, so difficult. This is why it is advisable to photograph people while they are performing some task. The subjects are involved with the task, and so are less aware of either their body or the photographer.

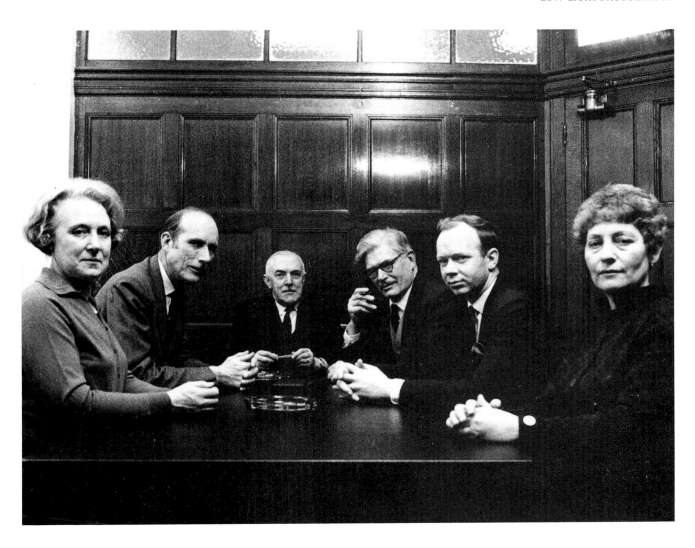

In this group shot I allowed the subjects to choose where they sat and how they looked. Those in dark clothes sat together against the dark wood panelling, while the two in ligher clothes sat opposite them. The figures on the dark ground blend into the background, throwing attention onto their hands and faces. (Tri-X 800, Nikon 35mm: 1/60 sec – f4)

The photographer's first task is to define those points in the subject's action that will provide interesting pictures. Nearly all activities follow a regular pattern, and therefore the movement can be broken down, and the points that might provide interesting pictures noted. Work activities are slow-moving, as they have to be sustained over a long period, while sports involve faster movement, usually over a shorter period of time. The sports that involve individuals, rather than teams, will provide the best material – field events in athletics, gymnastics and diving. All these follow a set pattern that is usually repeated a number of times. This gives you ample opportunity to decide what and when to photograph, and also the chance of a second shot if the picture is missed the first time.

Dance is more difficult to photograph, because, although it does have a set pattern, unless you are aware of the pattern beforehand it will be difficult to track. The best time to photograph dancers is during practice, when their clothes will reveal bodyshape clearly, and their movements will be more regular, restricted, and predictable. Gaining access to dance classes may be a problem. There are, however, many day and evening classes that use movement to music as a way of keeping fit, and these can provide an alternative to dance classes.

Children at play are totally erractic in their movements and it is a matter of trying to anticipate what their next move might be. Part of the interest of photographing children, as with some animals, is this unpredictability.

Once the points of action have been defined, how do you capture them on film? Do you freeze the action or allow it to blur, thus retaining a feeling of movement? In low-light the only guaranteed way to stop action is to use flash. It is often tempting to do so, but, unless you have the opportunity to pre-plan the lighting, your

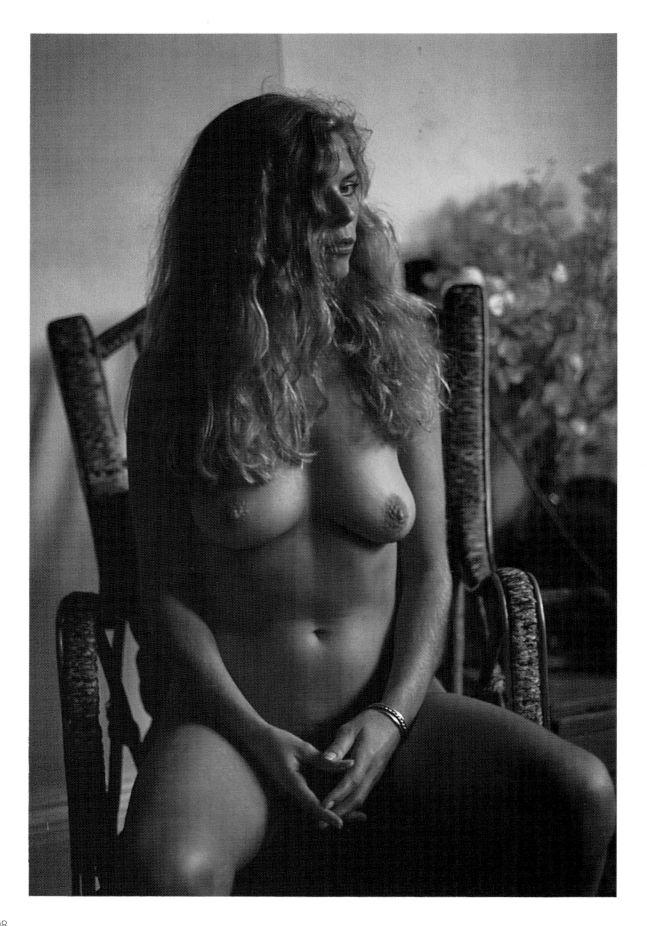

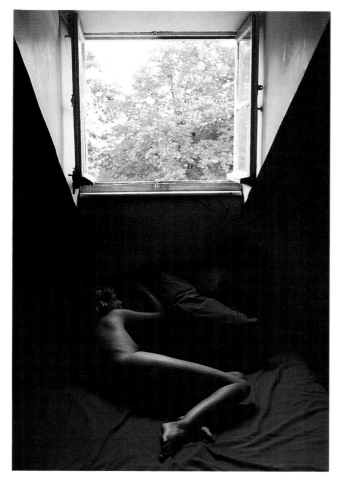

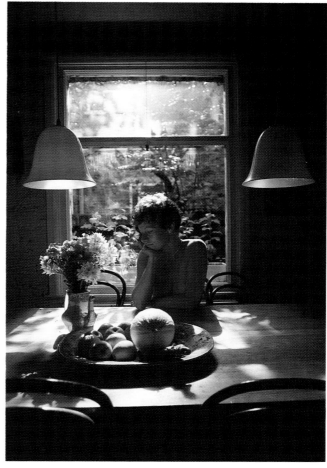

When choosing a background colour, care must be taken to ensure that it does not dominate the picture or affect the body colour of the model. In this picture the deep blue contrasts well with the skin tone; and the exposure was taken from the highlight areas of the body. The dominant shape over the attic window with the overexposed exterior, directs the eye down to the model. (Ektachrome 200, Nikon 24mm: 1/60 sec – f5.6)

Although the model is nude, this picture has more of the feeling of a portrait because of the very domestic environment. Once again the window is used as a frame within a frame, and the light from it rim-lights the model and the objects on the table, giving the picture great depth for such a small space. (Kodachrome 64, Nikon 35mm: ½ sec – f5.6)

OPPOSITE The underexposure on this picture gives the colour a sensual quality. This is enhanced by the way the model's face is covered by her hair, revealing only one eye. (Ektachrome 200, Nikon 35mm: 1 sec – f3.5)

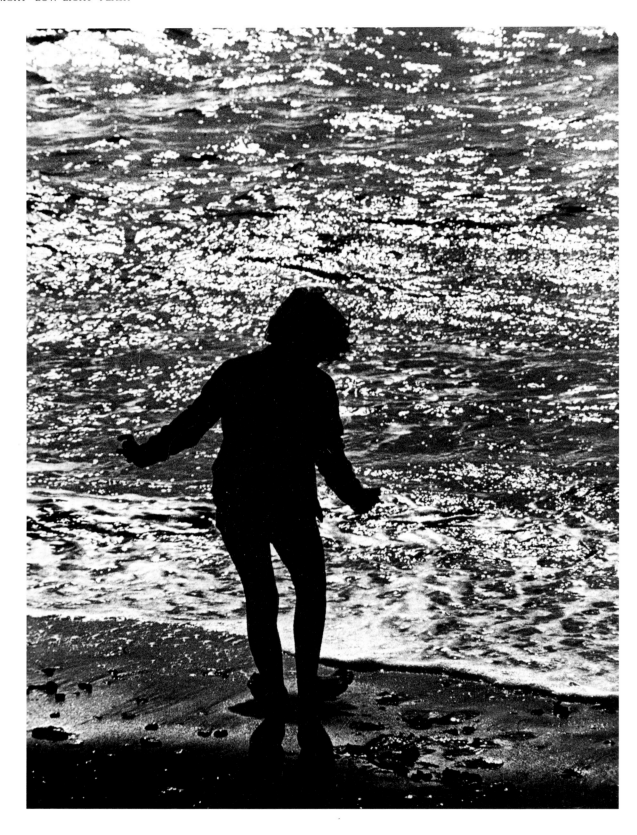

Playing by the sea's edge, this little girl takes up a pose that could be from a dance. The late afternoon sun sparkling on the sea throws her body into silhouette, making the pose even more striking. (Tri-X rated at 400 ASA, Nikon 50mm: 1/125 sec – f8)

In this picture the dancing busker has a pose similar to the girl by the sea. The photographer has caught the dancer as he is about to spin around, which gives more shape to his body.

ABOVE *The early morning light and the fact that it had been snowing combined to give this picture its blue cast, making the bikes look more mechanical. The shot had to be taken in the early morning to get a clear background and not block the, at other times busy, mews. (Ektachrome 64, Nikon 50mm: 2 secs – f11)*

RIGHT *At first glance this picture would seem to be a natural or found still life. It was in fact set up to give the impression of an artist's work table. It was lit by two flash heads, one either side of the camera, bounced into the ceiling. (Kodachrome 64, Nikon 35mm: flash – f11)*

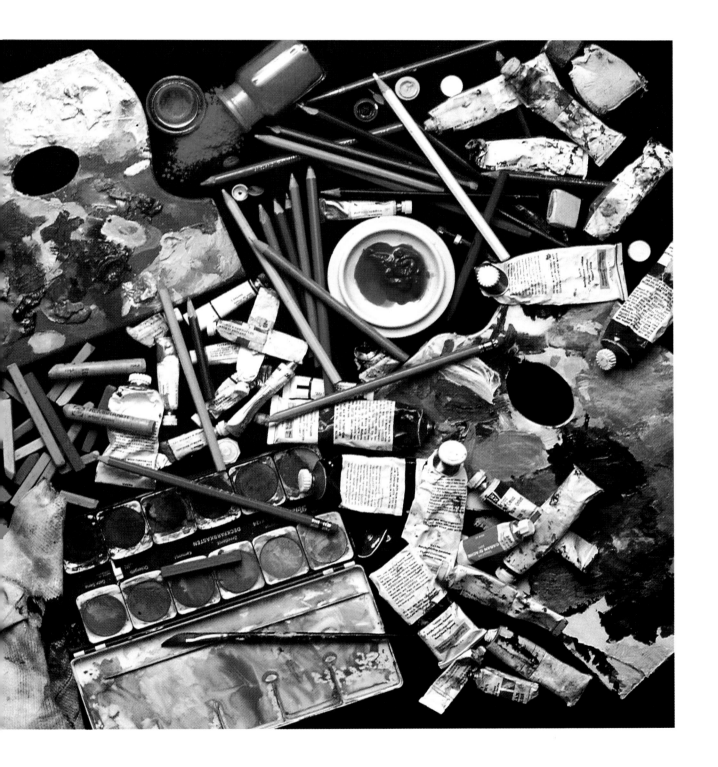

picture will look rather dead. There are points in the flow of movements, when the body is at a point of balance, appearing static or near static. These are also the times when the body will appear at its most graceful. They are the points to look for.

Focusing can also be a problem with a moving subject, and depth of field will be limited if you are shooting under poor light conditions, using a fast shutter speed. The repetition of action allows for pre-focusing and framing.

Photographing floodlit sport is covered in the 'Night' section of this book. Floodlight, although adequate for photography, is not the best light to describe the human form. The daylight found in dance studios and some gymnasiums, which is directional without being hard, is very much better. The body like any form is most interesting when there are areas of shadow to highlight and describe its contours. Outline is as important as detail, and if the lighting is inadequate for detailed photographs it can usually be used for silhouettes. This can be done where there is backlighting, or if the subject is against a lit or light background, by exposing for the background only. Attention, however, must be paid to the backgrounds so that nothing cuts into the subject's outline, or draws the viewer's eye away from the subject. A regularly patterned background, such as a series of parallel horizontal or vertical lines, will emphasize any foreground shape that cuts it.

Composition is also important; pictures of the human body taken from a sequence of actions should be dynamic, giving a feeling of continuity of movement. This is often achieved by asymmetrical composition where the balance of the picture is away from the centre of the frame. If, however, the aim of the picture is to show balance and rest, then a symmetrical composition will help.

The nude

The nude must be one of the most challenging and difficult of photographic subjects; it can be explored as an abstract form – a vehicle for lighting – or deliberately used to display human sexuality. It can even be a portrait, where the sitter just happens to be naked. No matter what your aims, the nude offers great opportunities for lighting and composition. As a subject for lighting it responds well to low light.

The type of picture you wish to take should be made clear at the outset, not only to make sure that the model has no objections, but also to involve the model in the mood of the project. Wherever you are working, make sure the model is as comfortable as possible; this includes being warm enough. Ask the model not to wear any tight clothing that may mark the skin before the sitting; ugly lines are left by elastic or straps, and they take a long time to disappear. If you are working in close-up, particularly with an abstract picture, they can ruin the result.

As a way of exploring form the nude can be treated abstractly, the body being viewed with regard to its textural qualities, tonal values, shapes and lines. Recognition is unimportant either as to what part of the body is being shown, or to the identity of the sitter – a fact that makes it easier to get a model to pose for this type of nude picture.

The different areas of abstraction can be explored individually, or combined into one picture. For the abstract nude a plain background is the best choice, but if texture or tone is being dealt with specifically, then contrast can be emphasized by placing the body against a background that has a strong textural quality of its own. The skin then acts as a foil against the roughness or smoothness of the background. Colour can also be exploited in this way.

The nude offers great opportunities for lighting. As already stated, shadow is needed to define form, and therefore, a natural, diffused, directional light is the best. If shape and line are the objectives, then more high-key frontal light can be used to reduce the body to linear forms. On a darker background, rimlighting can be very effective, allowing the body to go to silhouette with just the outline contours catching the light.

Use the full range of camera angles when photographing the nude on a plain background. As a form it will stand considerable distortion and, being something that we all recognize, it is interesting to see how far it can be abstracted.

For the naked portrait, as much as any other type, a relationship needs to be established between the sitter and the camera if the personality and character of the model are to be captured. If required, the naked portrait can be made to have erotic overtones. Once, however, you move away form the nude as abstract or portrait, and into the area of glamour or erotic photography, questions of taste and morality come into play. The vast majority of nudes seen by the public come under the category of the pin-up, and have little or no aesthetic merit. When we decide to take a nude photograph we need to be clear in our own minds what our intentions are.

Once the nude is placed in an environment, as with the portrait, this background will both change and add to the meaning of the picture. The model can be placed in an intimate part of the domestic scene, such as a bedroom or bathroom, or else in some less obvious part of the house – a kitchen or hall. These latter may have more erotic value as nudes are not normally seen there. The natural lighting of these situations can be exploited, as well as any domestic objects that come to hand. The nude seems to become more erotic with the addition of some clothing or covering, and, as with distortion, it is interesting to see how great an erotic effect can be achieved with how little nakedness.

Placing the nude in nature – photographing one natural form against another – is a common and effec-

tive theme. Photographing the nude outdoors, in the countryside or by the sea, or, if secluded enough, your own back garden, can increase the erotic effect, by placing the model in an unexpected context. If you wish to shoot outside, you may well find the only times you can use are the early morning and the night. In the countryside, or by the sea, it is possible to find secluded locations. There are public beaches where nudity is quite acceptable, but you will find there may well be objections to the use of cameras. When taking any photograph of another person you are better off working without an audience.

The questions of which lens and film to use will depend on the kind of picture you are taking. The nude has long been considered a classic black-and-white subject, because the subtleties of texture and tone can be considered without the dimension of colour. With colour you are likely to get wide variations of skin colour registering in the photograph. Such unevenness of skin colour can, however, be hidden with lighting and printing in black-and-white photography.

For the greater part of the history of the nude in photography it has been the female form which has dominated the subject, but today the male nude is becoming more widely accepted as a subject to photograph. For the non-professional photographer the difficulties of finding and establishing a working relationship with a nude model may prove too difficult. It is an area of photography with a long history, but is still regarded with suspicion by some. It is, however, worth pursuing, and once you have interesting and original pictures to show, you will find the problem of getting models less difficult.

STILL LIFE

This is an area where the objectivity of the camera can find beauty in the simplest of objects. Still lifes can either be constructed by the photographer, or discovered by chance. With the constructed still life the choice of objects and backgrounds is as significant as their composition and the way they are lit. Still life need not, however, be restricted to the studio, nor be purposely constructed for photography. Many interesting still life subjects can be found in the home, or beyond, amongst the everyday objects of the street. With the aid of a tripod and cable release it is possible to photograph in the dimmest light, using a fine-grain film to achieve high-quality results, with both colour and black-and-white.

Here the photographer's contribution is the discovering, framing and lighting of the subject. What we choose to photograph can be related to personal interest, or to an idea or theme. Found still life subjects are very numerous; from the recording of other peo-

ple's design – the way they lay out a market stall, or paint a truck – to the tin can crushed into the tarmac by the traffic.

Colour, tone, line, pattern and shape can all be explored. As there is usually no pressure of time with a still life, unless you are shooting with natural light, the picture can be composed and taken in a number of ways, exploring more than one facet of the subject. Even with a found still life it may sometimes be necesary to manipulate the subject, removing something that interferes with the composition or adding a reflector to enhance the lighting.

A subject area of found still life that I think is particularly rewarding is decay – the way the weather or time changes the texture and colour of an object. As well as looking outside, look around your home; there will be many items worthy of consideration. Look at the way books are grouped, or at discarded newspapers, the way a bed looks after use. All these things are photographic possibilities when viewed with a critical eye. Also look for places where the available light is interesting. If you decide to use a space as a studio, you must make sure that there is enough room in such a space to position a tripod and manipulate any lighting you might want to use.

Most forms of mechanical transport will prove interesting to photograph. The challenge is not dissimilar to taking a portrait; the character as well as the likeness has to be captured. All the many different considerations of portrait photography apply – the use of background, close-up and even movement. Low-light conditions are particularly good to shoot in, as is the aftermath of rain; raindrops on the metallic and glass surfaces, or the vehicle standing on wet tarmac, are good photographic ingredients.

There are a number of things to consider when selecting and constructing a still life. Is the picture to convey a particular meaning or idea? Does it aim to explore colour, tone or texture? Or is it purely concerned with composition and lighting? These decisions will affect the choice of objects and backgrounds. Objects may be selected for their generic relationship, their visual relationship, or for colour or texture. Whatever your intention always have as large a pool of objects as is possible. Even if you have a clear idea of what you want in the picture, you may find that changes to your original plan are needed once you begin to construct the still life through the camera. This applies to the background material as well. Moreover you must make sure that your background material will give adequate space to work on. If you are using an existing background or room setting, rough-out the extremes of the composition to check that you have given yourself enough space to work in.

When setting up the still life, first select your key objects for the composition. These are the things that will establish the structure of the picture. Until you gain

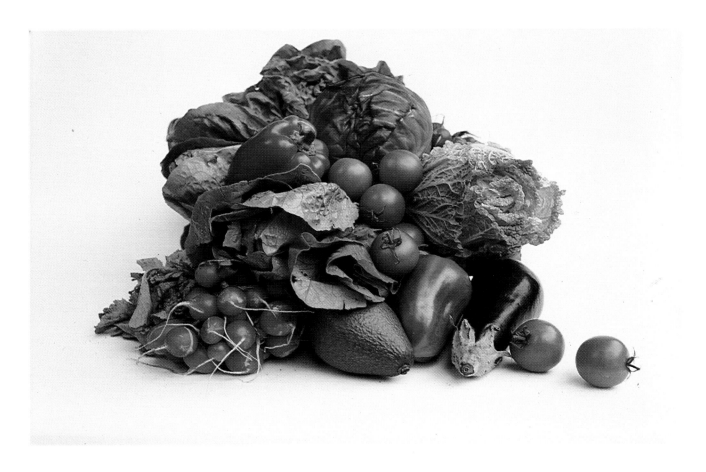

ABOVE AND LEFT *Having gone to the trouble and expense of selecting the materials for this still life, I made sure that I got as many pictures out of it as possible. These are just two of a number taken. A white background was set up in a shaded corner of the garden, and white reflectors were placed all around to get the shadowless lighting. (Kodachrome 64, Nikon 50mm: 1 sec – f11)*

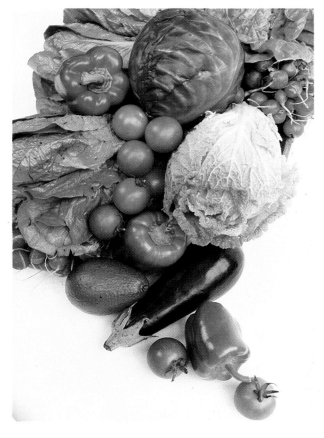

OPPOSITE *Often the minimum of information can give a picture its impact. Here the red traffic signal, reflected on the wet pavement, silhouettes the woman with the umbrella. (Fuji 400 rated at 800 ASA, Nikon 135mm: 1/60 sec – f2.8)*

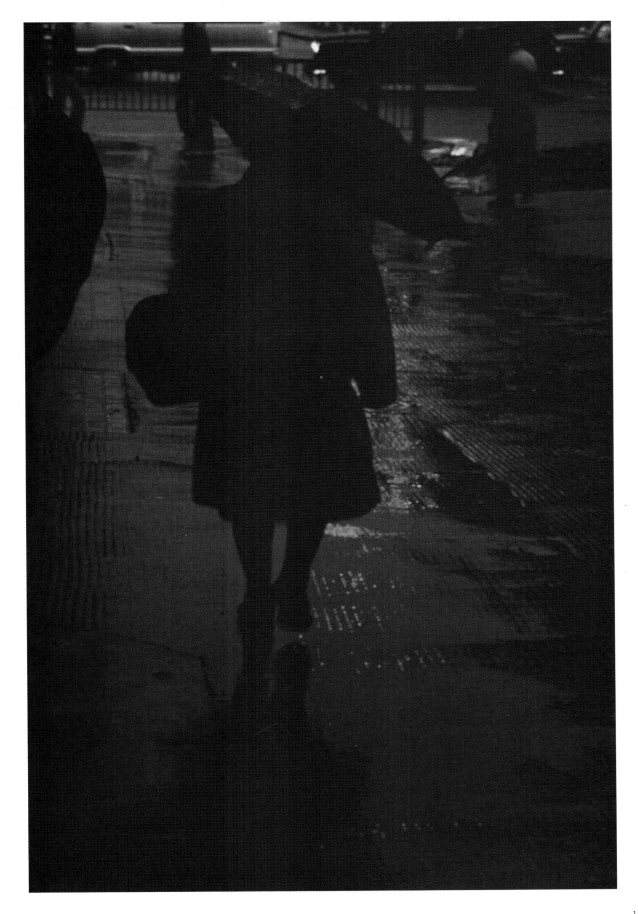

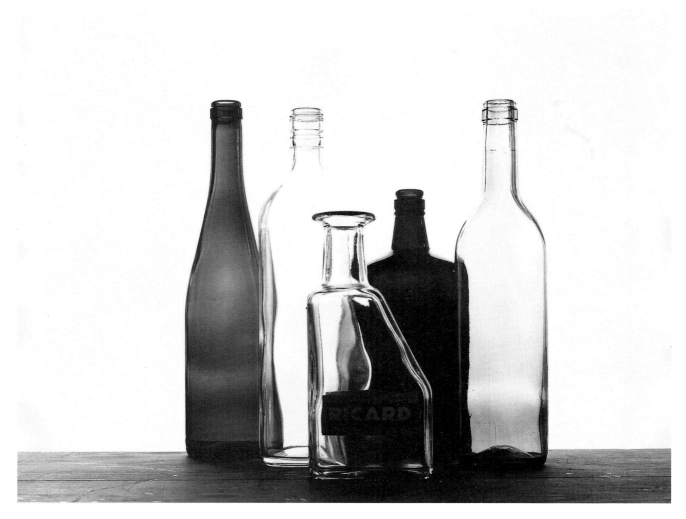

some experience of still life, keep your subjects simple – this is not a bad principle to start with when photographing any subject. Once you have done this, set up the working area and establish the relationship of background, subject and camera, making sure you have enough background to work against. It is best to allow more than you need in the camera viewfinder. Once the composition is established in the viewfinder, the camera can be moved in to reduce the volume of the background. A large background area will also allow for the subject to be positioned off-centre, if required.

For most set ups, work at table-top height, so the level of the camera can be altered easily. For a top shot it is best to place the objects on a board, so that the whole composition can be moved if required.

There are of course no hard-and-fast rules for lighting a still life. With the found still life the existing light should probably be an essential part of the picture. At times, however, it may be necessary to introduce a reflector, or some supplementary lighting, to enhance the available light. This may be needed as a fill-in when more shadow detail is required, or when the existing

ABOVE *In this still life the emphasis is on shape and tone. Only the white background has been lit, outlining the shape of the bottles. This is an ideal way to light glass, as it gives a darker outline and will also pick up some engraving and cutting on glass. (Plus-X rated at 125 ASA, Nikon 50mm: flash – f11)*

OPPOSITE *Outline shape is the basis of this picture. The right camera angle was necessary to catch the light bouncing off the frozen pond. (HP5 rated at 400 ASA, Nikon 35mm: 1/60 sec – f8)*

RIGHT *Making a story of a family event can be quite interesting. The following pictures are of a barbecue party. This first picture sets the scene before the party has started. Taken in the failing dusk light, it gives a richness to the food. (Fuji 400 rated at 1600 ASA, Nikon 24mm: 1 sec – f8)*

BELOW *Here the same table is shown from a different angle, with the guests arriving and the fire being lit. There is still some daylight to shoot by. (Fuji 400 rated at 1600 ASA, Nikon 24mm: ½ sec – f4)*

ABOVE *This shot was taken by the light of the flare, hence the strong red cast although it was shot on tungsten film. (3M 640 tungsten rated at 1280 ASA, Nikon 80mm: 1/30 sec – f2.8)*

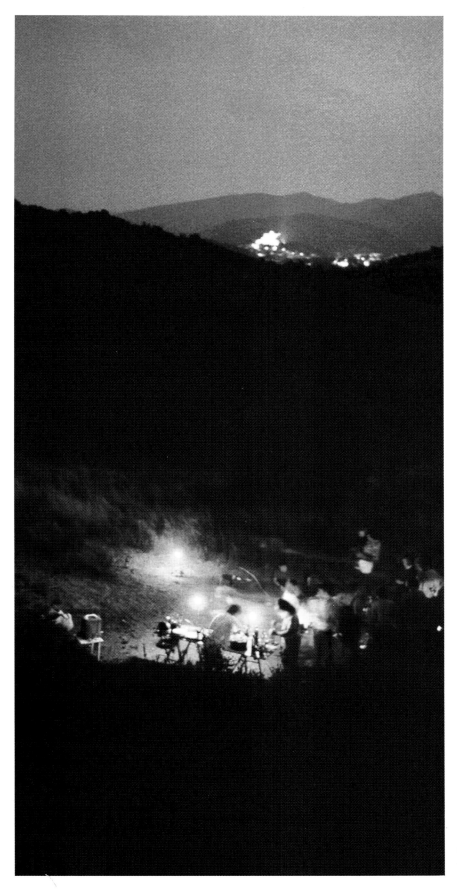

LEFT *Now the daylight has gone. This long shot sets the scene of the party into the surrounding landscape. (Fuji 400 rated at 1600 ASA, Nikon 35mm: 1/15 sec – f2.8)*

light is uneven. If supplementary lighting is used, care must be taken not to create secondary shadows. These can be particularly noticeable with isolated objects on a plain ground. If you are shooting in colour on transparency film, the light will also have to balance with the existing colour temperature of the light and film used. The constructed still life is a great way to study the effects of lighting. The subjects can be chosen for their qualities under light, and they can be photographed for as long as you wish, in as many ways as you wish. With the still life there is no model to tire or get bored.

Keep the lighting simple; start with one main light, and build around this, making sure that its original effect is not destroyed by any of the new lights. If the background requires its own lighting make sure that this does not spill onto the foreground subject.

Using a small flash unit, even one that is capable of taking three heads, has its problems even in the studio. The main difficulty being that you cannot see exactly what effect the light is having on the subject. If you intend to use flash in this way, a set of modelling lights will also be required to indicate the effect. There are quite cheap, domestic clip-on spotlights that can be used for this purpose. If you employ this method, and are shooting in colour, make sure that the working light is switched off during exposure, as you will be using daylight film with flash, and the tungsten light would create a colour cast. You may wish to work totally with tungsten light, and there are relatively cheap, clip-on floods available. Remember, however, that photographic bulbs and tubes are overrun, which means they have a short burning life and they get very hot. So handle them with care, make sure they are not placed too close to anything that could be damaged by heat, and run them only when needed. Using tungsten light with colour will necessitate the use of tungsten type film, or a conversion filter if you have daylight film in the camera.

Picture quality is important to the still life and, as there are no problems of movement, a film of a finer grain can be used; the medium-range films – 100–160 ASA – should prove adequate. If you are using flash, you may find the slower films will not allow you to stop down far enough to achieve the depth of field required. To overcome this, multiple flashing can be used. Each extra flash will allow a decrease in aperture of one stop. To avoid the risk of a multiple image, set the camera on bulb in a blacked-out room, and operate the flash by hand.

Having gone to the trouble of collecting and selecting material for a still life and setting up the lighting, make the most of the subject. Take a number of pictures varying the composition, lighting, and camera angle and position.

THE PHOTOGRAPHIC ESSAY AND PICTURE STORY

The photographic essay and picture story are collections of photographs linked by a common theme. The picture story has been with us for a long time, and stems from the picture magazine and the tradition of documentary photography. In recent years the picture essay, or thematic collection of pictures, has gained ground, with the proliferation of photographic galleries and the mass marketing of photographic books.

While all photographs are basically documentary, the term 'documentary photography' is applied to the recording of an event, place, or passage of time, that has some personal, social, or historic significance. The documentary series may be news-worthy but it does not have to be. The aim is not merely to capture *what* is happening in front of the camera, but also to reveal the emotions and reactions of the people involved, and the photographer's response to these.

The picture essay is a collection of pictures that have a common theme, but it need not follow any logical sequence, nor necessarily be seen in any particular order. It could be a photographic description of a place, including portraits, street scenes, landscape, architecture and still life; the sort of collection of pictures that we all take when on holiday. Holiday photographs could be presented either as a documentary series or as an essay. Most of the important social events in our lives are recorded photographically; weddings, holidays, visits to places of historic or scenic interest, make up a substantial part of the photographs taken every day all over the world. The family snapshot album is a documentary record of the development of a family and a collection of essays on different locations and themes.

Before undertaking a picture story or essay, decide what it is that interests you about the subject from a photographic and human point of view. Being specific will help the continuity of a picture story or give an essay more focus. The decisions you make in advance can also affect the equipment and film you choose to work with.

The photographic documentary story has traditionally been a black-and-white subject, as it originally stemmed from the demands of the picture magazines, which could only print in black-and-white. Rendering subjects in black-and-white without the interference of colour was, and is, thought of as a way of giving pictures a starker reality.

The documentary story is also considered to be an available light subject, involving much work in low-light conditions. Indeed part of the challenge of this kind of photography is the problems of gaining an exposure, and coping with the wide variety of light conditions.

If you are covering an event to which you have easy access, a visit can be made to consider any likely

technical problems, such as exposure, or filtration if you are shooting in colour. If you are able to do this, photograph in as many areas with different light levels as you can, using the film as a test. This test film will reveal if any up-rating or special development is required. Also consider possible camera angles.

With documentary photography you must be prepared to use a lot of film, particularly if shooting in low light. The success rate of usable pictures is low, and this is where pre-planning helps to conserve film, as well as saving time. Pre-planning will help you decide what equipment to use, so that you need take only the minimum, thus remaining as mobile as possible.

If you are shooting in a public place make sure in advance that photography is permitted. If it is not, ask for permission; you may find by doing this that you can gain access to areas not generally open to the public.

To make the most of available light you need fast lenses and versatile film; the lighting will vary from the flat, overhead light of a fluorescent strip, to pools of light, or the full glare of stage lighting. With colour you will need to remember the problems of mixed light, which constantly occur in low-light photography. Such things as a tripod and flash will have a limited use, and may prove a hinderance rather than a help. Not only are they heavy to carry but they also draw attention to the photographer, which is something you want to avoid if you are to get good pictures of people. Again pre-planning helps here; the photographer can spend less time checking exposures and deciding which lens to use at a certain point.

A good range of lenses is very necessary, the wide-angle and the telephoto being the most useful. There is a great temptation to use a motor drive on these occasions, but, unless the story involves fast action photography, it should be avoided. Motor drives are noisy and they use film at a fast rate. Part of the art of documentary photography is to judge the decisive moment at which to take a picture; using a motor drive goes against this ethic.

The photo essay does not usually have a chronological sequence, the pictures being held together by a common theme. They may be a collection of individual photographs linked only by a subject theme – a series of portraits, for instance. The condition of the light or weather can also be taken as a connecting theme. In an essay the photographer is presenting a number of pictures to be seen together so that they gain visual impact, or have more meaning than would the separated, individual images.

A theme we are very familiar with is the one of place. For the keen amateur, holiday time is perhaps the highlight of the photographic year, as time can be spent taking pictures. A holiday or trip can be treated as a documentary. It has a given time sequence, and can be photographed chronologically, but doing this on a day-to-day basis could prove more than a bit tedious. The photo essay is a better way of recording the events and places of a holiday. In this way holiday snaps, portraits, still lifes of local food, landscapes and architectural photographs, can be mixed to form an overall impression. In this mix, night and low-light photographs will have a role, showing familiar places at unfamiliar times.

Time itself is a good theme for an essay. An object or place can be photographed over a period of time, long or short, showing the effects of light, the weather, the seasons, and even the process of decay.

If you have undertaken a picture story or essay, care needs to be taken over its presentation. With black-and-white pictures the print quality should be compatible, particularly if the pictures are of the same location, or have common elements appearing in them. The tonal values of each print need to be matched to the whole set, even if the prints are looked at one at a time. The size of the prints has to be considered – are they all going to be same format and, if not, should they be on the same sized mounts? These problems need to be faced before you start the final printing.

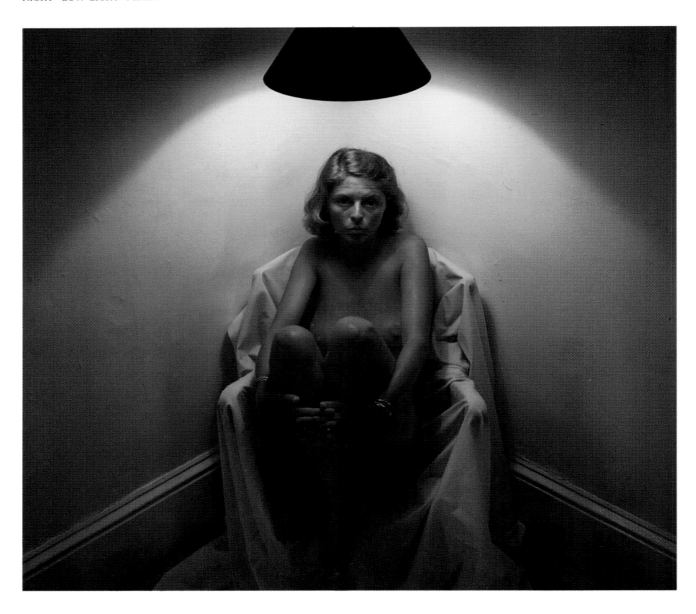

Almost any domestic light source can be used for photography. This nude in a corner under a light was lit only by a 40-watt bulb. The white sheet and the surrounding walls bounced back the light from the bulb. The strong red skin-tone is the result of using daylight film. (Kodachrome 64, Nikon 35mm: ¼ sec – f2.8)

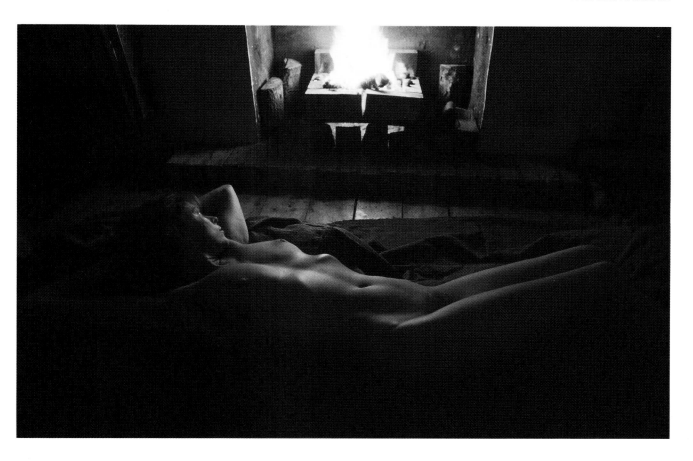

ABOVE *Here the only light source was the fire. This time tungsten film was used, but the skin-tone is still red. (3M 640 tungsten rated at 1280 ASA. Nikon 24mm: 1/60 sec – f4)*

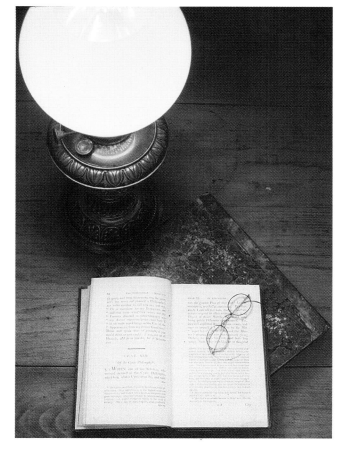

LEFT *Having a light source in the picture can create difficulties, particularly if the light is an important part of the composition, as it is in this picture. The exposure on the bowl of the oil lamp was one stop higher than the rest of the picture, I therefore used a brown graduated filter over the top half of the picture to even out the exposure. (3M 640 tungsten, Nikon 50mm: ½ sec – f5.6)*

115

This picture is one of a series taken on Derby Day. Unlike most Derby Days this one was wet and dull. I found that people were so intent on watching the racing that they were ideal subject matter. This is one of the few pictures in the series that gives an indication of the location.

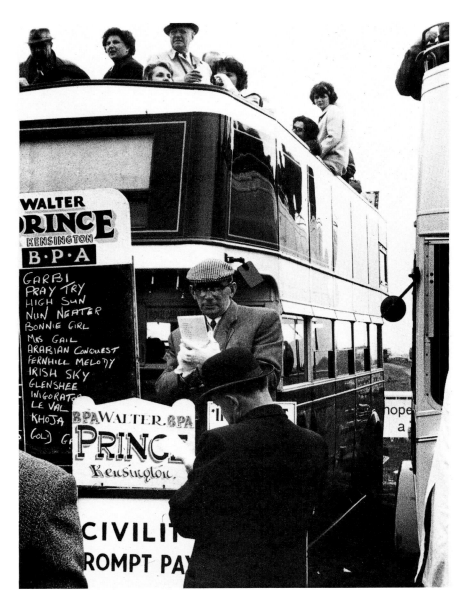

The newspaper headline suggests the occasion. Most of the pictures in the series are full of people and movement, which can be distracting in a photograph. Therefore a strong focal point is needed to hold the attention.

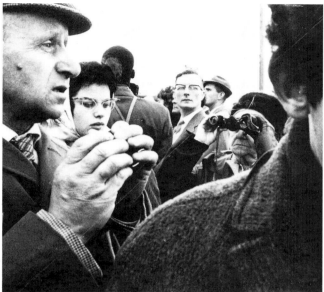

This is obviously a posed picture. When they saw me, these two buskers took up this pose; an interesting one, with one of them standing behind the other, adding depth to the picture.

This picture shows just how close you can get with a camera and not be noticed. The figures on either side of the picture contain the rest of the photograph, directing the eye into the scene. (Tri X rated at 800 ASA, Canon 50mm)

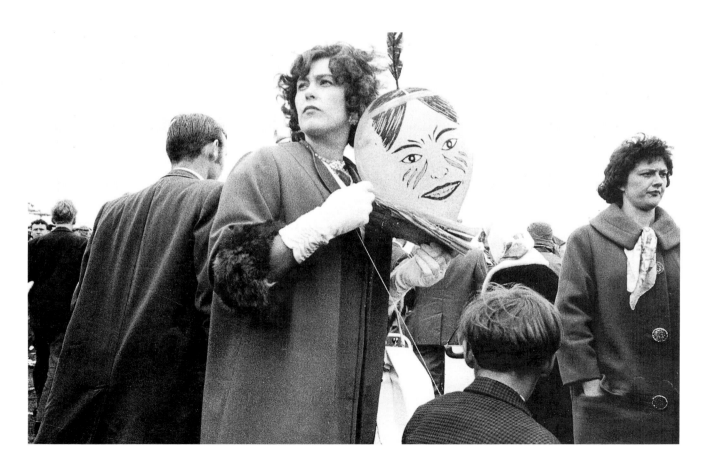

On occasions the humour of oddity in a situation catches the eye.

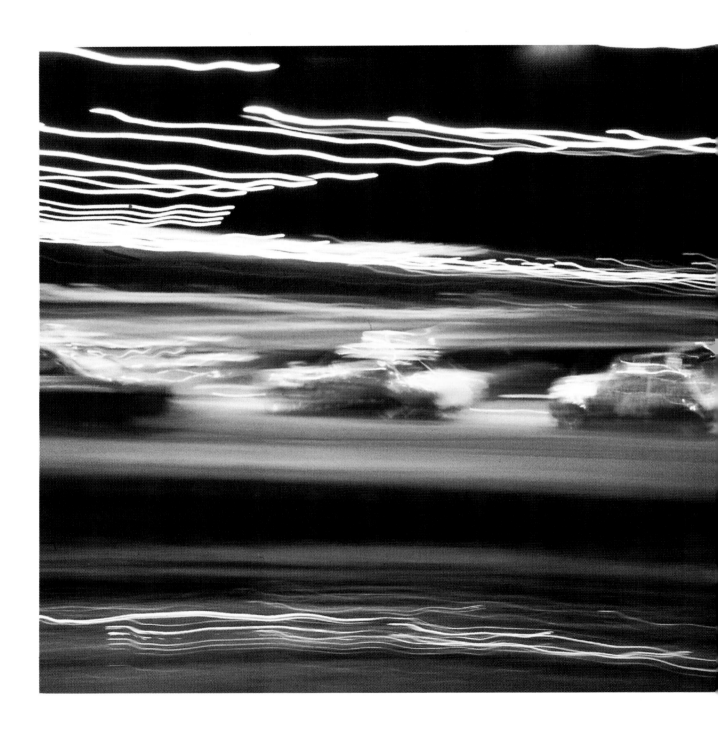

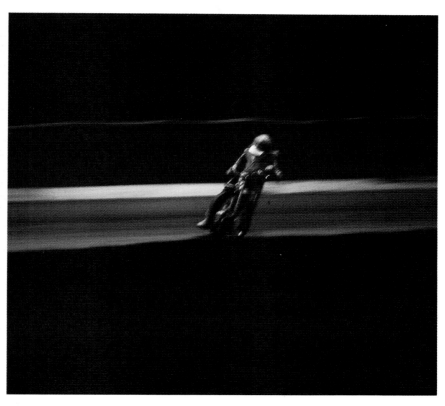

ABOVE *Although the pan was smooth, the bike was juddering around the bend. (Ektachrome 400 rated at 1600 ASA, Nikon 135mm: 1/30 ASA – f4)*

LEFT *This picture of a hot-rod race at night was taken using the Ernst Haas method. (Ektachrome 400 rated at 1600 ASA. Nikon 24mm 1 sec – f8)*

5 NIGHT PHOTOGRAPHY

INTRODUCTION

As our visual perception of the world is for the most part based on what we see during the hours of daylight, our natural expectation of any picture, including a photograph, is to see the subject rendered in clearly defined detail, as if lit by bright sunlight. In such high-light conditions the shadows created by the sun define a subject's shape and form. At night this does not occur. Apart from the moon, the only light sources are artificial, and their light defines shape and form against the dark, unlit areas of the picture. With the clutter of the daylight world stripped away, composition can become easier, as only limited areas of the picture are defined by light, with even these areas having a very limited colour or tonal range in photographic terms.

The necessary camera equipment will be much the same as for low-light photography. A lens hood is essential, as you will often be photographing into the light, or light sources will be appearing in the picture. A lens hood will reduce the risk of flare. For some subjects a camera stand and cable release will be required. The other essential is a pocket torch (flashlight), which can be used to set camera controls by, and to light up a subject for focusing. It is particularly useful when using flash, as it may be the only way to get an idea of the effect that the flash's light will have upon a scene.

The subjects of night photography are numerous; at night, using flash, any subject from a still life to a nude can be isolated against a sold black background. There are many pastimes and leisure activities that take place at night. Most sports are played under floodlight, indeed some indoor sports are only seen under floodlit conditions. The light levels at these occasions, and at events like pop concerts, are adequate for photography, if the right film is used. At such events, flash should be avoided, as it is rarely sufficient for lighting a subject at a distance from the camera, and is also irritating for both spectators and participants. In many venues where photography is permitted, the use of flash is strictly forbidden. Displays of light, such as funfairs, seaside illuminations, advertising signs and, of course, fireworks, all make interesting photographs.

A word of caution; if there is a black background in the photograph, care needs to be taken after the film is processed that the picture is not cut into, as the edge of a negative or transparency between the frames will not be visible. If you are sending such pictures for ouside processing have them returned intact as a roll, so that you can make the decision on cutting.

The main problem for the night photographer is knowing how much detail can be captured on film. The eye is able to define shape and detail in the dimmest light, but the normal sensitivity range of photographic materials is limited. Because the night photograph lacks the detail seen in a picture taken under daylight conditions, tonal separation becomes more important in those areas that are defined by light, and an understanding of the ways black-and-white film responds to colour becomes more critical.

The essence of night photography is light, which for the most part will be from artificial sources. Outside, such lighting will usually radiate in all directions and, having few or no surfaces to reflect from, will fall off abruptly at a short distance from its source. The inverse-square law governs the intensity of the light in relation to the distance from light to subject. For instance, a light at ten feet (3m) from the subject will be four times as strong as the same light at twenty feet (6m). Invariably the pictures will be contrasty, with pools of localized light surrounded by dark, featureless areas. The light sources themselves will become visual elements of the night picture, at times being the very subjects of the picture.

With black-and-white the problem is to overcome the naturally contasty nature of the subject. Fast panchromatic film has a softer graduation than a slow or medium-speed film, and will generally give better results, even on a long exposure, that a finer-grain film.

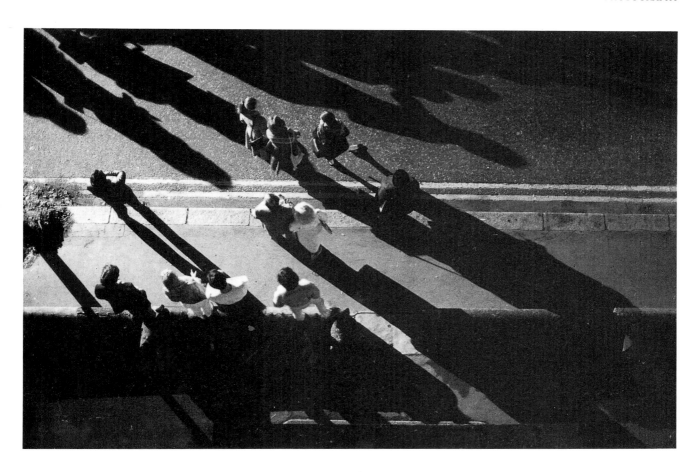

Strong directional light makes this picture dramatic. The group of people are waiting to see a famous ballet dancer leave the theatre. Their shadows cut across the pattern of parallel lines that run up the picture.

If a quality result is required, there are a number of fine-grain developers available. The combination of exposure and development will vary according to the subject. Where light sources appear in the picture, too much exposure or development may give poor results, on the other hand where there are no lights appearing, a generous exposure will give maximum shadow detail, and a reduction of the development time by twenty-five per cent will reduce overall contrast.

The new chromogenic black-and-white films, which are based on colour-negative technology, respond well to tungsten light because they have a higher sensitivity to red than the normal black-and-white film. This, combined with their wide exposure latitude make them particularly good for night photography.

Night photography has, until recently, been seen as a black-and-white subject, but all the new developments in black-and-white film come from colour technology. There are in fact more high-speed colour materials generally available than there are black-and-white. Colour film in now available in speeds up to 1600 ASA.

Combined with push processing, this means that transparency film can be rated-up to as much as three stops with acceptable results. At three stops the working speed becomes 12 800 ASA., It is therefore possible to take colour photographs under almost any light conditions and get some sort of result.

As with low-light, night photography has to be approached from a subjective point of view. If objective clarity and colour are required, then some kind of lighting will need to be used.

It is impossible to give a fixed formula for correct exposures at night, as every subject will have its own requirements, and most subjects can be interpreted in many different ways. If light sources appear in the picture, the minimum exposure will register a pattern of points of light and nothing else. If the exposure is extended, more shadow detail will appear on the film. It is possible, where there are no light sources in the picture, to increase the exposure on a subject, to a point when the picture looks as if it has been taken in daylight. In most cases, however, there seems little point in doing this as it would destroy the night effect. For the majority of night pictures the exposure lies somewhere between these two extremes. With black-and-white photography, further controls can be applied when processing and printing, by the choice of developers and grades of paper.

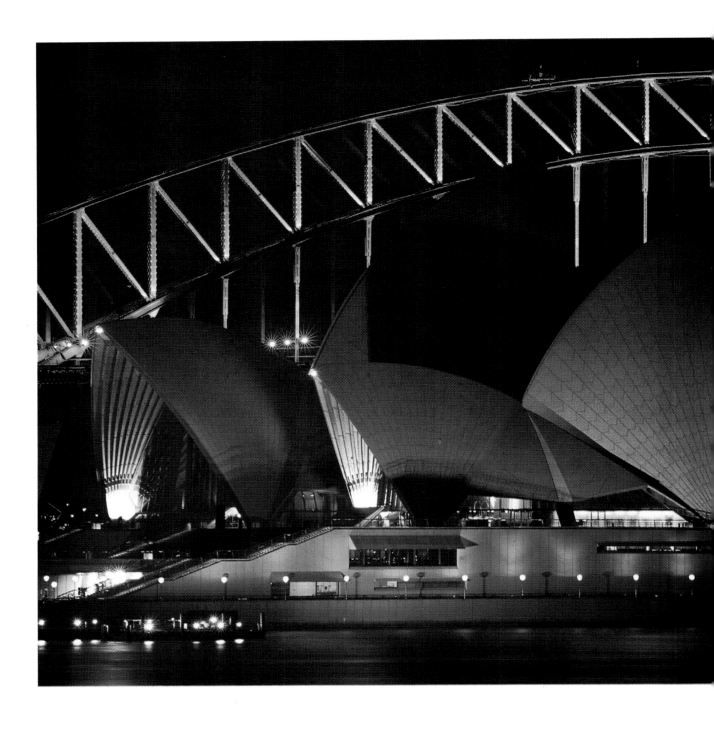

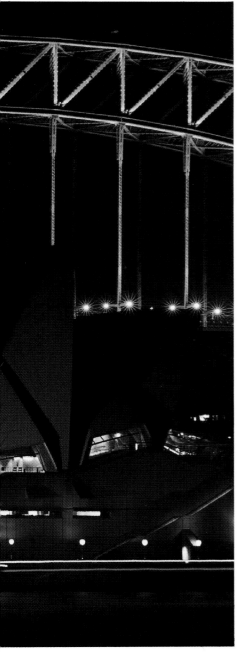

ABOVE *To keep any real detail some remaining daylight was necessary in this picture, but it looks like a night picture because of the flood lighting and street lights. (Ektachrome 400 rated at 1600 ASA. Nikon 180mm: 1 sec – f4)*

LEFT *The distinctive shape of the Sydney Opera House makes it an ideal subject for night photography. The sail shapes contrast well with the grid structure of the Sydney Harbour Bridge.*

Lighting

Scenes photographed purely by moonlight are reduced to their simplest elements; without the presence of artificial lights, colour and detail disappear. The emphasis of the picture is on basic shapes. With the illumination coming only from the sky, the landscape will register as a silhouetted skyline. On a clear night with a full moon it is possible to take a photograph using the moon as the only source of illumination, but the subject needs to be light in tone or colour, and the camera positioned to avoid shooting towards the moon.

To retain some detail in a landscape picture, the best time to photograph is while there is still some daylight present in the sky. The scene can be made to look as if it were a true night shot by slight underexposure. The sky at this time will have a luminous glow that will photograph well in both colour and black-and-white. As at any other time, cloud will help break the monotony of the sky. Likewise, you get the same exposure problems if the moon appears in the picture as you do with the sun – the moon after all is reflecting the sun. An exposure made for the moon will leave the rest of the picture without detail unless there is some reflective surface in the scene. Reflective surfaces become very important at night, as they are often the only way to break up an otherwise featureless foreground.

In very low light, such as moonlight, you will find your camera's built-in meter will not register a light reading; a much more sensitive meter, such as the CdS type of hand-meter, is required. Even with this meter you may find that a reading cannot be obtained in the normal manner. If this is so, get a piece of white card, take a reading from this, and multiply the result by six. With a long exposure – twenty seconds or more – keep the moon out of the picture; it will either burn out, or appear as a blur, because it moves through the sky.

With black-and-white film, very long exposures are possible, but with colour there is the problem of reciprocity. On very short or very long exposure, the exposure needs to be increased after a certain point, by up to three times the given length. With daylight or short-exposure colour film, the reciprocity factor starts to apply on exposures longer than one second. Reciprocity not only affects the exposure, it also affects the colour balance of the film.

Apart from the moon, all sources of light at night are artificial, and such artificiality should be played upon, with any lighting being used in a dramatic way. The kind of lighting that would be considered harsh and unacceptable when mixed with natural or available light at other times, will not look out of place at night. Strong directional lighting that gives hard shadows can be put to very good use for night portraits.

To avoid blurring around the edges of the subject during longer exposures, the camera should be placed on a stand and the subject asked not to move during the time exposure. Blurring, however, can be deliberately used to give the effect of movement or to add interest to the picture. This ghosting can be achieved either by asking the subject to move during the exposure, or by moving the camera.

The most convenient form of lighting is electronic flash, although other forms of lighting, traditional and unconventional, can be used. The headlamps of a car or motorcycle, candles and garden flares, and that essential tool for the night photographer, the pocket torch (flashlight), can all give exciting results. Flash can be used at night in the same way as at any other time, but its effect will be more dramatic. If you wish to have a greater degree of control over the finished picture, an off camera unit will give the best results.

Flash can be used most creatively at night, when there is no other light; a subject can, by careful lighting and cropping, be totally isolated in a sea of black. At night any dark, open area, indoors or out, can become a studio, giving the photographer total control over lighting, and allowing him to use such techniques as multi-flashing and multi-exposure.

Flash can also be used as a fill-in light when a reflector proves inadequate, but it is difficult to balance the exposure demands of the flash against the exposure demands of the available light; this applies to both black-and-white and colour. A film selected for its speed when shooting with available light may be unworkable with flash, and another film will have to be chosen that is compatible with flash use. This film will need to give you a workable aperture and a flash-to-subject distance that gives the kind of lighting effect you want. Once a working aperture has been established, light readings can be taken to gauge the available light exposure at that aperture. The synchronization on the camera can be used at speeds slower than the one indicated, even on bulb. It is therefore possible to make a time exposure that will include a synchronized flash. The flash will fire at the beginning of the time exposure, this will fix the main part of the image, while the rest of the exposure allows for the available light.

Apart from the difficulty of balancing a mixed exposure, there are other problems with using flash at night. If you are using a shop window, or some other form of brightly lit interior behind glass, as a light background for a head or figure shot, and flash is used to avoid silhouetting, watch out for flare or reflections in the glass. Any flare, however, may not be apparent until the pictures are processed. By placing a pocket torch in the same position as the flash head you can, however, get an indication of possible flare, and the light can then be adjusted to avoid it. If it is not possible to adjust the flash position, the torch can also be used to set a polarizing filter on the camera, thus reducing the flare or reflection. But do not forget to allow extra exposure if a polarizing filter is used.

When using black-and-white film be careful that the

subject does not blend into the dark background; subjects with dark hair or clothing are likely to do this. Some form of back lighting may be necessary to help separate the subject from the background. When using flash with colour you will have to use daylight film, or a conversion filter on tungsten film, because electronic flash is balanced to daylight colour temperature. If you are mixing a flash exposure with artificial light, a colour cast will result in those areas where the artificial light appears in the picture. Reciprocity failure will also create changes in colour on those areas that have exposures longer than a second. As most light sources give a warm cast on daylight film, the overall effect should be quite pleasing.

Movement

At night or in low light you will find that the choice of shutter speeds and aperture settings is restricted. This will be most obvious with moving subjects. Even if ultra fast up-rated film is used, there will be times when the shutter speed is not fast enough to stop action. This should not deter you from attempting to photograph fast moving subjects; try to turn this limitation to your advantage.

In the early 1950s the American photographer Ernst Haas found himself under failing light conditions with a slow colour film in his camera. He continued taking pictures using the panning method, but with shutter speeds much longer than normal. He found the results intriguing and went on to develop the method. The evocative but recognizable blur has become a hallmark of an Ernst Haas photograph, and is now a method employed by many other photographers.

The virtue of panning in the normal way, using a shutter speed of 1/30 to 1/125 of a second, is that the picture suggests movement as well as giving a fairly detailed shot of the subject. When panning, the background needs to contain some detail to produce an interesting blur as a foil to the subject; if the background is too plain the effect of panning is diminished. This is a problem when panning in the normal way at floodlit races, as there is no background – just darkness, and this is where the Ernst Haas method can be more effective.

Movement can also be simulated if you wish, and a static subject made to look as if it is moving. This is done with a zoom lens. Set the camera on a stand and use a relatively slow shutter speed – 1/8 of a second. Let the subject fill the frame with the lens set at its longest focal length, then zoom back while the exposure is made. With some practice it is possible to combine this method with panning, to create quite interesting effects. Coloured lights and internally illuminated signs are ideal subjects to photograph using camera movement or zooming; points of light become lines or arcs of colour, depending on how the camera is moved.

THE SKY AT NIGHT

For those with a passing interest in photographing the night sky it is possible to do so with standard photographic equipment, but for more accurate photography of the moon and stars a telescope mounted on an equatorial drive is needed.

With all astronomic photographs the main problem is the Earth's atmospheric turbulence, which produces blurring of the image. As the stars are only points of light, this has little or no effect on the picture, but the moon and planets are much closer, and detail is possible when using a telephoto lens, so it can affect the result. The best time to shoot is when the moon is at its highest in the sky, which means there is the least amount of the Earth's atmosphere to penetrate.

If you are photographing the stars, choose a clear moonless night. With a stationary camera star trails can be photographed. The stars appear to move across the sky; because of the Earth's rotation, any exposure longer than twenty seconds will create a blur. By giving a long exposure you can turn the movement of the stars to advantage. With an exposure of two minutes or more, the points of light – the stars – will become streaks or trails on the film. Once the film is processed, you can judge the effectiveness of the exposure by how clear the image trail is on the film; adjustments can then be made the next time you take star pictures. The lens should be focused on infinity, and the camera mounted on a tripod to avoid camera-shake. Even with star trails it is possible to distinguish the different constellations and star formations. Man-made satellites can be recorded this way, and they will leave a continuous trail right across the picture.

To get more accurate and detailed photographs the camera will need to be mounted on an equatorial drive. This rotates the camera or telescope at the same speed as the Earth's rotation, with the axis of rotation set parallel to the Earth's axis. This means that the camera-to-subject distance is effectively the same, and long exposures are possible without the danger of blur. Furthermore the camera can be mounted on to a telescope, either by means of an adaptor, that positions the film plane at the focal plane of the telescope, or by fitting the camera directly on to the eyepiece of the telescope.

If, however, you are using the camera off the telescope, it is possible to give added depth to a picture by having some foreground detail or by framing the sky with a silhouette.

A medium-speed film will give good picture detail when photographing the moon and the planets, but a faster film can be used with star photography, as there is no detail to register.

Information as to the occurence and position of astronomic and man-made bodies can be found in scientific publications, and the more spectacular

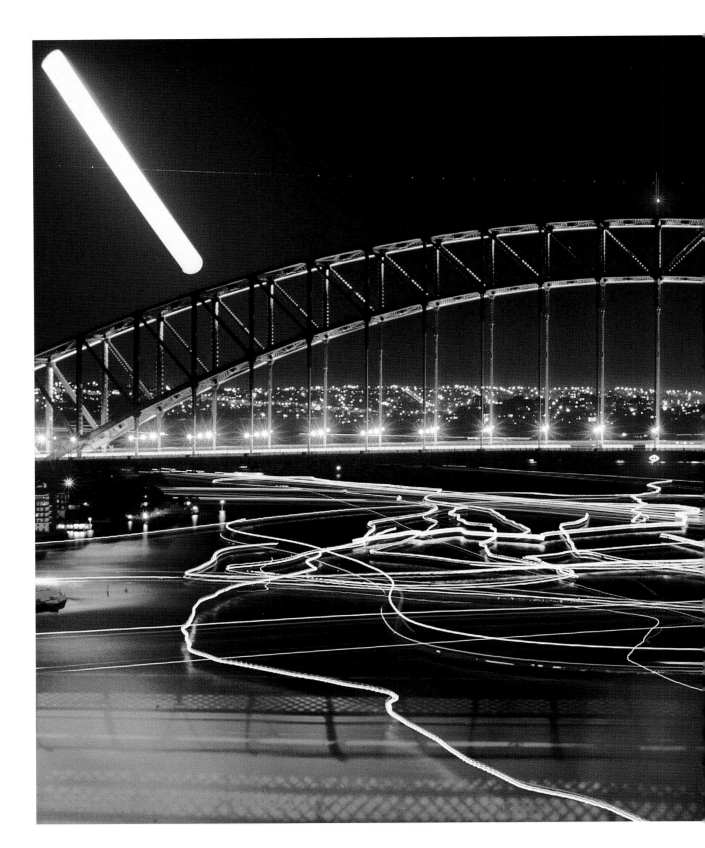

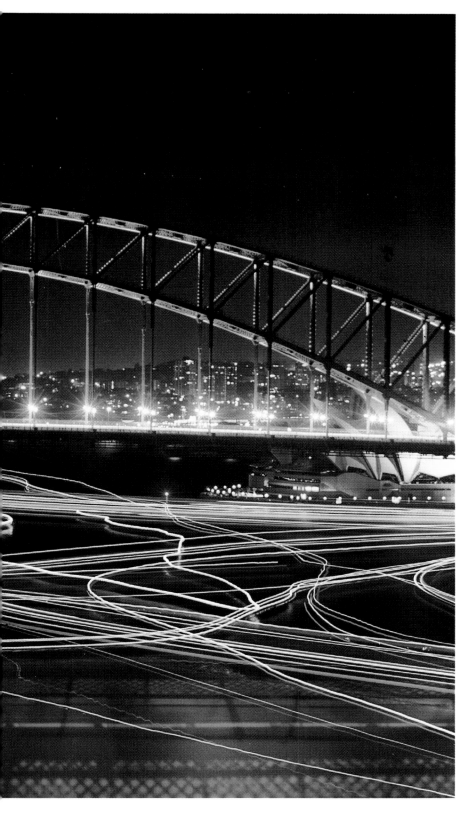

This picture shows the many interesting patterns of light that can be gained from a time exposure. The snaking trails below Sydney Harbour Bridge are boats moving in the harbour. The white streak in the top left-hand corner is the moon, and the broken dotted line in the sky above the bridge is made by the landing lights of an aircraft.

It took two attempts to get this picture of the moon. On the first attempt the film was completely overexposed and there was no detail in the moon. The exposure was taken from the camera meter, which gave a reading of 1/60 sec at f8 using 400 ASA film. I used this as a basis for the second picture, taking 1/250 sec as a starting point as I thought the first pictures where about two stops overexposed. The correct exposure turned out to be 1/250 sec – f11. (Tri-X 400, Nikon 300mm with a two times extender, equivalent to 600mm lens)

comets and eclipses will usually be publicized well in advance by newspapers as well as the specialist publications.

LANDSCAPE

Because the night picture often relies mostly on artificial light, its main subjects will be in the man-made environment – urban scenes and industrial sites.

Industrial landscape

The large industrial and commercial complexes that operate twenty-four hours a day are very exciting, not only because they are so photogenic, but also because they are unfamiliar as subjects.

The larger industrial sites are usually situated in almost open country, which gives the opportunity for taking landscape shots as well as close-up details of the structure. As they operate on a twenty-four-hour basis they will be floodlit, and many such complexes are also situated on or close to water. Both of these elements lend interest to the picture.

Of all industrial complexes the refinery is among the most rewarding to photograph. The structure is a complex of gantries, towers, storage tanks, and stacks for burning-off gas or releasing smoke and steam. Moreover much of the pipework and structure is colour coded. The combination of metallic structures, reflective surfaces, colour and light, make this an impressive subject. Similar complexes, such as distilleries and

power stations, are good alternatives. The other areas that provide good subject material are transport termini, docks and airports being the most interesting. All these subjects will photograph particularly well in adverse weather.

It is possible to photograph from outside the perimeter of such places and still get good pictures. Many of the public places mentioned – railway termini, docks, and airports – do not officially permit photography, and permission should be sought before taking pictures. You will find this a constant problem with many interesting night photography locations but, apart from at the more secret commercial and military installations it is usually possible to gain permission to take photographs.

Architecture

Many important public and historic buildings are floodlit at night, and they look much more dramatic than they do during the day because the surrounding areas are swallowed up in the darkness. Most buildings are floodlit from the base,with the lights directed up at the building from a distance. There should not be too much of a discrepancy in exposure value from the base to the top of the building. There will, however, be a chance of overexposure at the base if the lights are visible in the picture, but this can usually be avoided with careful framing and camera positioning.

Most of the areas of interest in large towns and cities – river fronts, bridges,, squares – will have decorative as well as street lighting, and these lights can be photographed for their own sake. Shop fronts and advertising signs can also be treated in this way. When specifically photographing the lights, the built-in meter on your camera will give a false reading unless the light source is filling the frame. As most built-in meters are designed to give an overall reading with a central bias, any light source that appears in a picture will be overexposed. By putting a telephoto lens on the camera, and filling the frame with the hightlight area, you can, however, then transpose the reading given to any lens you may be using. In this way you can take a detailed reading off any area of the picture, and work out a variety of exposures depending on what results are required.

When photographing plain white lights, colour can be added by using either coloured filters or diffraction filters. The different kinds of refraction and diffraction filters work through a prismatic effect, creating chains of light and colour, or a starburst of colour. When photographing just lights, try varying degrees of focus, camera movement, and multiple exposures. All these can be combined on to one frame if you wish.

Cities and towns

In the city or town, the amount of light and its quality will vary considerably depending on the area you are in. These variations will depend on the function and character of the area. In a modern city centre, with large glass-fronted office blocks, the light levels will be quite high, whereas residential areas will have more subdued lighting. Many towns and city centres have shopping malls and precincts that are lit to quite high levels, with added light coming from store windows and advertising displays. Light sources vary from this blanket effect, to the more scattered lamplight of residential areas, where the light appears in pools breaking the darkness.

When photographing in a built-up area it is likely that lights will appear in the photograph, and when light sources appear in a picture they are bound to show some signs of halation – a diffused halo around the bright areas of the subject. The effect becomes more apparent with overexposure, and most often occurs in pictures that include lights, but require some shadow detail as well. The halation is caused by the light passing through the film emulsion and bouncing off the camera back or film base. Avoiding lights, or shading the light by silhouetting, is the only way to overcome or reduce halation. If it cannot be avoided then try to make a virtue of it.

Where lights appear there is a limit to the extremes of exposure that the film can cope with. If you want shadow detail you must allow for overexposure in the highlight areas, although this can be reduced by cutting the development times, and also with different combinations of film and developer. The best way to do this is to make a comparison test on the same subject, using the different combinations and by comparing the end result, find the one you consider the most pleasing. Flare is the other thing to watch for when shooting into the light. It is more apparent in the camera than halation, and can be overcome by using a lens hood at all times and altering the camera angle. Flare can be used for effect, particularly with backlit subjects.

Traffic at night, whether stationary or moving, will create light patterns that can be photographed. With a long exposure the car lights will appear as a continuous band or streak. If you wish to take a picture in this way look for a vantage point that will give an interesting composition; perhaps at a junction where a road splits in a number of different directions. In all cases the view should be from above, looking down onto the traffic, or from an incline where the traffic is not level with the picture plane.

PEOPLE

In a city or town there is just as much to photograph on the streets at night as there is during the day. The cover of darkness makes the photographer less conspicuous, and pictures can be taken without the subject's knowledge. Moreover most people think that photography at

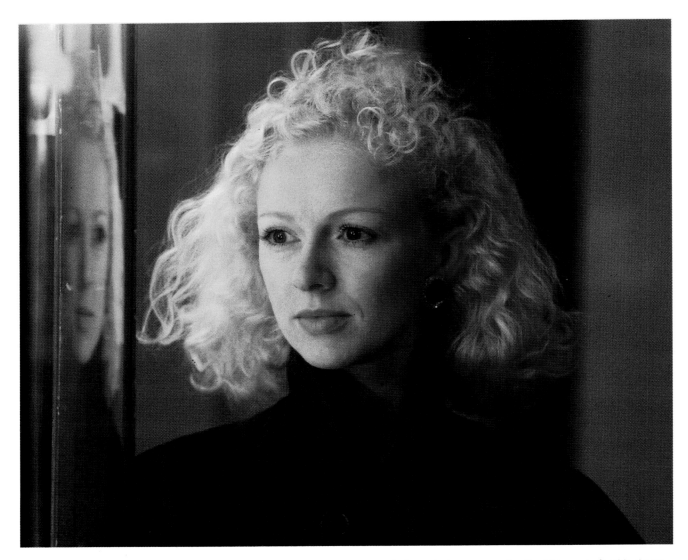

ABOVE *A shop window was used as the light source for this picture, and there was the added bonus of the subject's reflected image in the shot as well. (Ektachrome 400 rated at 800 ASA, Nikon 80mm: 1/60 sec – f4)*

OPPOSITE *This picture was taken with the available light from a street lamp and the light in the telephone box. The juxtaposition of the naked woman, the telephone box, and the night makes an exciting picture. (E 3M 640 tungsten rated at 1280 ASA, Nikon 50mm: 1/60 sec – f4)*

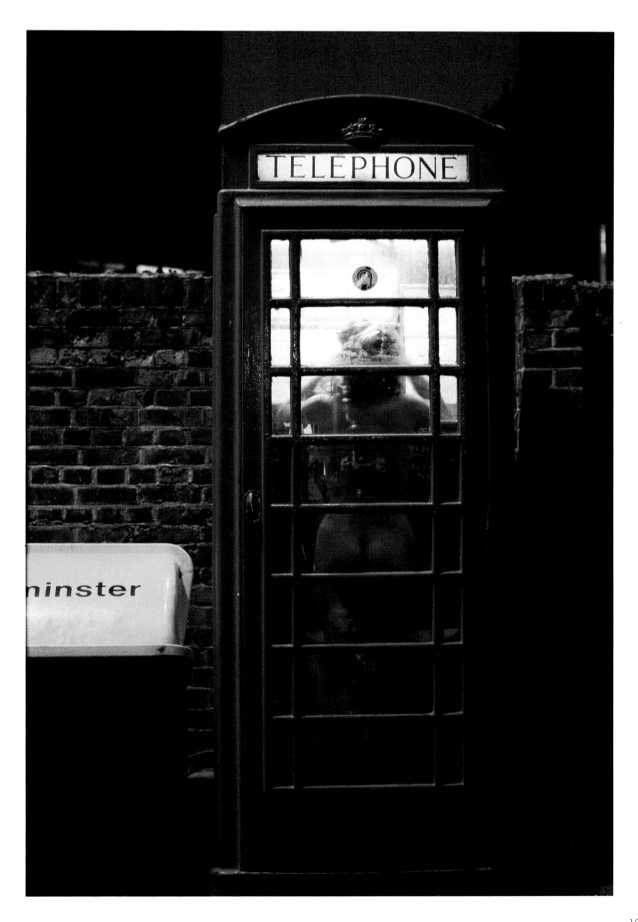

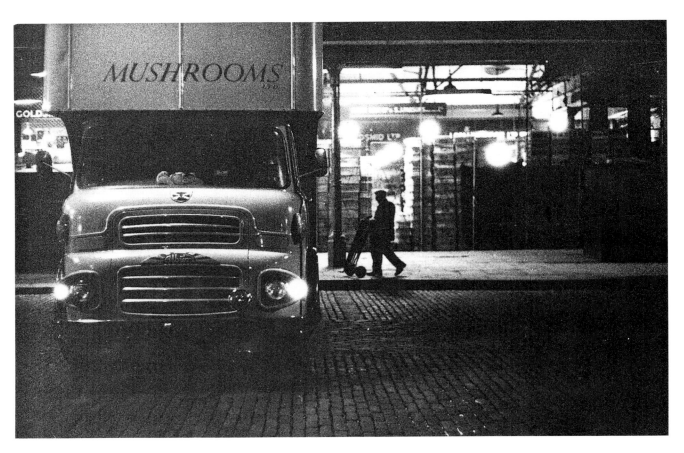

There are many activities that go on during the night that can make a good picture story. Photographing in the street at night means using up-rated film and fast lenses at maximum aperture. These pictures were taken in the old Covent Garden, which operated in the streets around the Opera House in London. Here the wording on the van and the stacks of boxes suggest the location. The figure of the market porter is positioned against a light area of the picture. (Tri-X rated at 3200 ASA. Canon 50mm: 1/60 sec – f2)

night is impossible without using flash, and so are likely to ignore you even if you are noticed. Subjects that have pronounced contrasts of light and shadow, or where the light has a definite directional quality, give the best results; the flat light of shopping precincts gives poor results with both colour and black-and-white.

Because of the limits of exposure, it is possible to isolate an individual figure, even in a crowd. The limited range of shutter speeds and apertures available can be put to good use with selective focusing.

Movement can be used to isolate an individual figure, as well as to give direction to a picture. A crowd of people moving in the same direction can follow a regular or irregular pattern, and this flow can be broken by a single figure crossing it or going the opposite direction. Find different vantage points – both high and low – to take pictures from. Look for different aspects of the human figure that make accidental patterns. The stacking effect of the telephoto lens will give a feeling of a solid wall of bodies advancing towards or away from the camera, while the wide-angle lens will give a feeling of the crowd engulfing the camera.

A well-lit shop window provides an ideal background for a night silhouette, either of an individual or a group. The limitations of light will again allow selective focusing and the use of slow shutter speeds, to give emphasis and direction to the picture. The shop win-

dow will also provide lighting for close-up shots of heads or single figures. As the subject's attention will be fixed on the window, quite close shots can be obtained. In some cases, where there are free-standing displays, it is possible to have the subject looking straight at the camera without being aware of its presence. Such close shots are also possible wherever people are engaged in a shopping transaction, as at a street market or bar.

People sitting on the platforms of railway and subway stations, and on trains and buses, provide good material for individual or group studies. Although the people are close together in a public place, there is often a feeling of alienation abou the scene. Pictures can be taken from both outside and inside the trains or buses.

Portraits

When taking a portrait at night, the whole atmosphere of the night must be exploited; do not try to make the

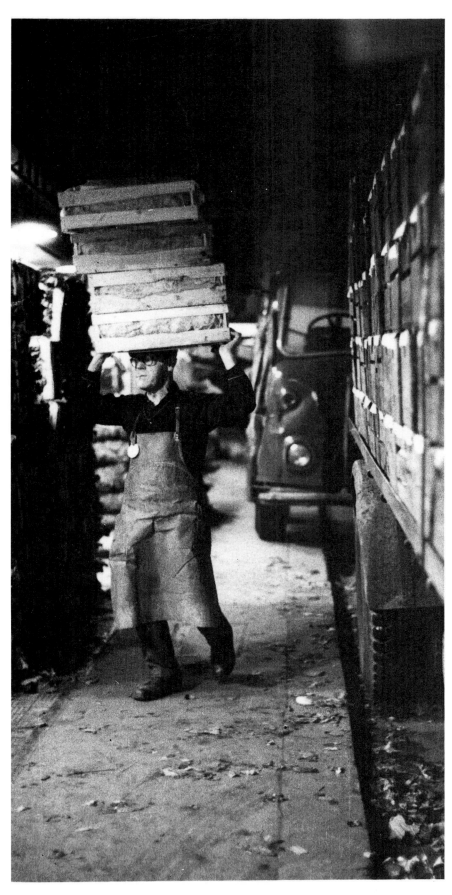

The light from the shops can be used to give extra lighting, as the street lights are very low. Here again the porter is positioned to prevent him from blending in with the background. The parked vehicles give the picture depth. (Tri-X rated at 3200 ASA, Canon 50mm: 1/125 sec – f2)

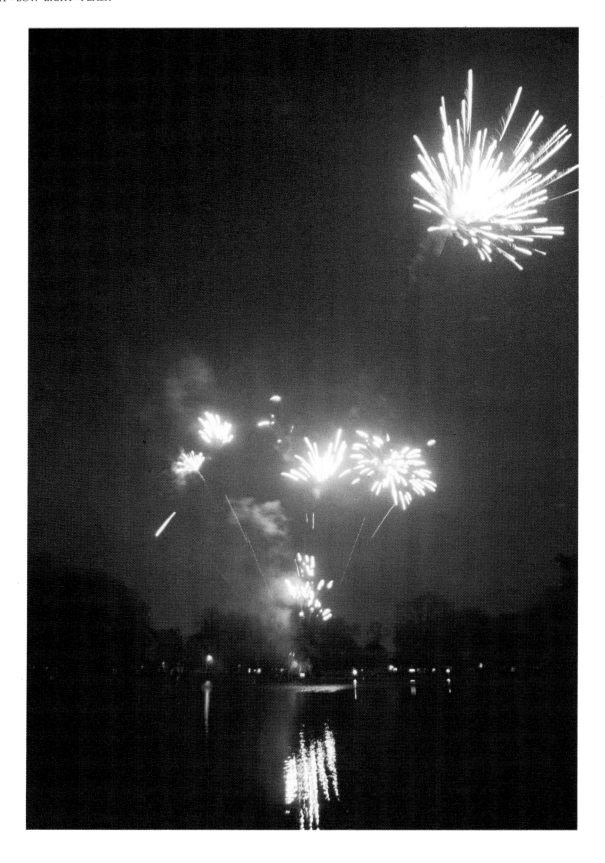

Here the shutter was left open for six seconds. The picture is alright, but the firework's image is lacking in colour and looks soft. The reflections in the water add some interest to the picture. (Ektachrome 400, Nikon 24mm: 6 secs – f5.6)

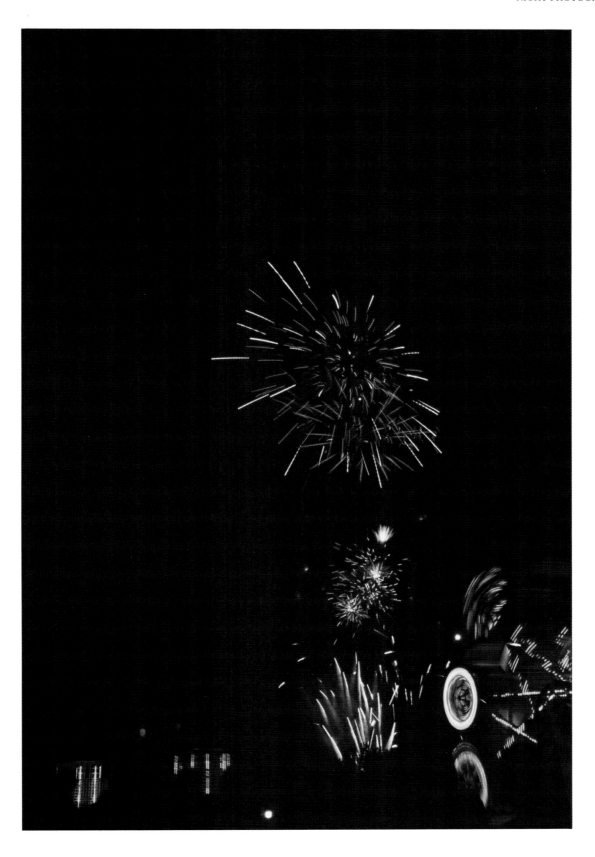

Here a number of shorter exposures were given on the same frame; the firework images
are sharper and the colour better. (Ektachrome 160 tungsten, Nikon 35mm: 3 x ¼ sec – f4)

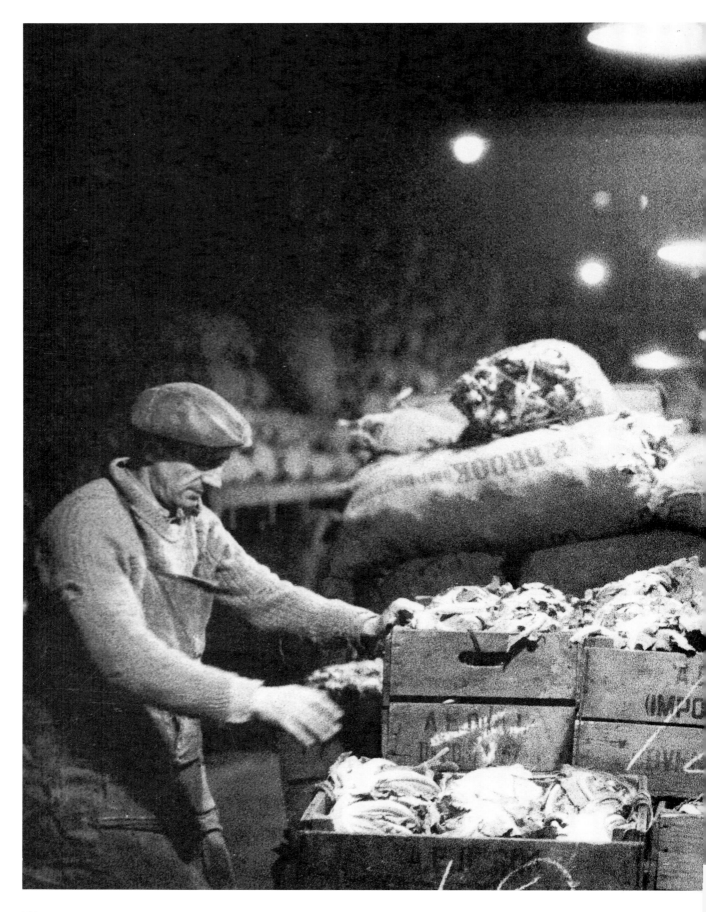

picture look as if it has been taken in daylight or in the studio. The subject should relate to the location. A subject need not be photographed close up; the figure could appear quite small in the picture and still be recognizable. People are often recognized by the way they stand or walk. The background and location will also give clues to the subject's identity. The locations discussed in the previous sections can all be used for the night portrait, and the ideas for both lighting and movement, exploited.

Try treating the subject in a semi-documentary manner. Ask the subject to walk a predetermined route, stopping in certain places where the light and background are interesting, and photographable. The subject can be followed, and photographed as if unconnected with the photographer. The subject's route being pre-set, the photographer knowing what exposures to give, and where the best shots can be made. Movement and selective focusing can again be used to throw the emphasis of the picture on to the subject, even when there are other people appearing in the shot.

For a single portrait there are many places where an individual can be made to look quite natural, even when the portrait is very posed. When the emphasis is on the head some attention has to be paid to the quality of lighting, and it may be necessary to provide some fill-in light. In most cases this can be done successfully with a reflector, a newspaper will make an adequate reflector and the subject can even be shown holding it. Again it is not always necessary to show the subject's face clearly, and the dramatic effects that can be found with available light at night, should be exploited to the full.

With the posed portrait, the subject can be asked to remain still for longer exposures, without this affecting the look of the picture. By selecting locations that have higher light levels, and having the camera on a stand, slower shutter speeds can be used. This will enable you to use a film of a slower ASA rating, giving finer results.

Because of the wide variety of lighting found when working outside at night, achieving accurate colour may be impossible without using some form of supplementary lighting. Colour casts become more noticeable on portraits, or on any photograph where skin tones appear. Flesh tones are one of the standards that we use as a colour guide. With the many variations of colour temperature that can occur in a night shot, it is impossible to give any accurate advice on films or

In a place like a market there are always stacks of boxes and sacks, making interesting shapes and patterns and giving plenty of still life material to photograph.

137

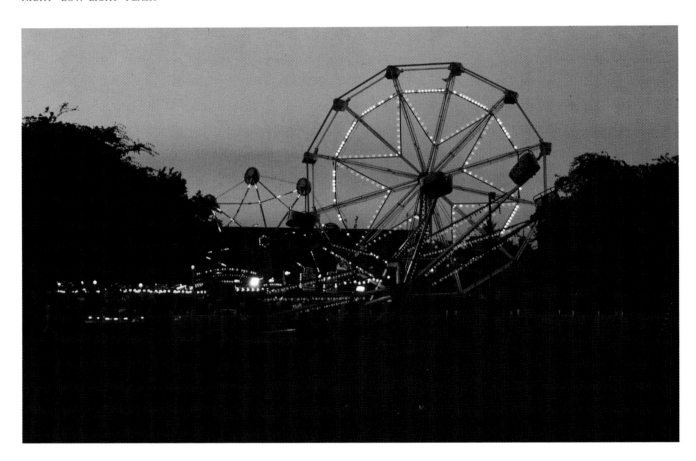

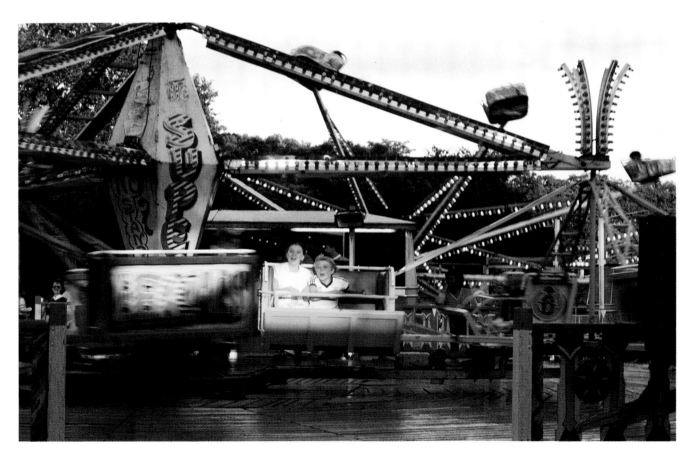

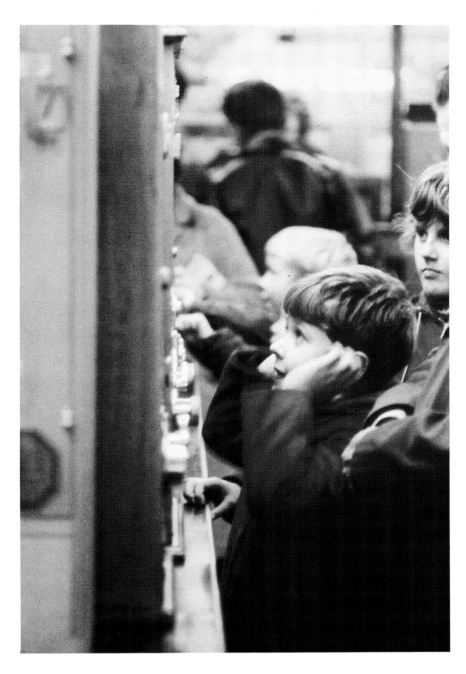

ABOVE *This child holds his ears at the possibility of a win on a pinball machine. The cold colour is due to the very poor quality fluorescent lighting in the amusement tent. (Ektachrome 400 rated at 800 ASA, Nikon 135mm: 1/60 – f2.8)*

OPPOSITE ABOVE *Viewed from a distance a funfair is just a pattern of lights, which is interesting enough, but to capture the real feeling and excitement you must show movement and the faces of the crowd. (Ektachrome 400 rated at 800 ASA, Nikon 50mm: ½ sec – f5.6)*

OPPOSITE BELOW *A shaft of sunlight spotlights these two children as they whirl past on a ride. They were moving towards the camera at this point, making it possible to use a slower shutter speed. (Ektachrome 400 rated at 800 ASA, Nikon 135mm: 1/125 sec – f2.8)*

filters, although a general guide can be found in the film section at the beginning of the book. Once again it is a matter of trial and error, and a subjective approach.

Human form

At night the approach to photographing the human form, naked or clothed, will be much the same as described in the low-light section. With the nude, using flash outside at night can produce very interesting pictures. If you have a model who is willing to pose outdoors, the combination of the nude and the night location can prove very dramatic. One thing to remember about using flash at night is that the flash can be very noticeable, even at a distance, and what at first may have seemed a secluded location may turn out to be a centre of interest after a few exposures.

The other problem is keeping the model comfortable and warm. It is surprising how often such basic things as where and how the model is to get undressed, are forgotten once you move away from the comfort and convenience of the home or studio. All these problems can be overcome quite easily by pre-planning, and the time the model has to spend in the open can be cut down, by knowing exactly what the lighting will be, and having the exposures already established.

STILL LIFE

Many mundane objects that go unnoticed during the daylight hours can, at night, become impressive. This is due very often to the effects of lighting. At night a nearby light can create an environment around the object, making a relationship of colours and forms not seen at any other time. Many man-made objects have internal lighting, which at night makes them very distinctive. A telephone booth is an example. Most forms of mechanized transport look impressive at night because of the combination of internal lighting and the way light reflects off their exteriors. This can look even more dramatic in wet weather, or when the vehicle is wet.

The forecourts of filling stations make good locations for photographing cars and motorcycles. Permission to photograph there will, however, need to be sought. The lighting at a filling station is usually high level and fluorescent. Shooting the car against the brightly lit interior of the filling station will give a high-key background against a low-key foreground. With enough distance between the foreground and background, this should work in terms of exposure balance. The opposite balance can be achieved if you select the right location. You could shoot a skyline broken by lights, with the car being lit separately by flash. And if the location is dark enough multi-flashing can be used for more adventurous lighting. Times can be chosen when

the background is either empty or busy. At most times reflections, flare and patchy lighting are to be avoided, but at night, so long as it is not too extreme, it can enhance the picture. Reflection and flare can be created or added to, both by the choice location and by using your own lighting. If you are using lighting make sure the flare or reflection is not too exaggerated. If it is too extreme it can effect the balance of exposure, creating an unacceptable and unprintable picture.

NIGHT EVENTS

There are numerous nocturnal events, some – like firework displays – require darkness, while many others take place under floodlights. Most of these events can be adequately photographed with the aid of ultra-fast film and fast lenses, without the use of flash. To use flash effectively you have to be within a reasonable working distance from the subject, which can prove impossible at many sports events and pop concerts. It is amazing to see people with quite sophisticated photographic equipment, trying to take flash photographs at events from way back in the auditorium, and expecting to get results. In many cases the only thing they are likely to get is thrown out of the event!

In some venues, and with certain sports, flash photography is strictly forbidden, and even without flash you will need to get prior permission to take pictures. If you wish to take high-quality photographs, such as frozen action shots, you will need permission not only to use flash but also to get close enough to the subject to make the flash effective.

It is perhaps best, once again, to aim for mood and atmosphere rather than accuracy, taking the subjective rather than the objective point of view. With a stage show or concert, the lighting plays an important part in the show, and using flash would destroy this. The other problem with using flash is that the restrictions of on-camera flash mean that all the pictures will have the same look about them, lacking any individuality.

Funfairs and fireworks

Funfairs and firework displays are excellent photographic subjects, and the energy and concentration of colour they offer are probably not found on any other other nocturnal occasion. Of the two, the funfair offers a wider range of subject matter because of the relationship of people to the activity; this is less strong with a firework display.

From the point of view of capturing light and colour the firework display will prove the more difficult, as exposures cannot be gauged with a light meter. As the firework is a burst of light, it is best just to open the shutter, allowing it to make its own exposure on the film. This overcomes the difficulty of trying to prejudge the

best time to make the exposure. The more airborne displays are the best to photograph in this way; set pieces on the ground burn for a long time and can be photographed with a relatively short exposure, a ¹⁄₆₀ of a second at f5.6 with a fast 800 ASA film. The concentration of a number of fireworks close together tends, however, to give a burnt-out effect, lacking any real colour. An aerial display, because the bursts of colour are spread-out against the black of the sky, gives a more concentrated colour, with a sharper image.

There are two ways in which a long exposure can be made, both require the camera to be on a stand. The first envolves setting the camera on 'Bulb', locking open the shutter with a cable release, and letting the fireworks burst in front of the camera. The lens can be covered between bursts to stop any ambient light. Quite long overall exposures can be made in this way, although on average each exposure period may only last seconds. The other way is to set the camera on half or one second, and make a number of exposures using the multi-exposure control on the camera, which allows the shutter to be cocked without winding the film on. With the second method the burst can be located in different parts of the frame by adjusting the camera between exposures. This can only be done if you have nothing in the foreground that is also registering on the film. If you are shooting a display over water, or have the heads of the crowd in the bottom of the frame, the camera will have to be kept stationary.

The atmosphere and energy of a funfair comes from a mixture of sound, light, colour and human excitement, and at night all these elements seem much more potent than during the day. The funfair is perhaps the place to photograph displays of coloured lights. The way that the lighting is combined with the design, structure and motion of the rides and stalls is not found in such concentration anywhere else. Although there is a lot of light at a funfair, the level of that light can be quite low. The lighting designs are made up from a number of bulbs or strips, very often of an equivalent wattage to the household bulb. This is fine for recording the lights on film, but does not always produce enough light for other photographs.

Taking details of facial expressions can sometimes prove difficult. The lighting is often from above or behind the subject, and the best facial shots can be caught either from the side, or by shooting across an island stall with a long lens. Stalls provide the best places for candid head shots, as subjects are engrossed in a game or competition. Often this will also mean that they are fairly static, so a slower shutter speed can be used. Watch out for the sudden changes of expression that often happen when somebody wins or loses. The expressions of fear and excitement, that you can see on the faces of people on rides, are more difficult to capture at night because of the speed of the rides and the lack of light. Dusk is the best time if you want

pictures like this; there is still some daylight but it is dark enough for the lights to be effective in the photograph. Rather than look for the more detailed shots, go for the pictures that capture the atmosphere of the fair, and do not worry about movement or lack of detail.

Try planning long exposures with the rides moving through the frame, and even take out-of-focus pictures, exploring the abstract patterns of the lights. The funfair offers many different subjects – people, movement, lights, still-life, and the possibility of combining many of these in one picture.

Concerts and shows

An open-air pop festival gives you the opportunity to photograph similar subjects by daylight and by stage lighting. You will find the pictures taken under stage lighting are far more effective. At dusk, a combination of both daylight and artificial light can be used to give some foreground detail against the spot-lit figures on the stage. The light levels at concerts appear much brighter to the eye than they really are. This is becuase you are looking at a brightly lit area in a sea of darkness. There will, however, be enough light to photograph by if an up-rated fast film is used. Unlike most stage shows, the light levels at pop concerts are not always constant, mainly becuase coloured lighting effects are used. For photographic purposes this could mean substantial differences in exposure values.

As the eye is fooled into believing that the stage is brighter than it really is, so a light meter, particularly a through-the-lens type, will do the opposite, and give a reading that considers the dark unlit areas as well as the stage lighting. This will give a result that is overexposed for the stage area. If the metering is centre-weighted, this will be less of a problem, but you must still take a reading from the centre spot, even if the main subject is positioned away from the centre frame. The ideal camera for shooting at a pop concert is an automatic camera with a centre-weighted mode.

To overcome the problem of false light readings, use a telephoto lens on the camera, to restrict the view and give a more concentrated central light reading; this turns the camera into a spot meter and, if required, readings can be taken from different areas of the stage, and averaged out for a more accurate general reading. Because of changing light levels there is always a certain amount of guess work involved when photographing at concerts. Many professional photographers use a set shutter speed, and bracket a stop either side of a selected aperture, shooting the whole concert on these combinations. One film is then used as a test, and any adjustments made to the remaining films during processing. This method uses a lot of film, but can guarantee results. If you are uncertain about the exposures on a film, the clip test method can be used – the first few frames being cut off and processed. This can

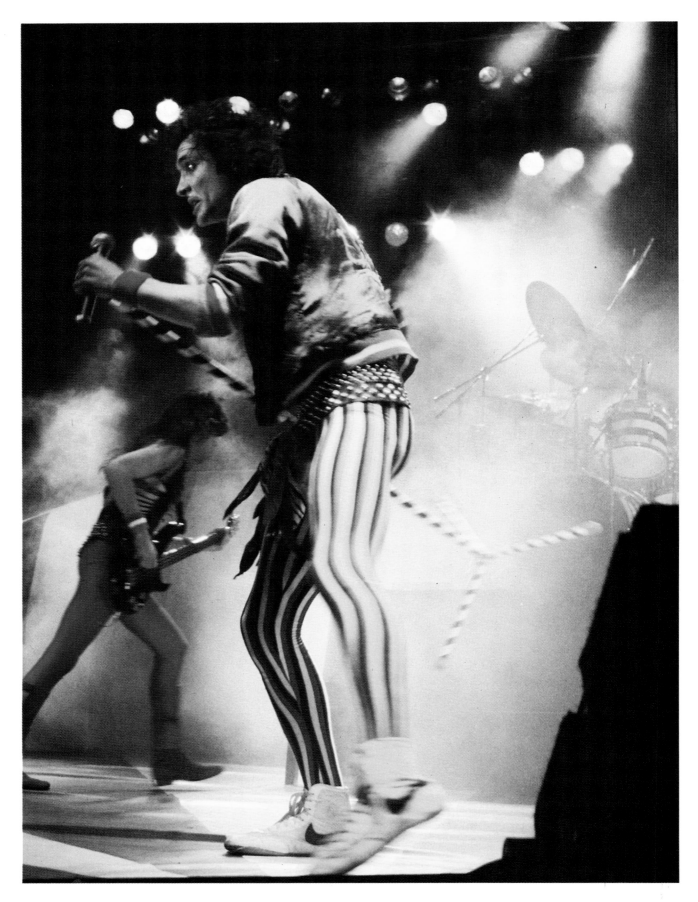

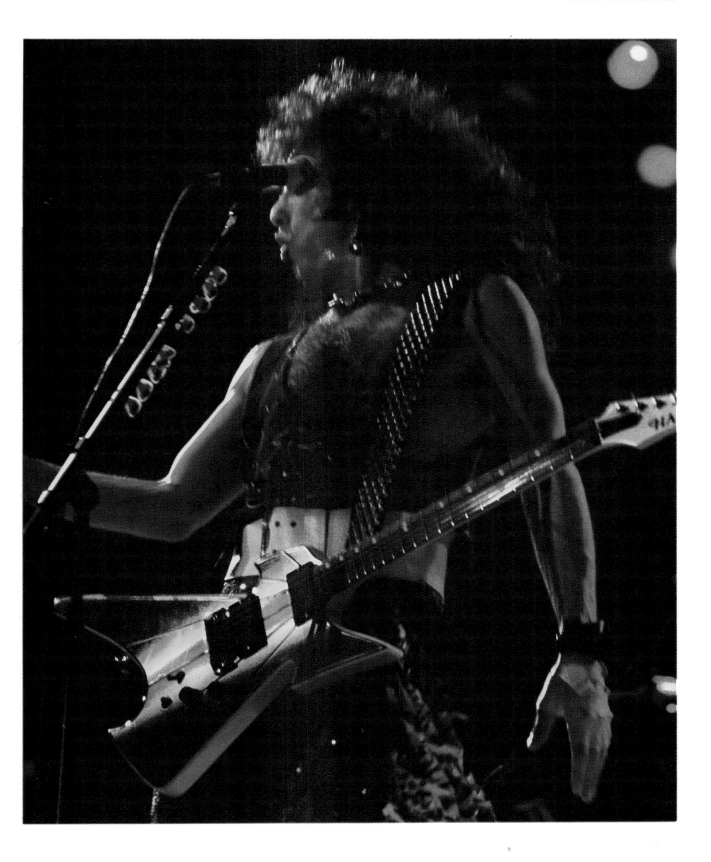

Of all pop concerts, the heavy metal groups provide the most interesting shows to photograph; there are plenty of effects and colour. (Ektachrome 400 rated at 1600 ASA)

be done with colour, as well as black-and-white film, and some labs do it at no extra cost.

At an open-air concert or festival it is easy to move about and get a variety of view points, but at a concert in an auditorium you will have to stay in your seat, or take the odd shot from a side aisle, unless you can get permission to shoot from the foot of the stage. Choose your seat with a clear view of the stage, at about the same level as the platform. If you pick an end-of-row seat, where the aisle gives you a clear view of the stage, you are less likely to disturb the people behind you, and you will also have a wider angle of vision.

A medium-range zoom, if it is reasonably fast, is a useful lens to have at a concert. You will find that you need a working shutter speed of at least a sixtieth of a second, which means a fairly wide aperture is required. It is not too difficult to change lenses when you are sitting in one place, although you might miss the odd shot while changing. If you are seated well away from the stage there is no point in attempting to use flash; it is only likely to upset the audience around you.

Shooting at stage level or above, affords a greater variety of options than shooting from auditorium level at the foot of the stage, where, not only will you get low-level shots looking up the performers' noses, but you are also going to have any stage lights behind the performers shining into the lens. Shooting into the light can be very effective, if you can control the camera angle, but this is not always possible at concerts because of the restricted work space. With backlighting you will need to compensate the exposure readings by opening up the lens by two stops if you require detail in the subject; otherwise you will get a silhouette.

The smaller local venues can prove just as interesting to photograph as the bigger more spectacular concerts. The lighting will be limited, and you can move around more, getting a larger variety of camera positions. These smaller venues are just the places to try out different techniques and film materials, before attempting the more restricted, larger concerts.

Other stage productions can be photographed in much the same way, but photography is rarely permitted during a performance. Often the only way to get photographs will be through attending rehearsals.

A spectacle that is well worth photographing, because it gives perhaps the widest variety of different subjects in similar light conditions, is the circus. The circus is in some ways a cross between photographing a stage show and a sports event. There are times when the action follows a set pattern, and is easy to predict, while at other times the action is more erratic, making picture-taking difficult. The lighting, however, will only change from act to act, giving you more time to judge exposures, and allowing for more than one exposure to be made of the same subject, thus making bracketing possible.

You will find the levels of light fairly high and as most big tops are not that big, a fair amount of light bounces back off the light-coloured surface of the ring, lighting the audience. The rows close to the ringside are often lit directly by the ring lights, making it possible to take photographs of audience reaction.

With so many different types of act you will find quite a wide range of shutter speeds can be used. For the acts that circulate the ring a number of times you can pre-plan a shot, focusing in advance on a spot the performer will pass. Movement is an important part of the show, and some effort should be made to capture this feeling by the use of planning and slow shutter speeds.

If you are confined to a seat, pick one opposite the entrance to the ring; in this way you can cover the artists entering and exiting. Moreover, as the entrance is closed off with a curtain during the performance, there will be times when the artists are performing against a plain background. Once again it would be useful to get permission to move around the tent, enabling you to shoot from many different positions.

A circus makes a fine story subject. It takes place over a set period of time, and pictures can be taken of the circus arriving, setting up, the acts practising, the individual performers (including the animals), the audience, the performance, and back stage while the performance is going on. One of the most impressive audio-visual shows I have seen was on the theme of a circus coming to town.

Floodlit sport

At any time when photographing sport, a knowledge of the game helps. This is particularly so for team ball games that follow no set route or predetermined pattern of play. For these sports a good understanding of the game will mean that you can predict the likely direction of play, as well as recognizing the moves likely to provide peak action. Being able to capture action is the essence of sports photography, picking out the moments of tension and grace that are missed in the general excitement of the game. This is what makes action photography interesting for both the viewer and the photographer.

Track and course events are the least difficult to cover, as they follow a set direction and course, which means that selecting camera positions, focusing and framing, can all be done in advance. With any sport, you want to be in the right position with the right equipment to get the widest possible variety of shot. It is only by experience that you will get to know the limits of your equipment and where the best camera positions are for a given sport. The next time you go to an event, or watch one on TV, look out for the professional photographers; they tend to group together in certain spots, and this is not because they enjoy each other's company. Once you start to take sports pictures you will discover that there are certain places that are

obvious camera positions, and these will differ from sport to sport.

Most of the professionals will be shooting with long lenses because they need to get tight action shots in which the players can be recognized. For the non-professional this is not always necessary, as the picture is taken, not for its news appeal, but for its aesthetic appeal. Nevertheless for any kind of sports picture a telephoto lens is necessary, and under floodlit conditions it will need to be pretty fast, even if you are using up-rated fast film. There are limits to the sense of using very long lenses hand-held, not because of camera-shake alone, but because it is very difficult to track moving subjects and keep them in frame. The ideal hand-held long lens for sport photography is the mirror type, which gives the same focal length as a normal telephoto lens but with half the length and weight. When using a long telephoto lens, a tripod with a smooth pan and tilt head is necessary for panning or tracking. This arrangement is most effective at track events, where a tight field of vision and direction of movement can be predetermined. If you can get close to the edge of the track, field, or arena, you will find that a 200mm telephoto is a workable lens to use hand-held. If the lens is of reasonable quality, and the subject is kept centre frame, the picture can be enlarged later, allowing the subject to fill the frame.

To freeze action you will need to use a fast shutter speed or flash. A fast shutter speed under floodlit conditions will not be possible very often, unless you are lucky enough to be at an event that is being televised. Shooting with long lenses away from the action, flash will be ineffective. Besides this, most sports events forbid the use of flash. In spite of these problems it is possible to get near-frozen action shots. There are times in any activity when the action reaches a peak, and for a short while the movement is suspended, as it changes direction. It is possible, with an understanding of all sport and a great deal of practice, to capture these moments. The direction of movement in relation to the camera will also affect the speed at which an action can be frozen. If the subject is moving towards the camera, a slower speed can be used than if it is moving across the camera.

To achieve very high-quality frozen action shots involves the cooperation of the player or players. An action shot can be totally posed and still look like the real thing. Most sports enthusiasts spend a lot of time practising, and would not object to breaking a training routine if they thought that a good action picture of them would result. The place to practise your photographic techniques is at a local event, where you have easy access to all parts of the field, and the participants are approachable and more willing to give their time. Look out also for trial or preview days for the major events; at some sports events it is possible to buy a rover ticket for any part of the field or stadium.

The other problem with fast moving sports is keeping the subject in frame. If you wait for the subject to gain the perfect frame position, by the time you have reacted and pressed the shutter release the subject is leaving or has left the picture. With an SLR, the picture is lost from view the moment the shutter is tripped, which adds to the problem. One way around this is to shoot before the subject is in the ideal position. Otherwise you can use a motor drive to take in the full sequence of the action as it passes through the frame. With a coupled, range-finder camera, this problem of picture loss does not exist. Panning fast action is very difficult as you need to know when the subject is about to enter the camera's field of vision, and with a tight full-frame shot this is a real problem.

The solution is to use a sports frame-finder. This fixes on the hot shoe of the camera, and allows you to view the action of the subject before it enters the picture area. It is possible to make a sports finder from two 35mm transparency mounts, of the type that have the two sections hinged together. Overlap one section of each mount and glue them together as a base. Position the remaining section of each mount at right angles to this base. Cover one mount with opaque tape, making a hole in the centre big enough to peep through. Fix the whole thing on top of the camera immediately above the viewfinder. To compensate for any discrepancy between the sports finder and the viewfinder, keep the subject towards the bottom of the makeshift frame.

All these limitations apply to sports photography no matter what time of day or night and whatever the condition of the light. Taking photographs at night under floodlight will add to your problems but, as with any other kind of night photography, the pictures will have their own unique value. Focusing and tracking a subject becomes more difficult under low-light conditions. At times, however, the lack of light will render fast shutter speeds impossible, making panning and the creative use of movement essential elements for successful photographs.

The problems of taking light readings are similar to those at a pop concert. The concentration of light, surrounded by a dark area, is likely to give a false reading. Unlike the pop concert your subject will be moving over a wide area, making readings difficult to take, but at least the light will be at much the same level across the whole area. Use the telephoto spot meter method described in the section on photographing 'Concerts and shows' (page 141).

With the exception of American football and rugby, the sports that have opposing teams playing for goals are perhaps the most difficult to photograph. The play can take place over such a large area, and is so unpredictable. In such games, the place where there is most chance of action is the goalmouth or scoring area. Take a seat or position yourself, either behind or to one side of the goal. In the front row you have the advantage

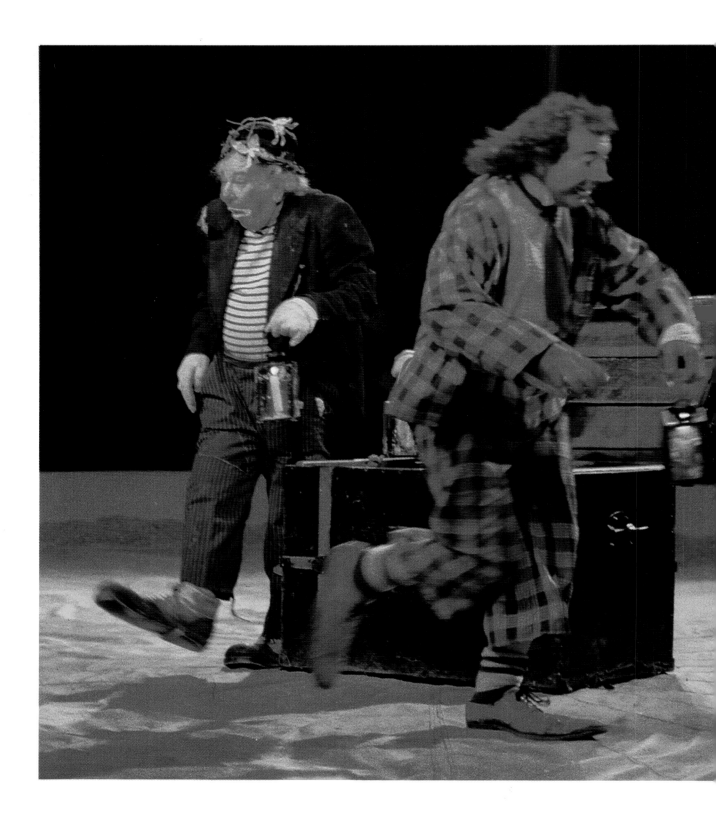

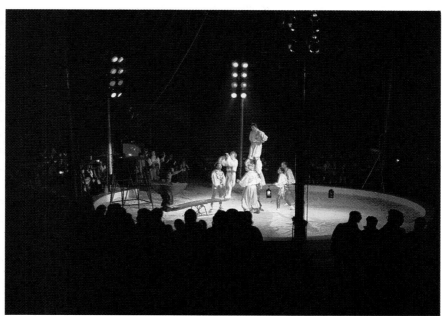

ABOVE *If you use close shots only, there is no indication of the size of the locations, but a wide shot can set the mood of a picture. (3M tungsten 640 rated at 1280 ASA, Nikon 24mm: 1/30 sec – f3.5)*

LEFT *Strong coloured lights will affect exposures. Constant checks should be made if you are not using an automatic camera. Here the light level drops by one stop because of the red lighting. (3M tungsten 640 rated at 1280 ASA, Nikon 135mm: 1/60 sec – f4)*

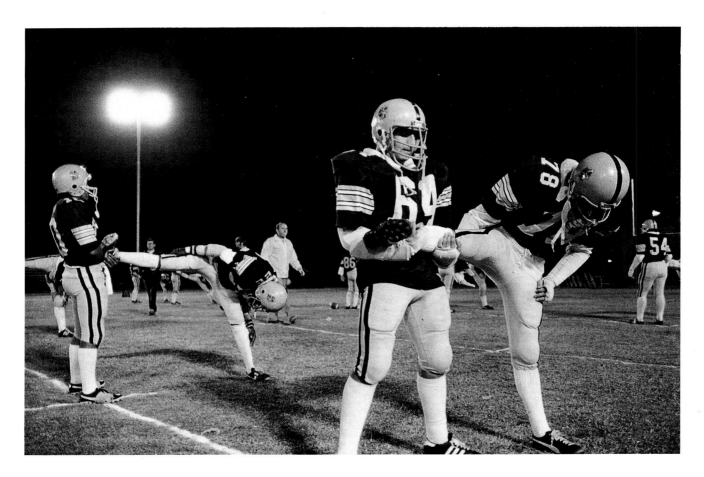

ABOVE *Not all sports photographs have to be of the action; there are other times that can provide good pictures, like this warm-up session before the match.*

of an uninterrupted view, but you may find that background detail is obtrusive. By taking a position a few rows back, you look down on the action with only the playing field as a background. You may, have to jump up when you shoot, to clear the heads of the people in front of you. From both these positions you can still take shots of the mid-field play, making these your wide shots, and keeping the tight shots for the goalmouth.

American Football and Rugby both have moments in the play where the action stops for lineouts or scrums. This allows the photographer time for framing and focusing in preparation for the action breaks that follow set pieces. In general, floodlight is an unattractive kind of lighting, giving no real modelling to the subject, and making shape and form all the more important for successful pictures. In the open there is nothing to reflect back the light, so that it will be predominantly top-light, giving heavy eye-socket shadows, and at times throwing faces into total shadow.

With some indoor games the playing surface will reflect a lot of light, giving higher exposure levels and more interesting lighting. Fortunately two of the faster indoor sports, basketball and ice hockey, have this advantage of being played on a light ground. To freeze a player in the air takes practice and anticipation. At the peak of his ascent the player can be stopped with a shutter speed of 1/125 of a second; while on the way up

OPPOSITE *This shot freezes the player in mid-air, and has some amusement value, as it seems that he is sitting on the head of the player on the ground. This sort of odd positioning happens quite often in sports pictures.*

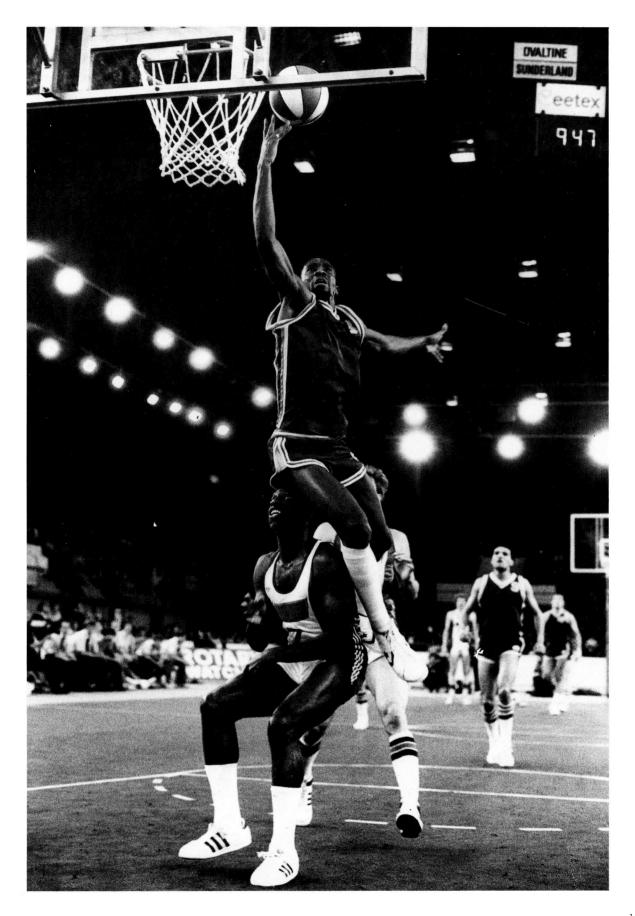

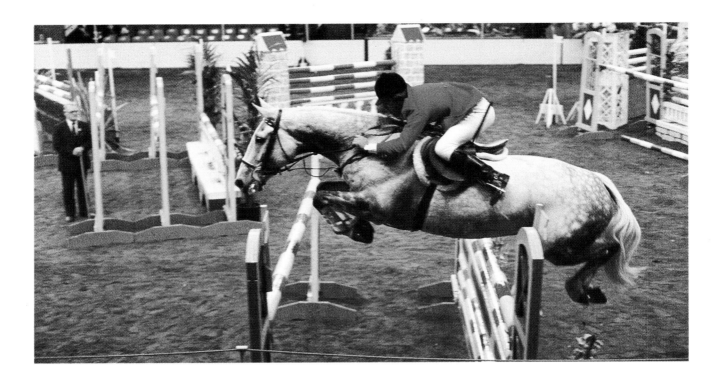

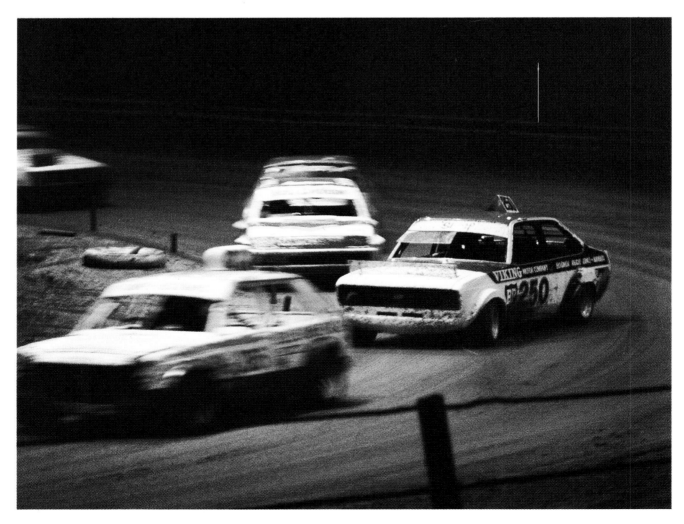

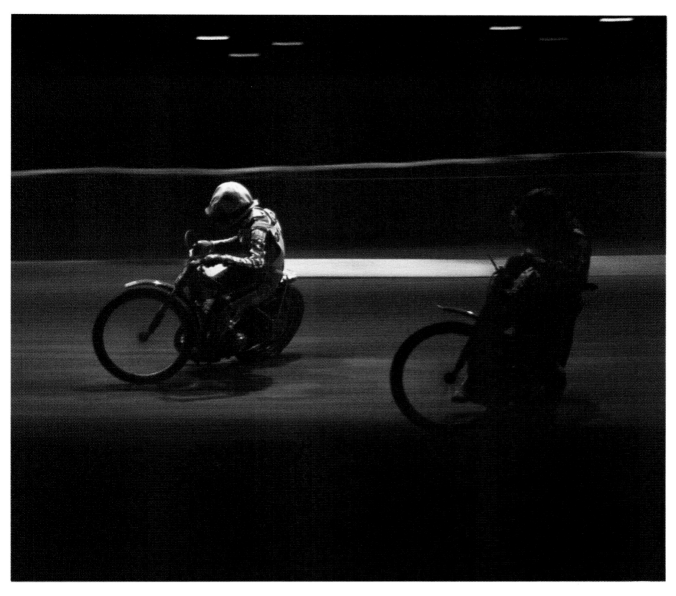

ABOVE *Tracks can be unevenly lit, and catching a rider in the right position means taking a lot of shots. Most good riders, however, do follow the same line, if they can, on each circuit, allowing more than one chance of a picture. To take this picture, planning the camera was necessary. (3M 640 tungsten rated at 2500 ASA, Nikon 135mm: 1/60 sec – f2.8)*

OPPOSITE ABOVE *When photographing showjumping, catching a competitor in the perfect position takes a lot of experience or a lot of luck. Shows are very often ruined by obtrusive backgrounds, and some cropping was required on this shot because of distracting background at the top of the picture. (3M 640 tungsten rated at 1280 ASA, Nikon 35mm: 1/250 sec – f4)*

OPPOSITE BELOW *There are points when motion seems suspended, as in the shot of the basketball player and here, where the hot-rod is at the point of changing direction. Both the car in front and one behind show signs of blur. (3M 640 tungsten rated at 2500 ASA, Nikon 180mm: 1/60 sec – f2.8)*

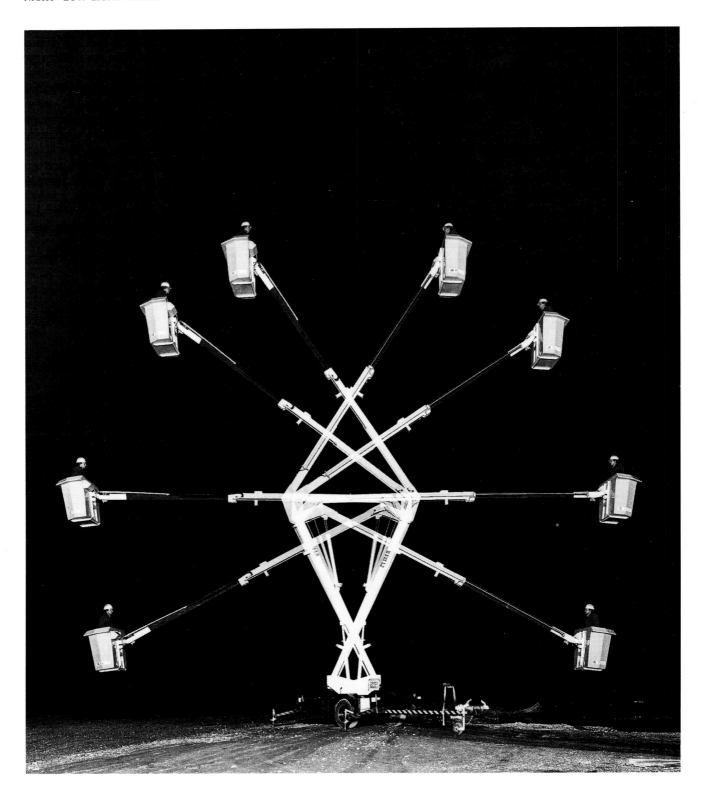

This picture shows just what can be done with skill and patience when using flash. Two flash guns were used, placed forty feet (12m) from the subject. For each of the positions of the platform lift the camera was left open and the flash fired four times. The top two positions each required six flashes. Thirty-six flashes were needed to produce this image. (100 ASA, f8)

it will take 1/1000, and on the way down 1/500.

There are many types of track event that can be seen at night, ranging from the relatively slow action of athletics to fast moving speedway racing.

Track events afford the photographer time and opportunity to try out different camera positions, as you can usually move around more freely at such meetings. However, you may find that you have to take a camera position away from the trackside to overcome the problem of safety barriers when photographing speedway and hot-rod racing. There are a number of races, and many involve several circuits of the track, allowing more than one exposure to be made of the same or similar subjects. As the contestants follow the same line each time, you can pick a spot to pre-focus on, and then wait for the subject to move into focus. This can either be done with the subject moving towards or past the camera, or with a panning shot.

With fast moving subjects the distance they are from the camera, and the direction they are travelling in, will make a difference to the shutter speed needed to stop the action. The further the subject is from the camera, the slower the shutter speed required. This means that a small subject filling the frame will need a faster shutter speed than something that is larger but takes up the same picture area. If the subject is moving towards the camera it can be stopped with a shutter speed that is a quarter as fast as for one moving across the camera.

There are many other sports that provide diverse and stimulating photographic prospects, each having its own particular problems and points of interest. For the most part we have been considering the action sports, but there are many sports – high diving, field events in athletics, or gymnastics – where action can combine with the grace of body movement, poise and balance. These are also among the sports where you may find it possible to take arranged shots, exploring the potential of multi-flash and multi-exposure.

A picture series is another way to show action. Choose a sporting activity that takes place in a limited space – a gymnast on parallel bars, a pitcher in baseball – set the camera in a position from which you can take in the complete sequence of the action, and shoot as many pictures as possible. You may find a motor drive useful for such a sequence. The finished pictures will need to be presented as a group to have their full impact.

MULTIPLE EXPOSURE

At night, or at any time when there is a large area of black in a picture, multiple exposure techniques can be employed. These involve the superimposition of more than one image on the same photograph by means of a number of separate exposures. It is not difficult, but to achieve the best results takes pre-planning and fairly accurate exposures. Most modern SLRs have the facility to cock the shutter without winding on the film, which makes multiple exposures a lot easier to take. The composition of the picture has to be worked out in advance – you must know exactly where each element of the picture is to be in the frame. With this technique it is possible to manufacture an elaborately contrived picture that looks completely natural.

One of the easiest ways to create a multiple image is with flash: set the camera on a stand and photograph the same figure in a number of different, pre-selected areas. It is possible to shoot an action sequence in this way, having the complete action in one frame. Care needs to be taken over the positioning of the flash, it must be kept at the same subject-to-flash distance for each exposure if it is to give consistent lighting, and if the subject has to be closer or further from the flash, the aperture should be adjusted accordingly. If you wish, the combination of time exposure and multi-flashing can be used to give a sense of movement or to allow some of the background to register.

It is possible to adopt a more arbitary approach to multi-exposure by exposing the film once through the camera, winding it back into the cassette and re-exposing it. By shooting a simple, even out-of-focus, pattern on the first exposure, which will appear in those unexposed areas of film on the second exposure, you can create some interesting effects.

Masking techniques can be used for multiple exposure shots, but they must be well planned if they are to work. With a mask it is possible to isolate a subject, or part of a subject, that is not normally seen on its own. It is possible, for instance, to make a composite view of an historic building, including several view points and even some architectural details. To make the picture as natural looking as possible, make the composition from subjects that are relatively isolated in their own right.

First you need to decide where all the separate elements should fall within the frame, to make up the overall composition. Draw these areas out on a sheet of paper, about 20 × 16 inches (50 × 40cm), allowing a generous marking around the composition. Isolate each area with an irregular frame that has no straight edges – an ellipse shape is best. Transfer this to a piece of thick black paper or thin card, cutting out each of the areas to leave a hole. Then take pieces of black paper and cover these holes in such a way that they can be uncovered and re-covered easily. The mask is now ready for use. Line up the camera for the first shot, and place the mask in front of it, fixed on two stands to hold it steady. The distance from mask to camera needs to be such as to give the picture size required, without the mask being in focus or distinguishable. The first hole is

ABOVE *A slide projector can be a useful tool in making images. The screen is an artist's canvas and the easel seemed an appropriate stand for it. To register the easel as part of the picture, light was allowed to come from outside the room. (Ektachrome tungsten 160, Nikon 24mm: ¼ sec – f3.5)*

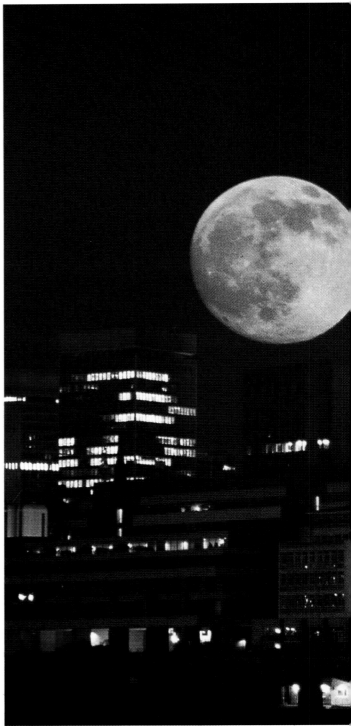

RIGHT *This picture is made up of three separate exposures on the same frame, using two different lenses. First the cityscape was made using an 80mm lens. Keeping in mind the area already exposed on the film, the second shot was made of the moon using a 300mm lens with a two-times extender; the third likewise. (Ektachrome 400 rated at 800 ASA)*

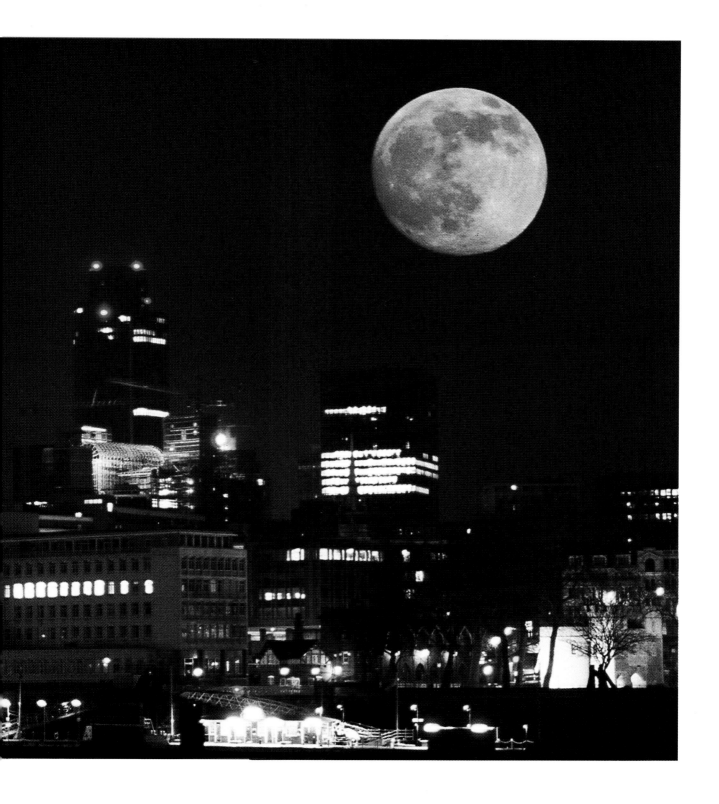

uncovered and the exposure made, the hole is then re-covered and the next shot lined up, and so on until the whole exposure is finished.

Multi-exposure, multi-flash, and masking techniques can be combined, enabling quite complex pictures to be taken in a fairly small area. With both the lighting and the subject completely under the control of the photographer, almost anything is possible. Figures can be reduced and incorporated into a still life, or the same figure made to appear in different sizes and positions within the frame. It is possible, with careful planning, to incorporate a studio shot with an exterior shot, to make up the most unusual pictures. Interesting effects can also be achieved by using an existing colour slide or black-and-white print that has an area of black in it. By copying this onto a new film and then re-shooting on top of it. The existing image can be used as a reference to where the second image should be placed. The techniques of multi-flashing or multi-exposure may sound very complicated, but in fact they are quite straightforward, although they do require a degree of planning and accurate exposure control. Using these techniques extends your photography beyond the found image, into the realms of created and manipulated imagery.

INDEX